ART
IN THE
THIRD
REICH

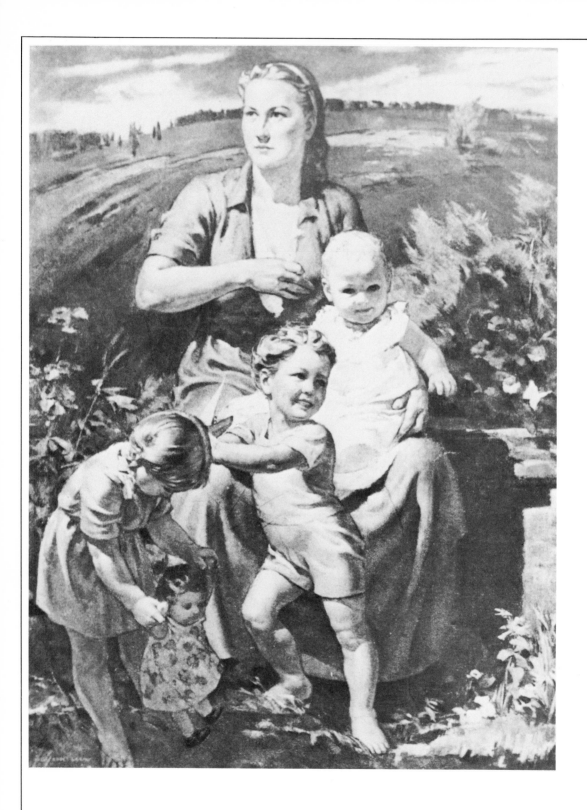

ART IN THE THIRD REICH

by Berthold Hinz

Translated from the German by Robert and Rita Kimber

 Pantheon Books, New York

Library of Congress Cataloging in Publication Data
Hinz, Berthold.
Art in the Third Reich.
Translation of Die Malerei im deutschen Faschismus.
Bibliography: p.
Includes index.
1. National socialism and art. 2. Painting, German.
3. Painting, Modern—20th century—Germany. I. Title.
ND568.5.N37H5613 709'.43 79–1899
ISBN 0–394–41640–6
ISBN 0–394–73743–1 pbk.

Manufactured in the United States of America

First American Edition

Design by Robert Aulicino

CONTENTS

FOREWORD

This version of my book, *Die Malerei im deutschen Faschismus: Kunst und Konterrevolution* (*Painting under German Fascism: Art and Counterrevolution*), was prepared with the American reader in mind. When the original appeared in Germany in 1974, it represented a first attempt to fill the gap between 1933 and 1945 in German art history. Since then, this subject has been discussed with increasing frequency in other publications and in television programs. Some of these studies have been serious efforts; others, unfortunately, have pandered to widespread popular interest in this theme. I realized when I began this study that the material was susceptible to commercial exploitation that might possibly idealize it, but I felt this danger should not be allowed to stand in the way of illuminating such an important aspect of National Socialist rule. The fact that this rule was total and all-inclusive is all the more reason for insisting on an equally total and all-inclusive understanding of it now, even though it lies some thirty years in the past.

Although National Socialism and the art it produced were thoroughly German, if not hyper-German, phenomena, their significance is by no means restricted to Germany alone. The aggressive imperialism of National Socialism visited incalculable suffering on many nations, and only international and intercontinental alliances, aided by resistance within occupied countries, were able to defeat it and liberate Europe. Several hundred million of the world's citizens, both directly and indirectly affected by the struggle, joined forces against fascism. The United States played a major role, morally and militarily, in this effort.

The political interest of the United States and of the entire English-speaking world in fascism was accompanied by an early scholarly interest. The studies by Sweezy and Neumann are milestones in the development of a theory of fascism, and Lehmann-Haupt's book is one of the first on the subject of art and National Socialism.

In this book, I will be dealing primarily with National Socialism, not with the broader concept of fascism, which political scientists use to include all national variants of this particular kind of governmental structure. I want to emphasize that I am concerned here only with the German situation and not with that of other fascist countries. There is a widely held view that similar governmental systems will produce similar art. Nothing could be further from the truth. Futurism, for example, achieved significant cultural

standing in fascist Italy. In Germany, however, an allied country with a similar political system, futurism was banned. In fascist Spain, art was little affected by domestic policy and therefore remained relatively free. This was the case to an even greater extent in Portugal. These differences can be traced back to traditions in art ideology that vary from country to country.

Nor will I be dealing here with socialist realism as it developed in the Soviet Union during these same years, even though my failure to do so in the German edition was criticized in several reviews. The occasional similarities that do exist occur in the manner of presentation, in the marked focus on objects, but this is hardly sufficient evidence for assuming that these two styles are identical. Not only are the dominant modes of art in these two political systems different in origin, a key factor in distinguishing between them is their divergent attitudes toward reality. Two major themes of Soviet art, the truck driver and the female tractor driver, do not occur at all in the art of the Third Reich. In contrast, men appear almost exclusively in the role of the plowing, sowing, or resting farmer, and there are innumerable paintings of women as nudes—the National Socialist version of the American pinup girl—and as mothers. Whatever similarities occur in symbolism and in the repertoire of emblems are the result of an effort to disguise National Socialism as a form of socialism and to "prove" this identity visually by means of copying and borrowing.

The American public recently had a chance to see a major collection of National Socialist art now in the possession of the Department of Defense.[1] This collection is made up entirely of war art and art produced in the field by soldiers and war correspondents. It is therefore not a representative cross-section of National Socialist art.

The approximately 700 paintings that the U.S. Army assembled in a so-called "collecting point" at the end of the war, and that are now located in Munich under the administrative control of the federal Ministry of Finance, provided a major source of the art on which this study is based. This collection, from which all war paintings and all paintings displaying specifically National Socialist symbols have been removed, is not accessible to the public. The various art publications of the period in question provided me with even more important source material. The works reproduced in these publications are not necessarily representative of art production as a whole at that time, but they do give an idea of the image of art the state wanted to project in the Third Reich, the kind of art it chose to represent it and with which it identified. A special section of this study is devoted to art as it appeared in the media and in mass reproduction. I will also show and discuss some pictures that date from before 1933 but that the National Socialists

exploited for propagating their own views on art.

Quotation marks usually indicate words, sentences, and phrases that are actual quotes; only rarely are they used to indicate ambiguity or irony. The sources cited by short titles throughout the footnotes can be found in their full form in the bibliography.

This study is the distillation of a number of seminars and lectures in art history that I held at the University of Frankfurt in the years 1972–1974. I would once again like to thank the participants for their interest and their contributions to our discussions. One result of this book was the exhibit "Art in the Third Reich—Documents of Oppression." This exhibit, which was shown in West Berlin and in several cities of the Federal Republic of Germany, met with great interest. It was sponsored by the Frankfurt Art Association. I am particularly grateful to Dr. Georg Bussmann, director of the Association, for his valuable cooperation and for the many new perspectives he opened to me on this material.

The motto I would like to set over this book is the watchword of the Italian anti-fascists:

Non dimenticare!
Don't forget!

West Berlin, June 1977

INTRODUCTION AND METHODOLOGY

What makes the period of "art in the Third Reich" so remarkable is the fact that it constitutes not merely a stylistic phase or a chapter in German art history, but is the result of an unprecedented struggle in the art world. This struggle ended with only one kind of art still visible. This was the art that called itself "Art in the Third Reich."[2] Everything that had been generally recognized before the NSDAP (*Nationalsozialistische Deutsche Arbeiter Partei*— National Socialist Workers' Party of Germany) assumed power in 1933 as representing modern German art was taken out of circulation and eliminated.

The fate of this eliminated art, branded "degenerate" by the National Socialists, and of the artists who produced it, became the focus of widespread interest after the defeat of National Socialism in 1945. This interest gave rise to a number of studies and collections of source material.[3] We are therefore quite well informed about the actions and measures taken by the government to suppress art. This is as it should be: The oppressed certainly deserve more sympathy than the oppressors. But we know very little about the art promoted by the state. This art is the primary subject of this book. The assumption has been, and in many cases continues to be, that this art, commissioned by the state and therefore unfree, is nonart and does not deserve our attention. "On the whole, the art dictated by National Socialism represents an alien element that is not worth examining here."[4] This is the rationale the great majority of art histories of the twentieth century give for neglecting to document the National Socialist version of art.

But this view overlooks the fact that thousands of artists sent thousands of works to the official art exhibits held in the Third Reich. Art works in such vast numbers could not simply be willed into being. They must have already existed somewhere in some form. The twelve years the National Socialists had to pursue an active art policy could not have produced more than a few years' worth of artists schooled specifically in the National Socialist vein. And by the time these artists would have been ready to produce, the war was already under way, and it was no kinder to artists than to anyone else. At least in the first few years after 1933, there could not have been a specifically National Socialist art expressive of a state or party ideology. It is equally incon-

ceivable that several thousand painters, graphic artists, and sculptors would suddenly have renounced their artistic heritage and submitted to any official decrees on art.

Politically, National Socialism developed and possessed a definite and sociologically verifiable mass base. We have to assume that it also had a large following among artists. These artists were not necessarily politically committed— many artists successful under National Socialism would later cite this point to exonerate themselves—but subscribed to pictorial and formal traditions that the art policy of the regime found useful, or at least not objectionable.

These few remarks contradict, in the realm of art, the popular view that National Socialism was a unique phenomenon, catastrophic as it may have been. Just as German fascism may appear, at a cursory glance, to be a "fluke of German history"—a special case separable from the continuum of that history—German fascist art, too, especially painting, is often seen as an "alien element," a disruption in the normal course of art history. This theory of discontinuity, under which we can classify such interpretations of National Socialism, asserts that the period in question does not belong to Germany's "natural" history, that it is not rooted in that history, and that it has no further consequences. This theory may be understandable as an attempt at exoneration and apology, but it is of no value as a basis for a scholarly understanding of the historical structure of National Socialism and its art.

In this study, we will counter this thesis and provide evidence for continuity even in this phase of German history. As we do this, we will have to keep in mind the interaction between permanent and changing elements in this period, for the spectacular manifestations of National Socialism— and art is clearly one of these manifestations—were designed to project a sense of "revolutionary" discontinuity and novelty. They do not themselves express or reflect a revolutionary beginning. But first we will have to outline a phenomenology of aesthetic expansion in National Socialism.

From the beginning, the Third Reich spared no expense and used all available aesthetic means to project its image. At this point, we will not analyze but merely mention the marches, pageants, and the meticulously organized mass meetings and Reich party rallies as examples of the new "mass aesthetic." No less emphasis was put on propagating traditional cultural values and artistic genres. Whenever highways, bridges, representative buildings, or even whole cities were planned or built, they were justified in terms of their aesthetic and cultural significance. Their practical value was ignored and not even admitted as a point of discussion. We are left with the impression that the National Socialist state tried to capitalize on its cultural achievements and play up its aesthetic projects and activities rather than

lay claim to any social achievements or improvements. In this way, it avoided any possible criticism or skeptical inquiry. The government's constant reference to Germany's "greatness" and to the realization of that greatness in the "Thousand-Year Reich" was in reality never more than an aesthetic claim, not an argument based on practical goals and considerations.

An exaggeratedly high social value was placed on the visual arts in all their forms, and they were given a prominent place in public ceremony. The government even went so far as to declare that the cultivation of the arts was of greater and more lasting interest to the people than the "satisfaction of their daily needs." The following "saying of the Führer" was often quoted in this connection: "Art is the only truly enduring investment of human labor" (Nuremberg, 1936). This overweening claim for the arts informed all possible public events and was expressed with all the vapid dignity and pomp characteristic of National Socialist jargon.

The report in the *Völkischer Beobachter* of July 17, 1937, covering the opening of the first "Great German Art Exhibition," illustrates the mystifying use to which art was put. "Imbued with the sacred aura of this house and with the historical greatness of this moment, we closed our sublime ceremony with national hymns that resounded like a pledge from the people and its artists to the Führer. At the conclusion of the solemn dedication, the Führer and guests of honor from the diplomatic corps, the government, and the leadership of the NSDAP moved on to the large, airy rooms of this new temple of German art to admire the first Great German Art Exhibition." The pleonasm of pseudoreligious words in this typical example of National Socialist diction can hardly be ignored. There was no narration whatsoever in the newsreel coverage of this exposition; the film was accompanied instead by the entire first movement of Beethoven's Second symphony. Four years earlier, on October 15, 1933, Hitler laid the cornerstone for the museum in which the exhibition whose opening we have just described was held. On that occasion, Hitler had been proud "to lay the foundations for this new temple in honor of the goddess of art," a temple that was the first public building dedicated by the Third Reich.[5]

The openings of later Munich exhibitions and of other art exhibits held elsewhere, as well as the ground-breaking for and the dedicating of numerous official buildings—these and similar events were all occasions for huge headlines, parades, newsreels, celebrations, and "cultural speeches" by the Führer. Because of this obvious interest that the National Socialist state took in art and in the theatrical use of it, the public was—and still is—ready to believe the propaganda claim that art was of great personal importance to the Führer. Even today, credence is still given to the deliberately

promulgated legend of the "artist" and architect Adolf Hitler, who wanted to be and could have become a Michelangelo if he had not instead been destined to become the "architect" of the Reich.[6] The symbiosis of "architect" and "Führer" that Fritz Erler strove to achieve in his portrait of Hitler reflects a genuine symbiosis of the products of architect and Führer: art and the state. This symbiosis is a constantly recurring metaphor in fascism.

Why is it that German fascism made such extensive use of art and of obviously aesthetic means in making its case? And why did it attempt this with a kind of art that completely excluded all other kinds of art? How did National Socialism organize the exclusion of other art and assure the triumph of its own? These are the questions we will bring to the history of National Socialist art in our effort to determine its structure and analyze its specific modalities.

Once we have answered these questions we should have at our command the materials and tools necessary for understanding the vast martialing of art and other aesthetic means in the Third Reich not as accidental elements, not as mere attractions or eccentricities, but as necessary conditions for the existence and political practice of a system suffering from an overwhelming lack of legitimation. We will conclude this study by extending our focus beyond the limits of painting to include architecture and the reflection of National Socialist aesthetics in the mass media. This approach will, I hope, prevent the material treated from appearing alien and limited to a single nation and point in history. I would hope, too, that it can be of some use in understanding and judging present and future aesthetic phenomena that transcend national borders.

PART 1

HISTORY

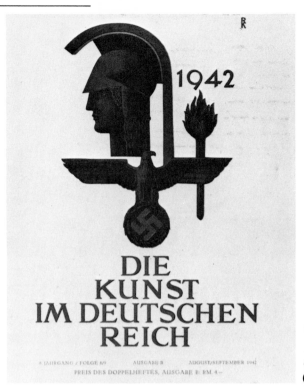

Title page of the periodical
Kunst im Deutschen Reich
(*Art in the German Reich*)
(first published in 1937).

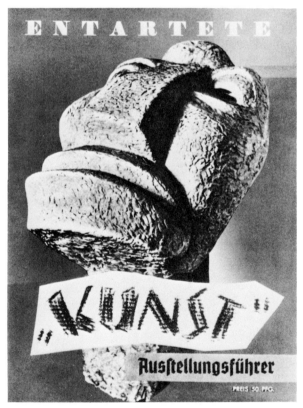

Title page of the guide
to the exhibit "Degenerate
Art," 1937 (sculpture by
Otto Freundlich, murdered
in a concentration camp).

National Socialist leadership gave the visual arts a period of four years—from the assumption of power by National Socialism in 1933 until the opening of the House of German Art in 1937—to adjust to the cultural policy of the new government. During this same period, a campaign was mounted against "degenerate" art and artists. It is therefore fair to say that the year 1937 represents a major turning point not only in the history of art during the twelve years of National Socialist rule but also in the history of German art as a whole. By planning the opening of the Great German Art Exhibition of 1937 in Munich to coincide with a show of Degenerate Art, the National Socialists meant to underscore the triumph of "art in the Third Reich" over "degenerate" modernism. The premiere of official art, celebrated with great pomp and festivities, was held on July 18, 1937. On the following day, the exhibition of the "degenerates" opened close by in a few rooms of the gallery in the Hofgarten arcades.

In this exhibition, officially unacceptable German art was shown to the public for the last time. The exhibit drew 2,009,899 visitors, more than three times the number that attended the "German" exhibition, and was probably the most popular art event of all time. From this point on, the art favored by the National Socialists held undisputed sway in the cultural life of Germany and, after 1939, dominated the artistic scene in the occupied countries of Europe as well.

Before turning to "degenerate art" in the next chapter, we will first examine the "new" National Socialist art. The eight exhibitions that were held in the House of German Art in Munich between 1937 and 1944 offered what National Socialism considered a valid cross-section of the best artistic efforts from all of Germany. We therefore feel justified in singling out these exhibitions from the vast number of other annual and seasonal exhibitions held in Berlin, Düsseldorf, Karlsruhe, and Dresden—to name only the more important art centers—and in defining the new painting in terms of these representative exhibitions.

The spectacular ceremony surrounding these exhibits clearly emphasized their representative nature. Local publicity at the opening of expositions was provided in a number of ways. Pageants designed around the theme of a "Day of German Art" took place. Participants wore historical costumes and fancy dress, and models of German artworks were displayed. Hitler gave "cultural speeches," and the entire National Socialist leadership attended. Newspaper and magazine reports, pictures, postcards, radio, and newsreels publicized the events and art objects among the masses of "compatriots" who could not be present. According to official records, the resulting attendance was as follows (numbers rounded off) : In 1937 there were 600,000 visitors; in 1938, 460,000; and in 1939, c. 400,000. In the early war years, attendance rose even higher. In 1940 it was about

CHAPTER 1

ART IN THE THIRD REICH

600,000; in 1941, 700,000; and in 1942 it was more than 840,000.[7]

Since the exhibition of 1937 was the first of these exhibitions and therefore set the tone for the rest, we will take a closer look at it here. The "cultural speech" Hitler gave at the opening of this exhibition began by calling attention to the obvious break that had occurred in the history of German art. "When we celebrated the laying of the cornerstone for this building four years ago, we were all aware that we had to lay not only the cornerstone for a new home but also *the foundations for a new and genuine German art* (italics added). We had to bring about a turning point in the evolution of all our German cultural activities."[8] This turn toward a "new and genuine German art," i.e., a turning away from "degenerate art," called for a rewriting of history; and the entire National Socialist ideology did in fact, as we shall see, revolve around anchoring the present in the past, dehistoricized as the National Socialist conception of the past may have been.

The notion of "eternal German art" was often invoked as a proof to support the idea of a Thousand-Year Reich, which was itself a metaphor for permanence and immutability. At the same time, the National Socialist concept of history, based as it was on the aesthetic category of "greatness," precluded any possibility of progress or change.

Seen in this context, the pageant called Two Thousand Years of German Culture was intended as an "incarnation of German history," as an aesthetic manifestation of what was permanent in that history, not as a historical illumination of an ever-changing present or of the present world. "What we are seeing here," the *Völkischer Beobachter* wrote on July 19, 1937, "is another world—the images, figures, and symbols of history recaptured. The language they speak is powerful and awe-inspiring. And indeed thousands upon thousands stand spellbound by this splendor, by the incredible beauty of this spectacle, a spectacle that dissolves the present day and moment, a scene that is the distillation of centuries: 'Two Thousand Years of German Culture.' "

This is an understanding of history "that dissolves the present day and moment," that excludes experience of the present, and that manifests itself in the form of pictures, i.e., in aesthetic categories.

Early Germanic history introduces our lofty theme. In the wake of a golden Viking ship the centuries roll by. Germanic warriors, Germanic women, Germanic priests and seers pass before us. . . . Even these mere imitations of mighty symbols drawn from the mythical world of our ancestors have the power to overwhelm our modern sensibility. The sun, the symbol of day, the moon, the goddess of the night, are convincing and impressive in their brilliant colors. Figures from our

**Der Kampf geht
weiter bis zum Endsieg!**

Detail from the title page of A. Rosenberg, *Wesen,
Grundsätze und Ziele der N.S.D.A.P.* (*Essence, Principles,
and Goals of the NSDAP*), Munich, 1930.

Drawing by A. P. Weber for E. Niekisch, *Hitler—ein
deutsches Verhängnis* (*Hitler—A Disaster for Germany*),
Berlin 1932.

forefathers' sagas are suddenly among us. . . . The
stirring tones of trumpeters and drummers on horse-
back rouse us from our ecstatic meditation. The first
great scene in this pageant has passed by.

German cultural identity, transcending both class and the
course of history, is proclaimed time and again.

The next great era of German history is the Romantic
period (*sic*). Charlemagne, king of the Franks; his
enemy Widukind; Henry II, founder of cities; Fred-
erick Barbarossa; Henry the Lion, the great colonizer,
all belong to this epoch. Representations of their deeds
affect us more powerfully than the symbolized figures
themselves. Bamberg and Naumburg, cities founded by
Henry II, and Henry the Lion's German colonization,
symbolically evoked before us, become tangible, be-

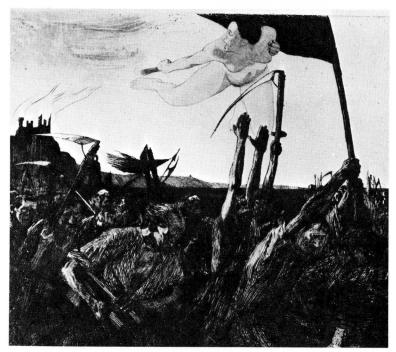

Käthe Kollwitz, "Uprising" (1899).

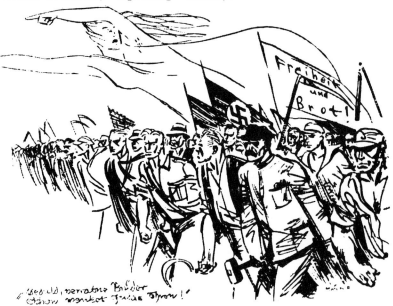

Hans Schweitzer ("Mjölnir"), *Patience, My Betrayed Brothers, Judas's Throne Shakes Already* (before 1933).

come reality. Then comes the Gothic period with its knights, ladies, and works of art. . . . Here, too, small details—carvings on capitals, choir stalls, and altarpieces—these hand-wrought symbols bring a whole world to life in our imagination. . . . Mercenaries, accompanied by pipers and drummers, head the parade of the German Renaissance. In the shadow of their

sword, Dürer, Holbein, and Kranach (*sic*) created their works of art for the German people. *Are they not brothers, the artists and soldiers?* Tableaux from the High Baroque . . . the classic, and the romantic periods are followed by the modern age, our age.

The historical part of the pageant included 3,212 costumed participants. The modern section included 3,191 marchers, 456 animals—horses, dogs, falcons—and 26 trucks.

The report continues: "Is it really necessary to portray the modern age to us who are the builders, workers, and toilers of this last era of German history? Yes! We are too close to our own time. We lack perspective on it. Today, on this day, we were granted that perspective! Today we sat as spectators in the theater of our own time and saw greatness . . ."

Perspective or distance, which should be the result of reflection, was the last thing the benumbed spectator at this pageant could gain. Instead, he was encouraged to identify with a concept of German greatness projected in mystical and aesthetic terms, a concept that made any kind of distance on individual and collective history, indeed, any kind of aloofness at all, impossible. If the historical part of the pageant had the effect, in terms of mass psychology, of suggesting a meta-historical unity and identity in German existence, the final section made unmistakably clear, in visual terms, who the actual guarantors of present German "unity" were.

At the end of this pageant celebrating 2,000 years of German culture, soldiers appeared again, soldiers in gray, soldiers in brown, soldiers in black. . . . The *Wehrmacht* (armed forces) and the SA (*Sturmabteilung*—Storm Troop) marched down lanes of cheering spectators. NSKK (*Nationalsozialistisches Kraftfahrkorps*—National Socialist Motorized Units), *Arbeitsdienst* (Work Corps) and SS (*Schutzstaffel*—Elite Guard) reaped the final waves of applause.[9]

The concept of a dehistoricized culture, in which a militarized present had its place, found expression not only in the pageant but also in the newly constructed House of German Art. This building, designed to replace the Munich Glass Palace, which had burned down in 1931, was the first major architectual project of the Third Reich. Hitler laid the cornerstone of the building on October 15, 1933, and that ceremony, too, had been accompanied by a lavish celebration in honor of this "Day of German Art." A model of the new building was exhibited in the parade held at that time. The Weimar Republic had opened a design contest for this building before 1933, but the National Socialists canceled it and rejected the earlier functional models that had been submitted.

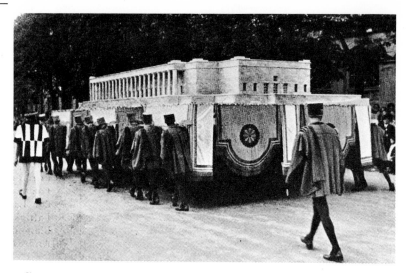

Group marching in the "Pageant in Honor of the Day of German Art" with a model of the House of German Art, Munich, October 15, 1933.

The Glass Palace of 1854 had been a pioneering German achievement in modern glass and steel architecture. It was one of the first buildings to break the dominance of nineteenth-century representative architecture. Now, after three generations—and, of course, after Hitler's assumption of power in 1933—this innovation in modern architecture was to be totally negated. The aim was not to construct a functional building but to create a symbol.

Indeed, as the catalog says, it was a "symbolic act that the Führer joyfully dedicated the first monumental structure of his government to German art," and this symbolic act has to be interpreted in the light of the entire National Socialist aesthetic. The symbolic aspect of the exhibition building was maintained both in its new name, House of German Art, and in its "rich decor."

This is reminiscent of a comparable event in earlier German cultural history. Immediately after Napoleon's occupying armies had been driven out of Germany in 1814–15, the Prussian king, in connection with the political restoration and the refeudalization of the political order, commissioned the building of the first German museum, the so-called Old Berlin Museum. This building, designed by the Classicist architect Friedrich Schinkel, featured an imposing façade that provided the inspiration for the Munich museum over a hundred years later. In both cases, the façade incorporated a portico that extended across almost the entire front of the building. In Munich, the portico is about 575 feet long.

The Munich museum, designed by Paul Ludwig Troost with Hitler's active collaboration, was built of massive cut stone and had a marble interior. The materials chosen had a special significance. "Professor Troost insisted from the

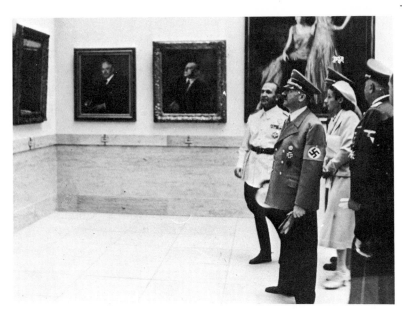

Opening visit at the Great German Art Exhibition in
Munich in 1939 (Hitler, von Neurath, Alfieri, Mrs.
Troost).

beginning that the House of German Art be not merely a
showplace for paintings but a representative structure, a
temple of German art. At first, only the Führer had shown
understanding for this concept. Now everyone recognizes
that it was correct."[10] The anachronistic design and the
expense of the lavish decor, which Troost, who had made
his reputation as a designer of interiors for luxury liners,
favored but which was totally unjustifiable in view of
Germany's economic situation, give the building a definitely
monumental character. Functional considerations were sec-
ondary, but despite this the building had all the latest
modern equipment. "The cellar houses a combined heating-
and humidity-control system powered by gas. At a lower
underground level there is a modern air-raid shelter. It
would be fair to say that the most advanced technology
available has been utilized, but the building does not bear
the mark of technology."

The masking of modern features behind a consciously
anachronistic and, as it were, "thousand-year" façade is an
immanent tendency in National Socialist architecture. In
the particular case of the Munich museum, the building was
to express "in its proportions and in the quality of its
materials the dignity and greatness" of German art. That
is to say, the building itself was to support and complement
the artistic self-expression it housed. Hitler remarked on
this relationship between the building and its contents:

This masterpiece is as notable for its beauty as it is for
the functionality of its technical equipment, but no-

where do subordinate, technical requirements intrude on the design of the whole. It is a temple of art, not a factory, not a power plant, not a train station or a transformer station. With this building, we set ourselves a historic task. It is not only the great and unique artistic conception of this museum that has helped us fulfill this task but also the magnificent materials used and the exacting and conscientious execution of the design. . . . The result is a house worthy of sheltering the highest achievements of art and of showing them to the German people. The building was also conceived of as a turning point that would put an end to the chaos of architectural dabbling we have seen in the recent past. This is the first new building worthy enough to take a place among the immortal achievements of our German artistic heritage.[11]

The art that was to be displayed in such a noble setting represented, as the art historian Hans Kiener put it in the foreword to the first catalog, "more . . . than [just] one side . . . of man's intellectual activity. It will once again speak to us all as the glorious expression of the most noble and heroic will of our whole nation."

But what exactly was this "temple" to contain? If we follow the parallel to the Berlin museum in the first half of the nineteenth century, we would expect to find works of art that laid claim to a greatness comparable to that of the building. When the Old Museum was built in Berlin its purpose was to house masterpieces from the collection of the Prussian crown and to make these works available to the public for the first time. The building was a kind of symbol for the sovereign right of the people to enjoy and, in an ideal sense, to own art, which was no longer to be reserved for royalty alone.

The original plan in Munich, too, had been to extend the theme of the pageant to an exhibition also entitled A Thousand Years of German Art, which would pay tribute to the history of German culture and its popular character. But that is not what happened. Hitler himself apparently demanded "a comprehensive and high-quality display of contemporary art."[12] With this demand he not only satisfied the interests of many contemporary artists but also seized the opportunity to shape policy affecting art. There was still a lack of clarity, however, on just what "contemporary" art was, on what it was to look like, and, therefore, on guidelines for government policy on art. Since there was no conceptual basis to work from and no plan as to how National Socialist culture, whatever that might be, should be presented, the government resorted to an open competition.

Adolf Ziegler, painter of nudes and president of the *Kulturkammer* (Chamber of Culture), signed the announcement for the competition. "All German artists in the Reich and abroad" were invited to participate. The only require-

ment for entering the competition was German nationality or "race." The deadline for submissions was extended once, probably because the entries did not meet the grandiose but undefined expectations of the judges. According to the catalog, papers for 25,000 works were submitted. In fact 15,000 works were sent in, and of these about 900 were exhibited.

We have no information on the criteria of selection for what was now officially to be "art in the Third Reich." There probably were no clear guidelines whatsoever. Most likely, the decisions of the judges reflected their own ambitions and personal preferences. Eyewitnesses report that Hitler himself stepped in at a preview and accepted a number of works by painters who had not been previously selected. Among them was Ferdinand Staeger, who later expressed his gratitude and devotion in propaganda painting. Hitler furiously rejected eighty other pictures with the remark: "I won't tolerate unfinished paintings!"[13] The powerful precedent set here probably remained decisive for the overall development of art in National Socialist Germany as well as for the next seven Great German Art Exhibitions, the organization of which Hitler entrusted to his personal photographer, Heinrich Hoffmann.

In any case, Minister Wagner, *Staatskommissar* (State Commissioner) for the House of German Art, declared at the opening of the exhibition: "It is obvious that our only nationwide art exhibition—and it is the Führer's will that the annual exhibition in the House of German Art in Munich be this one exhibition now and for all time—will show only the best and most perfect products of German art. Problematic and unfinished work is not and never will be acceptable in the House of German Art." With this statement Wagner articulated a kind of two-point program that would be adhered to for the next seven years: First, German art was to be "finished" and unproblematic. We will see later exactly what constituted such art. Second, the House of German Art was to be a museum for changing exhibitions of contemporary art, which would, of course, no longer include "degenerate art."

This museum was not intended, as we might think fitting for a temple, to display timeless masterpieces and to bring them together in a permanent, mutually enhancing community, but became instead merely a gallery for exhibits that changed every year. In spite of this practice, publicity still continued to speak of "timeless" art.

The two points of Wagner's program were, of course, incompatible. The concept of an annual exhibition, by its very nature, makes it impossible to accept only unproblematic and "finished" work. Timeliness, which is the basic element in any seasonal or changing exposition, is at odds with claims to permanence and timelessness. This conflict did in fact give rise to innumerable misunderstandings. The

principles of vitality, flexibility, and novelty inherent in the concept of annually changing exhibitions led artists to submit many works that were deemed "unfinished" and "problematic." In his 1938 speech opening the second Great German Art Exhibition, Hitler explained: "In the case of many ˙pictures it was obvious that the artist had confused the two exhibitions, the 1937 exhibition of 'German' art and the concurrent one of 'degenerate art.' I therefore decided to make a clean break and to set one task and one task only for our new German art. I would force it to hold to the direction the National Socialist revolution had marked out for our new national existence. . . . It is as difficult to know now as it has always been whether we have artistic geniuses of lasting stature working among us. . . . But we do know that we have created the conditions under which great genius can flourish. . . . I thought it essential this past year to give the decent, honest artist of average talent a chance."[14]

Somewhat later in this same speech, Hitler touched on the high achievement of the arts in the nineteenth century, an achievement that the "Dadaist sensationalists, Cubist plasterers, and Futurist canvas smearers" had attacked and endangered. It was essential, Hitler said, to pick up this valuable tradition again. Hitler was simply acknowledging here a process that had in fact been going on for some time: Traditionalist art rooted in the nineteenth century was making use of the National Socialist assumption of power—not only in terms of form and content but also in terms of cultural policy—to assure its own position of dominance in the art world.

The annual changing of exhibitions in the House of German Art carried on the tradition of the old Munich Glass Palace and reflected standard practice in German provincial art centers. The annual spring, summer, fall and winter exhibits put on by local and national art associations gave artists an opportunity to show their recent work. The eight Great German Art Exhibitions, too, were nothing more than displays of work for sale. The notes in the catalogs make this perfectly obvious: "The prices of works offered for sale and the terms of purchase can be obtained from the exhibition offices." Works not for sale—and there were few of these indeed—were marked by an asterisk in the catalog; they included major commissioned works, statuary, and portraiture. The size of the exhibition also far exceeded that of any other twentieth-century exhibits.

Modern international art was usually presented—and still is today—in a small, intimate, and carefully chosen setting. It was customary to hold one-man shows or to exhibit the works of related groups of artists together in one show. In the context of such shows, whatever was unusual and individualistic was given full visibility. These exhibits were not conceived of as marketplaces but as cultural events of

special interest to people who already had a self-image of their social group and were seeking a cultural identity within a specific artistic movement. The branch of modern art that had been branded "degenerate" had no ties to local art associations. These associations were guided, in both form and content, by local pictorial traditions oriented to the tastes of certain established classes of art patrons. In contrast to the new regionalists, the "degenerate" artists saw themselves and their work in terms of the international standards of modern art. Because of this, National Socialism accused them of Bolshevist internationalism.

The external organization of the Munich exhibition is reminiscent of nineteenth-century methods of art distribution. Works were offered for sale in Munich even though the term "art outlet," had been rejected. The Munich exhibits followed nineteenth-century tradition both in size and in principles of classification. The numbers of works exhibited over eight years were as follows: 884 in 1937; 1,158 in 1938; 1,322 in 1939; 1,397 in 1940; 1,347 in 1941; 1,213 in 1942; 1,141 in 1943; and 1,072 in 1944. The corresponding numbers of exhibiting artists, given here in round figures, reflect a similar pattern: 550, 650, 760, 750, 750, 690, 660, and 540. With the exception of the exhibition of 1937, in which the number of artists was relatively high in comparison with the number of works displayed, the ratio is about two works to each artist. We should also note that from 1938 on "a number of additional works of high quality were accepted for the exhibition" once sales had cleared space for them in the halls. In 1938, for example, "exchanges" of this kind gave 244 more works the prestige and sales potential of "Great German Art." In 1940, 317 works were added to the exhibition in this same way.

Sales opportunities were excellent. This may have corrupted quite a few artists and prompted them to go along with official policy. On the average, 800 to 1,000 works were sold each year, bringing the artists 1.5 to 2 million Reichsmark (RM), depending on whether the sum is figured as gross or net income. An individual work therefore sold for an average of 1,500 to 2,500 RM. In view of the fact that, as we shall see later, a large proportion of the works sold were purchased for display in public buildings—these were primarily sculptures and large paintings that were high priced and of little interest to the private collector—the prices cited above are modest and in line with what one would expect to find at art sales. Private dealers followed the trend set by public art sales, encouraging the production of large pictures. This fact adds to our difficulties in making an analysis of prices for "art in the Third Reich."

Unlike the Munich catalogs, those for the Great Berlin Art Exhibitions list individual prices. Oil paintings could be bought for about 250 RM and up, drawings for about 120 RM and up, and prints for 10 RM and up. From this we

can assume that the average price of an oil painting in Germany was under 1,000 RM. Some oil paintings commanded much higher prices. Among them are Johannes Beutner's *The Graces* for 15,000 RM; Karl Edward Olszewski's. *Swans Fleeing Before the Storm* for 13,000; Georg Lebrecht's *Bombs over England* for 10,000; Reinhard Amtsbühler's *Path in the Black Forest* for 8,000; and Anton Müller-Wischin's *Mountain Idyll* for 6,000. These relatively highly paid painters were, as a rule, established masters, or they demanded and received inflated prices for their special themes and formats. Painters who fall in this second category are Beutner and, even more so, Lebrecht, whose less sensational titles never brought him more than 2,000 RM. The prices at the Berlin exhibitions, in which the "great" names of National Socialist art rarely appeared, were probably lower than those at the official Munich exhibitions. But the Berlin exhibitions may well be more typical of the art of this epoch, for it represented a triumph of the provinces, a triumph, as it were, of local painters who at no time commanded spectacular prices. And after the liquidation of the modern school, Berlin's artistic life certainly became provincial.

The campaign against "degenerate art" had constantly called attention to the high prices often asked for modern art. Now prices had come back down to a reasonable level. "Pleasing artwork worthy of decorating the walls of our homes" was once again within reach of the German family. But the great mass of "compatriots" whose interests the National Socialists claimed to represent still went empty-handed as far as the enjoyment or possession of art was concerned. The art scene had remained typically middle-class.

The social classes unaccustomed to visiting museums or art shows in their leisure time were offered occasional exhibits that were held in empty factories and that were sponsored by the *Deutsche Arbeitsfront* (German Workers' Front), an organization both employees and employers were obliged to join.[15] By making a genuine effort to introduce culture to the working class, or to form a new culture with the aid of that class, the ruling party could have lent credence to its propaganda and provided some justification for its name, the National *Socialist* German *Workers'* Party. But any activities of this kind, inspired in part by the early Soviet Proletcult and aimed at bringing workers and culture or production and art together, were limited to a few scattered events organized by the *NS-Gemeinschaft "Kraft durch Freude," Amt "Feierabend"* (NS-Group "Strength through Joy," Division "Leisure Time"). These events were not publicly advertised and therefore cannot be considered part of the regime's official cultural program.

Even the name of the sponsoring organization, Leisure Time, modeled on the Italian fascist organization *Dopo*

Lavoro (After Work), shows that no attempt was made to break the cycle of work and leisure. Culture functioned merely as compensation for alienating work. It was not seen as a synthesis of work and leisure in both individual and social life. The activities of Division Leisure Time were designed to elevate the workers' taste to middle-class standards. The graphic art shown in the factories and offered at "extremely low" prices was meant to replace the cheap prints and kitsch that decorated workers' living quarters. But there was no attempt to create a workers' culture that would incorporate the worker's experience, cultivate his self-awareness, and give him an identity.

Although prices for art had undeniably been lowered, i.e. although the price levels that had always been customary at art association shows became the universal rule once modern art and its dealers had been eliminated, public expenditures for art were more extravagant than ever before. What had been criticized as irresponsible extravagance on the part of government art buyers in the Weimar Republic was now—under the aegis of National Socialism— praised as a special virtue, despite the fact that art was never made accessible to the people as a whole.

This point is illustrated, for example, by a list of "the paintings, prints, and sculptures displayed in the annex to the Reich Chancellery and bought by the Führer from the House of German Art."[16] For this new building designed by Albert Speer and completed in 1939—a building closed to the public and rarely used by the National Socialist government—144 works (132 oil paintings, 8 prints, and 4 sculptures) costing 367,530 RM were bought from the Munich House of German Art alone. The most expensive of the paintings were Constantin Gerhardinger's *After Work* for 23,000 RM; Elk Eber's famous *This Was the SA* for 12,000 RM; the fashionable National Socialist painter Sepp Hilz's *After Work* for 10,000 RM; and Hermann Gradl's German landscapes (15,000 RM each) for a dining room in the Chancellery. The average price in this group of paintings was about 2,500 RM. The fact that these 144 works were all bought from the Munich exhibition of 1938 clearly shows that the government was the major buyer in the House of German Art and set the standards for both form and content. While it was an honor to have work accepted by the jury for the Munich exhibition, it was obviously much more prestigious for an artist to be able to display the label "purchased by the Führer" on his work. Therefore any artist who entered the exhibition hoped to improve his chances of official acceptance by complying, in the choice of theme and execution of subject, with openly expressed or implicit trends.

The public purchase of art along with the opportunism of many artists increasingly determined the structure of art. There was no need for the rigid guidelines or special regula-

tions that later commentators have assumed must have been in force. A detailed analysis of the structures of National Socialist painting will be offered later. At this point, we need discuss only as much of this material as is necessary for a basic understanding of the organization of the Munich exhibitions and mention only those historical conditions that formed the premises of "art in the Third Reich."

None of the already mentioned features of the Great German Art Exhibitions—the number of works shown, their regional quality, the emphasis on sales, and the prices asked —are novel in the history of art exhibitions. The only new element here was the state's use of all available means to ennoble these features. They had been the rule in Germany until the rise of modern art, and even after that they continued to characterize exhibits in provincial art centers, expecially in Munich. In this respect, the German Art Exhibitions of Munich held in the Glass Palace before the fire of 1931 are, as their catalogs show, comparable to the Great German Art Exhibitions beginning in 1937. Even the conditions of purchase were stated in similar terms. The director of the earlier exhibits, the architect Eugen Hönig, popularly known as "Art-Hönig," became the first president of the *Reichskammer der Bildenden Künste* (Reich Chamber of Visual Arts), an agency that Goebbels created for the surveillance of art and artists.

There is a widely held view that the Third Reich created an art unmistakably its own; but, as we have seen above, the conditions governing National Socialist exhibitions and the methods of running them show considerable continuity with the past. There is also a great deal of continuity in the people involved. The earlier Munich art expositions were organized by the *Münchner Künstler-Genossenschaft* (Munich Artists' Association), the *Verein Bildender Künstler Münchens* (Munich Guild of Visual Artists), and the Secessions, none of which had ever been very receptive to modern art, though an occasional Expressionist was exhibited.

Among the nearly 950 painters and sculptors displayed in the exhibit of 1930, only a dozen or so could be classified as modern. These were Ernst Barlach, Ernst Ludwig Kirchner, Alfred Kubin, Hans Meid, Emil Nolde, Emil Orlik, Max Pechstein, Karl Schmidt-Rottluff, and—depending on how we define modern art—Käthe Kollwitz. These figures make up less than 2 percent of the artists represented, and their works account for just over 5 percent of the work displayed. After 1933, this small group, as well as the Jewish artists and a few more whose work I am not familiar with, was eliminated on account of degeneracy.

But if we count the names that appeared in the exhibitions both before and after 1933, we arrive at rather sizable numbers. From the artists listed in the catalog for 1930 alone about 250—more than 25 percent—also appear in the catalogs of the Great German Art Exhibitions of 1937, 1938, and 1939. In the interval of seven to ten years a number of

older artists either died or stopped producing while younger artists moved up to replace them.

In interpreting these figures we also have to take into account that the Munich exhibits before 1933 drew essentially on Munich artists, but that from 1937 on "all German artists in the Reich and abroad" were invited to submit their works and that many of those works were accepted. These figures, which could be duplicated for other art centers, show clearly that National Socialist cultural policy did not stimulate creativity but instead merely built on existing traditions and continued the trends established long before the German fascist assumption of power. We can no more speak of a revolution in art than we can speak of one on the social level.

The contradiction, mentioned in the introduction, between social continuity and an alleged cultural revolution has proved to be illusory. It is true that a noticeable change took place on the cultural scene; what appeared there, however, was not something new but something old, indeed, something antiquated. The claim that German fascism created its own art, and particularly its own painting, out of nothing can no longer be taken seriously. All it did was reactivate those artists who had been left behind by the development of modern art but who were still active after 1933 and who seized the opportunity to move into the vacuum once modern art had been liquidated.

To summarize our observations up to this point: The Munich exhibitions from 1937 on were not in themselves unusual. They seem unusual only to observers accustomed to modern methods of exhibiting art. There had always been traditional exhibits of this kind, particularly in Munich, and similar exhibits still take place today. But a press that was more attuned to avant-garde interests paid little or no attention to them. The only thing that changed radically in 1937 was that these exhibitions were staged for *all* of Germany, that they claimed to represent the *entire* range of present-day art, and that a "temple" for this art had been provided in the House of German Art. The way in which these exhibitions were staged created an impression of something new and unprecedented that was supposed to, and actually did, suggest the often invoked "spiritual renewal" in the Third Reich. Many of the factors we have discussed were no doubt determined by special local conditions in Munich, but in all essential points the kind of visual art and the way in which it was presented were the same everywhere in National Socialist Germany.

But how did painting conceive of itself in the context of these organizational conditions borrowed from the past? Is it not possible that the producers of this painting remained the same but that their art incorporated formal and thematic innovations that would justify the label of "art in the Third Reich"?

A contemporary source, the critic (or "art editor")

Bruno E. Werner, wrote in his critique (or "art report")
in the *Deutsche Allgemeine Zeitung* of July 20, 1937:

> Most of the painting shows the closest possible ties to
> the Munich school at the turn of the century. Leibl and
> his circle and, in some cases, Defregger are the major
> influences on many paintings portraying farmers,
> farmers' wives, woodcutters, shepherds, etc., and on
> interiors that lovingly depict many small and charming
> facets of country life. Then there is an extremely large
> number of landscapes that also carry on the old tradi-
> tions. In these paintings, and indeed in all paintings in
> this exhibit, sketchiness has been rigorously eliminated.
> Only those paintings have been accepted that are fully
> executed examples of their kind and that give us no
> cause to ask what the artist might have meant to
> convey. We also find a rich display of portraits, par-
> ticularly likenesses of government and party leaders.
> Although subjects taken from the National Socialist
> movement are relatively few in number, there is none-
> theless a significant group of paintings with symbolic
> and allegorical themes. The Führer is portrayed as a
> mounted knight clad in silver armor and carrying a
> fluttering flag. National awakening is allegorized in a
> reclining male nude, above which hover inspirational
> spirits in the form of female nudes. The female nude is
> strongly represented in this exhibit, which emanates
> delight in the healthy human body.[17]

This report, clearly written from a somewhat detached
point of view, accurately reflects the traditional orientation
and thematic organization of the exhibit. Photographs of
the exhibit show that the works were arranged primarily
according to subject matter: landscapes; paintings of
farmers, artisans, and animals; still lifes; portraits; nudes;
group portraits; allegories, and so on. This method of group-
ing pictures according to content and not, as is customary
in the twentieth century, according to schools, stylistic
affinities, artists' collectives, and other such categories, is
indeed reminiscent of a weekly outdoor market where fish,
flowers, meat, pottery, and other items are offered for sale
at different stands. This also illustrates the similarity of
such exhibits to art markets. Potential buyers do not go into
the gallery looking for "a Picasso," "a Kandinsky," or "an
Expressionist," but for a picture of a landscape, a cow, a
bouquet of flowers, or other specific subject.

The organizational principle in these exhibits, based as it
is on content, follows that of academies and art schools,
where the curriculum was organized according to subject
matter. In the course of the nineteenth century, classes in
landscape, portraiture, and so on were developed in addition
to the established classes in historical painting. Art acade-
mies had specialists in still life, horses, flowers, war paint-
ings, etc. In the twentieth century, long before the National

Socialist assumption of power, these "classical" categories were supplemented by paintings of industrial subjects, industrial landscapes, modern merchant and war ships, and, finally, by pictures of athletes and athletic activities.

The proportions in which different themes were represented at the exhibition of 1937 have been estimated as follows: landscapes 40 percent; "Womanhood and Manhood" 15.5 percent; animals 10 percent; classes of work, to the extent that they could be determined: farmers 7 percent; artisans .5 percent. National Socialist Germany was represented only by portraits of functionaries (1.5 percent) and by some views of new public buildings (1.7 percent).[18] But this estimate is open to question because it is not based on an actual inspection of the paintings and because the titles listed in the exhibition catalog often shed little light on the subject depicted. The paintings entitled *The Tides*, *By the Water*, and *Lonely Heights*, for example, are not landscapes, as we might expect, but young female nudes. Also, the estimate is not differentiated enough. The theme "Womanhood and Manhood" is not a genre in itself but can appear in any painting containing human figures. At any rate, we can safely assume that landscapes, nudes, and pictures of farmers dominated the exhibit, followed by portraits, still lifes, and paintings of animals and industrial subjects.

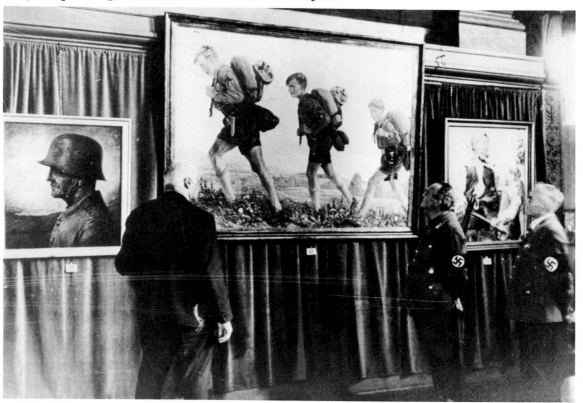

Exhibition sponsored by the League of Artists in Support of Front Soldiers in Berlin-Wilmersdorf City Hall.

The exhibit "Animals in Art," Berlin.

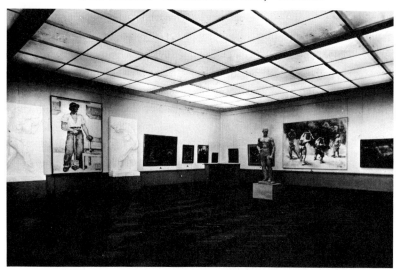

The exhibit "In Praise of Work," Berlin 1936.

The 1937 exhibit, being the first in the series, bore less of a National Socialist stamp than the later ones in which increasing emphasis was given to National Socialist iconographies, war paintings, allegory, and armaments. But the later exhibits were also thematically oriented and adhered to the principle of organization by content. This model was of no use as an organizational principle for modern art in which formalistic tendencies came to replace content. In the Munich exhibits, however, the specialist in a particular genre was restored to honor. Despite their shortcomings, the statistics mentioned above indicate that in terms of theme the Munich exhibition of 1937 contained nothing revolutionary. We cannot discern in it any particular program or unmistakable character that could justify the slogan "art in the Third Reich," the title given to the art journal founded

in 1937 to promote the new art.* As we have already suggested above, definite trends were established only by the selections of the jurors and by purchases made by National Socialist leaders.

The dominance of content and subject matter in the art of this period is also evident in the numerous thematic art shows that were arranged and sent on tour throughout Germany. The following exhibition titles can serve as examples: "Wife and Mother" (Posen, 1941); "German Farmer—German Land" (Gera, 1938); "Man and Landscape" (Bautzen, 1938); "Nordic Land" (Berlin, 1940); "The Forest" (Berlin, 1937); "Pictures of the Homeland" (Oberhausen, 1938); "Beautiful City" (Elbing, 1940); "The Sea" (Berlin, 1942); "Seafaring and Art" (Berlin, 1935); "Adolf Hitler's Highways Seen through Art" (Berlin, 1936); "In Praise of Work" (Berlin, 1936); "Nation of Workers" (Gelsenkirchen, 1941); "The Horse in Art" (Königsberg, 1940); "Animals in Art" (Berlin); "The Polish Campaign in Pictures" (Berlin, 1940); "War" (Weimar, 1931).

There were also thematic representations of various National Socialist ideologies. Some of the programmatic exhibition titles were "Knight, Death, and Devil," named after Albrecht Dürer's famous engraving of 1513; "Blood and Soil," one of the best-known slogans promoting Aryan racism and agrarian autarchy; and "Strength Harnessed in Form." These exhibitions were organized by the *NS-Kulturgemeinde* (NS Cultural Committee) in 1935 and 1936. There were also historical exhibitions. One, held in the Deutsches Museum in Munich in 1940, was called "German Greatness." Another, "Race and Nation," was a thematic exhibit of Wolfgang Willrich's works depicting the "Reestablishment of the Racial Ideal."

In some cases, the combination of sponsors interested in a given theme is worth noting. The exhibit "Seafaring and Art" was jointly sponsored by the NS Cultural Committee and the "Reich Association for German Dominance of the Seas." The NS Cultural Committee and the "Reich Association for Large Families" held a competition for the exhibit "Pictures of the Family." In their announcement, they stated that prizes would be given for "artistically exemplary representations of genetically healthy families with many children." The sponsors went on to say that this was "one of the most demanding themes . . . to which contemporary painting had to address itself."[19] The different genres of painting often searched out and found congenial locations where they could enjoy independent, if isolated, success.

Not only was contemporary art displayed in exhibitions

* The journal was initially named *Die Kunst im Dritten Reich* (*Art in the Third Reich*) and subsequently changed to *Die Kunst im Deutschen Reich* (*Art in the German Reich*).

of this kind, but—in keeping with the traditional orientation of German fascism—attempts were also made to legitimize the individual themes of these exhibits by reviving appropriate traditions that had to be reconstructed now that "degenerate" modern art had been eliminated. We can see from many details of the National Socialist art scene how the historical continuum of art was reestablished and reconstructed in specific cases. The catalog of the 1937 exhibition in Munich proclaimed, for example: "The picking up and continuation of a valuable tradition was made possible only by the fact that a strong group of genuine artists joined forces here in Munich."

Plans for the so-called Führer's Project Linz make eminently clear on what tradition these mediators between the National Socialist present and the art of the past drew. This project, probably Hitler's most outlandish in the field of art, is relevant to our study only because of the tradition it enlists for justifying "art in the Third Reich." After the German conquest of Europe, Berlin, the capital of the Reich, was to be renamed "Germania" and become the political capital of Europe. The Austrian city of Linz on the Danube was destined to become the art center of Europe. A massive cultural center, the so-called Hitler Center, was planned. This center would contain a supermuseum to house the most famous "Germanic" art works of the past and present. Although the plans for the building never progressed beyond the drawing board, the holdings of this future museum were energetically collected.

Aided by the war, the "Führer's Personal Emissary," the Dresden museum director Hans Posse, amassed a huge collection of Western art. He had large amounts of money at his disposal but also did not hesitate to use extortion, military confiscation, and downright theft, particularly in the case of works owned by Jews. The last inventory of this collection is entitled "Catalog of Paintings for the Gallery in Linz, vols. I–XX," and lists over a thousand paintings. Among them are masterpieces by Boucher (7), Pieter Breughel the Elder (2), Canaletto (4), Cranach (5), A. van Dyck (7), Fragonard (4), Jan van Goyen (9), Goya (3), Frans Hals (7), Leonardo da Vinci (1), Lotto (3), Adriaen van Ostade (10), Rafael (2), Rembrandt (10), Rubens (19), Ruisdael (18), Jan Steen (9), Teniers (14), Ter Borch (9), Tintoretto (13), Titian (2), Vermeer (2), Watteau (3), Wouwerman (7).

Thrown in among these great names of European art are many minor German and Austrian painters of the nineteenth century. These artists represented a tradition Hitler urged contemporary German painters to take up and continue. Some of these artists are Friedrich von Amerling, 1803–1887, 8; Heinrich Bürkel, 1802–1869, 8; Josef Danhauser, 1805–1845, 6; Franz Defregger, 1835–1921, 7; Eduard Grützner, 1846–1925, 7; Franz Lenbach, 1836–1904,

13; Hans Makart, 1840–1884, 9; August Pettenkofen, 1822–1889, 6; Carl Spitzweg, 1808–1885, 11; Ferdinand Waldmüller, 1793–1865, 27.

These bourgeois artists, some of whom are quite obscure, were, in the opinion of Hitler and his artistic advisers, the models that contemporary artists should turn to in re-establishing the continuity of great Western painting, a continuity that had been broken by "degenerate art." The gap in time between these nineteenth-century masters and the National Socialist present, populated as it was only by the now-forbidden moderns, had to be filled in by forgotten artists of that era, artists who were now newly "discovered" and posthumously declared the vanguard of art as seen by the National Socialists.

The National Socialists created continuity by making central figures out of peripheral ones. The constant falling back on nineteenth-century art and particularly on what was not the best art of that century amounts to an attempt to link it with the present by enlisting the aid of provincial art. Bruno Kroll's book *Deutsche Maler der Gegenwart— Die Entwicklung der deutschen Malerei seit 1900 (German Painters of the Present: The Development of German Painting since 1900)*, a title that seems to promise a comprehensive study, does just what we would expect of an historical "corrective" of this kind. It sees the present as being built on the work of masters whom we can hardly identify today because they are not even mentioned in any serious studies.[20]

German fascist spokesmen in the field of art rewrote art history with a double purpose in mind: They wanted, on the one hand, to eliminate modern art and, on the other, to legitimize their own "new start," but without having to initiate that start in any real sense.

The symbiosis between the revived genre painting of the nineteenth century and the unmistakable claims made by the National Socialist present is expressed with comic effect in a painting of a modest peasant portrayed in typical department-store art style. The peasant is shown reading a *Völkischer Beobachter* with the headline "A Historic No— Hitler Rejects the Suggestion That the NSDAP Work Together with a Non-National Socialist Government in Exchange for a Few Ministerial Appointments." Both peasant and painter thus pay their expected tribute to the spirit of the times.

Having surveyed the peripheral conditions of "art in the Third Reich" and the way in which it was presented, we now have to take a closer look at "degenerate art." We have to arrive at a definition of it, determine the range of work it includes, describe the procedures used to eliminate it, and clarify why the government attacked and destroyed it with such unprecedented fury. These questions necessarily touch on the entire complex of "negative art policy" in National Socialism, and on the significance of this policy in stabilizing the regime in the first few years after the assumption of power.

The main organizational agency responsible for change on the art scene between 1933 and 1937 was the Reich Chamber of Culture with its sub-chambers, one of which was the Reich Chamber of Visual Arts. Purges of political undesirables and prohibitions on hiring them enabled representatives of the "new" art to move into teaching positions and the official art bureaucracy, as well as to exhibit their works in public galleries.

In its early stages, the process of change was primarily a negative one designed to eradicate the opposition. Because of this it is difficult to know what was more important to the new regime, its spectacularly mounted art purge or the development of National Socialist art. The leading policy-makers for what was proclaimed to be a "new" and "folkish"* art had only the vaguest notions about the formal and thematic characteristics of this new art. This lack of clarity forced them, as noted, to resort to the practical expedient of a competition to assemble paintings for the 1937 exhibit. By contrast, however, they had a quite exact idea of what constituted the "degenerate art" that was to be eliminated. Even though no attempt had been made to define the enemy in any terms that could possibly be called scientific, there was still remarkable agreement among the censors as to the nature and extent of what was to be eliminated.

The constantly recurring labels of "degenerate," "Jewish," and "culturally Bolshevist" do not identify qualities that are evident in the paintings or that can be read into them. They denote nothing more than a political position. But because they imply some kind of commitment, they could be used as means of orientation in the vast range of forms taken by art. If we disregard the controversy over Expressionism and some conflicts involving the painters of the *Neue Sachlichkeit* (New Objectivity), there were hardly any differences of opinion on what was still acceptable and what was no longer acceptable.

This consensus on what was objectionable is all the more striking when we consider how diverse the prohibited art

CHAPTER 2

DE-GENERATE ART

* *Völkisch*, from *Volk* (folk) suggests "of the people" and stresses national and ethnic unity (trans.).

styles and programs were. They were so much at odds with each other that the possibility of some of them making common cause with National Socialism was not that remote. As an example we could cite the Expressionist Emil Nolde, who was a convinced National Socialist and old Party member, but whose work was prohibited nonetheless. Also, it would seem understandable if the government had been primarily interested in combating socially and politically committed artists, such as Käthe Kollwitz, Otto Dix, and George Grosz, to name only a few prominent examples, or Communist artists belonging to the ASSO (*Assoziation Revolutionärer Bildender Künstler Deutschlands*—Association of Revolutionary German Artists). In the case of this latter group, the attribute "Bolshevist" could possibly have been justified as characterizing their political convictions. But instead of eliminating only political opponents in the art sector, the National Socialists rejected and attacked just about everything that had existed on the art scene before 1933, whether it was abstract or representational, whether it was innocuously beautiful like the work of August Macke, or, like that of Beckmann, informed by social criticism.

If we consider which artists thought of themselves as modern, we realize with what a sure hand German fascism struck down the entire range of modern art without even having attempted to define it. All the National Socialists needed to do was to look at the various studies on modern art and to note who was mentioned and considered important and who was either excluded or given only passing notice.

The most rigorous art history of this kind was probably Carl Einstein's *Die Kunst des 20. Jahrhunderts (Art of the Twentieth Century)* in the *Propyläen* art history series.[21] This study excludes not only forerunners of modern art who were acceptable even to the cultural policymakers of National Socialism, but also Impressionists. The first chapter, which introduces the "Beginning" of modern art, treats Henri Matisse, Georges Rouault, Henri Rousseau, André Derain, Amadeo Modigliani, and Roger de la Fresnaye. What follows is not "art of the twentieth century" in its entirety, as the title would lead us to expect, but only those aspects of it that the author conceives of as modern: Cubism, Futurism, Expressionism, etc. Those are the headings of the later chapters. In German art, for instance, no mention is made of Lovis Corinth, Hans Thoma, Max Klinger, Franz Stuck, Max Slevogt, and many other major artists who were still producing important work well into the twentieth century.

We have documentation indicating that Einstein's book was regarded by the National Socialists practically as a self-definition of their opponents and that it was used for clarifying the line between friend and foe in the field of the visual arts. Troost, the architect of the House of German

Art and Hitler's most trusted adviser in art matters until his death in 1934, apparently used Einstein's book in explaining the Marxist element in modern art to Hitler and Goebbels.[22]

The first concrete measures against modern "Bolshevist," "Marxist," "Jewish," and "degenerate art" had been taken even before the National Socialist assumption of power. Elections for the Thuringian *Landtag* (provincial diet) in December 1929 resulted in a coalition government between the conservative parties and the NSDAP. The NSDAP representative to the Reichstag, Dr. Wilhelm Frick, former director of the political police in Munich, was appointed head of the *Innen- und Volksbildungsministerium* (Ministry for the Interior and Education). He was the first National Socialist to head up a ministry.[23]

Frick's policy of replacing most of the key officials under his jurisdiction soon gave him a position of power that he intended to use to make his ministry a "bulwark" of the new cultural policy. Frick's policy is of interest here because it represents a model, on a geographically limited scale, for the National Socialist "cultural revolution." The following are a few examples of his cultural policy: Walter Gropius's world-famous Weimar Bauhaus was transformed into the *Vereinigte Kunstlehranstalten* (United Institutes for Art Instruction) under the direction of Paul Schultze-Naumburg, a traditionalist of racist, nationalistic (*Alt-Völkisch*) convictions and, up to that time, one of the leading cultural ideologists of National Socialism. Gropius's Bauhaus, forced to move to Dessau, then to Berlin, had been a seminal center of international architecture and of modern design. Now, under Schultze-Naumburg, its halls were dominated by crafts, local art, and Germanic ornamentation. In the reorganization of the school, all twenty-nine of the faculty, including its most famous members, were dismissed. The workshops were consolidated into a school for crafts and applied arts and put under the direction of a Weimar bookbinder. The central idea of the Bauhaus, which had been to achieve a total integration of art and industry, was now replaced by the long obsolete ideal of the medieval artisan's guild.

A decree issued on May 4, 1930, titled "Against Negro Culture—For Our German Heritage," provided legitimation for a frontal attack on "Bolshevist" art. Films by Eisenstein and Brecht and Pabst's film of *The Threepenny Opera* were banned; Piscator's Berlin theater company was denied entrance into Thuringia; and music by Hindemith and Stravinsky was struck from concert programs. One of the first major acts of barbarism against culture occurred in October 1930 with the destruction of Oskar Schlemmer's frescoes in the stairwell of the Bauhaus, a building designed by Henri van der Velde. A few days after this demonstration, seventy works of modern art were removed from the

galleries of the Schlossmuseum in Weimar. Among these were works by Ernst Barlach, Otto Dix, Lyonel Feininger, Erich Heckel, Wassily Kandinsky, Paul Klee, Oskar Kokoschka, Wilhelm Lehmbruck, Franz Marc, Johannes Molzahn, Emil Nolde, Oskar Schlemmer, and Karl Schmidt-Rottluff.

The explanation given for this particular action was that Weimar, the city of Goethe, Schiller, Herder, and other writers of Germany's Classical period, was the place to which great numbers of pilgrims, German and foreign, came "to catch a glimpse of the past life of the German soul and spirit." The rest of Germany reacted more with irony and scorn than with outright protest. The crimes in Thuringia were interpreted as acts of provincial philistinism, and the seriousness of their implications was not recognized. No one realized that these were not the acts of one isolated National Socialist who had gone berserk, but that Hitler was aware of the actions of his first public official and fully supported them.

Because of his numerous illegal excesses, Wilhelm Frick lost his position as minister in April 1931. By then the public had already received a sampling of what could be expected from the NSDAP in the area of education and culture if this party were to come to power, a possibility that the growing number of NSDAP voters throughout Germany made more and more likely. Frick's cultural policies, however, proved to be anything but a liability to the NSDAP, for in the next *Landtag* elections in Thuringia, held on July 31, 1932, the National Socialists won an absolute majority.

The NSDAP had shown that in the field of cultural policy a party could stir up emotions to the point of open aggression without discrediting itself politically. It could even win parliamentary majorities this way. Battles over culture had proved to be effective means for influencing the masses and inciting quasi-plebiscitary movements. At the same time, it was essential, of course, to silence the opposition. After this largely successful dress rehearsal on the provincial level, the NSDAP was prepared for a grand opening on the national level in 1933.

Frick, who became Reich Minister of the Interior at that time, appointed so-called art commissioners whose task it was to implement the cultural views of the government in art institutions and in the offices and ministries dealing with culture. But since no clear program existed, they let their activities be guided by the ideas prevalent in the different National Socialist leagues and associations that were gathered together in the semiofficial *Kampfbund für Deutsche Kultur* (Combat League for German Culture), a centralized organization for proponents of folkish culture, and in the *Führerrat der Vereinigten Deutschen Kunst- und Kulturverbände* (Führer's Council of United German

Art and Cultural Associations). This council, formed in 1930 as an umbrella organization for cultural associations of a folkish, nationalistic bent, and totaling a quarter of a million members, was responsible for bringing together in an effective focus the varied and confused ideas represented in the broad spectrum of the organizations under it.

The Führer's Council made use of two channels: the publication *Deutsche Bildkunst (German Pictorial Art)* and, more important, the agency *Deutsche Kunstkorrespondenz* (German Art Correspondence), a kind of press- and public-relations agency that supplied, free of charge, about a hundred newspapers with National Socialist materials on cultural topics. In March 1933, the Führer's Council, through this press agency, now called *Deutscher Kunstbericht* (German Art Report), published a five-point manifesto titled "What German Artists Expect from the New Government." This pamphlet, which displays an unprecedented degree of open aggression, was crucial in setting the tone for future policy and will therefore be quoted here in some detail. We should keep in mind that this is not an official document but expresses purely private opinions which, however, in the course of the next few years provided the guidelines for National Socialist cultural policy. This pamphlet represents an attempt, and a successful one, on the part of certain art circles to make their particular interests, which they labeled "National Socialist," the basis for general policy.

What German artists expect from the new government! They expect that in art, too, there will be only *one* guideline for action from now on, and that guideline is a philosophy drawn from a passionate national and state consciousness anchored in the realities of blood and history! Art should serve the growth and strengthening of this folkish community. . . . They [artists] expect not only that materialism, Marxism, and Communism will be politically persecuted, outlawed, and eradicated but also that the spiritual battle . . . will now be taken up by the people as a whole and that Bolshevist nonart and nonculture will be doomed to destruction. Here it must be the sacred duty of the state to place in the front lines those soldiers who have already proved their mettle in cultural battle. In the visual arts, this means:

1. that all products of a cosmopolitan or Bolshevist nature will be removed from German museums and collections. First they should be brought together and shown to the public, and the public should be informed how much these works cost and which gallery officials and ministers of culture were responsible for buying them. Then only one useful function remains to these works of nonart. They can serve as fuel for heating public buildings.

2. that all museum directors who sinned against a needy nation . . . by their shameless waste of public

funds . . . who opened our art galleries to everything un-German . . . be immediately "suspended" and be declared forever unfit for public office . . .

3. that from a certain date on the names of all artists subscribing to Marxism and Bolshevism no longer appear in print. We must abide . . . by the old law of an eye for an eye, a tooth for a tooth! . . .

4. that in the future we in this country will not have to look at apartment blocks or churches that look like green-houses with chimneys or glass boxes on stilts and that ways will be found to claim restitution from the criminals who grew rich perpetrating such insults against our native culture . . .

5. that sculptures that are offensive to the national sensibility and yet still desecrate public squares and parks disappear as quickly as possible, regardless of whether these works were created by "geniuses" like Lehmbruck or Barlach. They must give way to the scores of artists loyal to the German tradition. The conscientious care and nurturing of all existing impulses toward a new flowering of art will have to go hand in hand with the radical negation that will free us from the nightmare of the past years! Our powers are waiting to be called to life! The people's love for art, immobilized by the *terror of artistic Bolshevism,* will reawaken . . .[24]

It is obvious that those "scores of artists loyal to the German tradition," artists who opportunistically identified themselves in this way and did in fact exist in droves, were clamoring for the position and influence the now maligned artists had enjoyed up to this time. For this reason, the folkish artists resorted to radical statements of this kind and offered their services in defining an as yet vague National Socialist cultural policy. We will see later how tactically clever the government was in its response to offers of this kind.

The first to respond to this appeal and become a self-appointed guardian of culture and judge of art was the painter Hans Bühler, whom the new National Socialist government in Baden had just appointed as academy director in Karlsruhe. Bühler was one of Hans Thoma's poorer students. He imitated the weak symbolic work of his teacher's later phase, not the vital realism, inspired by Courbet, that characterized Thoma's early work. Bühler was the first to organize "exhibits of infamous art" that paved the way for political measures and were designed to involve the people in the cultural struggle. The title "Government Art from 1918 to 1933" was meant to discredit the Weimar Republic by associating it with largely misunderstood modern art and, conversely, to discredit the art of that period by associating it with the often desperate social conditions in the Republic.

The exhibit included among the "government artists from

1918 to 1933" not only a large number of living Expressionists but also older artists, some of whom were long dead. The list included Max Liebermann (1847–1935), Lovis Corinth (1858–1925), Max Slevogt (1868–1932), Hans von Marées (1837–1887), and the Norwegian Edvard Munch. This exhibit was soon followed by one in Stuttgart titled "The Spirit of November: Art in the Service of Social Decay." (In November 1918 the German Kaiser was dethroned and the Weimar Republic proclaimed.) Included in it were works by Otto Dix, George Grosz, Max Beckmann, and Marc Chagall, a French Jew born in Russia. This movement to discredit modern art struck an early and successful blow in Mannheim. The National Socialists began by dismissing Gustav F. Hartlaub, the director of the Mannheim museum. Hartlaub was a highly respected director who was well known for his progressive policies as a collector and exhibitor of art and had an international reputation as a student of children's drawings. After his dismissal, the National Socialists showed a collection of modern art drawn primarily from the holdings of the Mannheim museum. With this disorganized exhibit of unframed paintings, the sponsors hoped to create a negative impression. This collection was also offered as a traveling exhibit in places where—for whatever reasons—modern art had not as yet been discredited in this way. In Munich, Nuremberg, Chemnitz, and Dresden local protagonists of "German" art were given free rein to attack the art that was at odds with their philosophy. Legal principles and property rights that were never abolished even by the National Socialist regime were totally ignored. The folkish and National Socialist press reported these actions widely and favorably, praising them as "purifications" of German culture.

We here see once again how artists and cultural officials, assisted by the Combat League, were the initiators of such actions. They were, for the most part, persons who were now taking revenge on their competitors for their own previous lack of success. German fascism made frequent use of this particular tactic. In its leadership positions and administration, as well as in its "purges," it did not employ functionaries unfamiliar with the particular profession or field in question, but instead achieved its purposes by capitalizing on the resentment that some members of a profession felt toward their more successful colleagues. Already-existing conflicts within professional groups and associations were exploited and their resolution left to members of those groups who thought they could improve their own position in the administrative hierarchy by supporting government policy.

Thus, in the visual arts, the mistaken idea could arise that artists themselves were at odds as to what were true and false ideals and that the "true" ideals could and would

emerge victorious.

Berlin was spared these art purges at first, probably because, as the national capital, it was more exposed to international attention and criticism. For a while, artists who had been banned in other cities could still exhibit in Berlin. But during this time, the campaign against "undesirable" art—organized primarily by private interests but with the tacit approval of official circles—swept through the country with growing force. It reached its first peak in the summer of 1933 and was unopposed even then because democratic and leftist elements had already been eliminated everywhere. Public opinion had been so manipulated that there was general outrage over the fact that a Dadaist collage had once been considered art, and the mobilization of feelings against the Weimar Republic was so intense that it blinded people to what was actually happening politically.

The campaign against literature, which culminated in ritual book burnings in May of the same year, had stirred up similarly intense feelings. In the climate thus created, any excess could be justified as a "purification" and win plebiscitary approval. The battle cry in those days was "You can't make an omelet without breaking eggs." But it was careers that were destroyed, then increasing numbers of human lives. Finally, the level of mass murder was reached.

The number of permanent dismissals, usually termed "leaves of absence," increased steadily, particularly among leading representatives of the German art world. The first victims were the museum directors Hartlaub, Sauerlandt, Schreiber-Wiegand, and Justi; the Chief Art Administrator for the Reich (*Reichskunstwart*)* Redslob; numerous middle-echelon officials; the academy professors Willi Baumeister, Karl Hofer, Heinrich Campendonk, Max Beckmann, Paul Klee, Käthe Kollwitz, Otto Dix; and the entire Bauhaus faculty. A number of artists and scholars were imprisoned in hurriedly constructed concentration camps that many would never leave again. The great majority emigrated. Credible estimates put the number of emigrants from the cultural sector at several thousand. This exodus shifted the cultural centers for German art and literature from Germany to other parts of the world. The most important places of refuge were London, Moscow, Paris, Prague, Stockholm, Vienna, Zurich, and Palestine. Then, after the outbreak of war and the occupation of some of these locations, increasing numbers of emigrants settled in North, Central, and South America.

At the end of the eventful "art summer" of 1933, which even a publication reflecting the views of "artists loyal to the German tradition" described as bearing a greater re-

* The *Reichskunstwart* was responsible for the designs used on stamps, banknotes, official documents, and in national monuments (translators' note).

semblance to a battlefield than to a field green with new growth,[25] a decision was reached at the highest level to create formal supervisory agencies for art. While the actions of Rosenberg's Combat League and of the Führer's Council could still be palmed off as spontaneous popular reactions against "smut and trash," the subsequent plans of the NSDAP for extending its power did not call for even the illusion of spontaneous popular backing. Now, after the first consolidation, the NSDAP was intent on creating a supervisory agency that would not get out of hand but could be deployed to accomplish specific missions.

What emerged from these considerations, in which the Minister for Propaganda, the *Kulturbund* (Cultural League), and the German Workers' Front vied for domination, was the formation of an organization that would govern everyone working in the field of culture. This was the Reich Chamber of Culture. Joseph Goebbels, the *Reichsminister für Volksaufklärung und Propaganda* (Reich Minister for Popular Education and Propaganda), emerged from this internal power struggle as the sole, self-appointed creator and the legally appointed president of this chamber. He thus won an important interdepartmental victory over Alfred Rosenberg and Rosenberg's Combat League for German Culture.

At a ceremony held on November 15, 1933, in the Kroll opera house in Berlin and attended by Hitler, Goebbels introduced this new organization to the public: In his speech, he proclaimed the "concept of corporate professional groups"* to be "the great sociological concept of the twentieth century."[26]

When the first order establishing chambers went into effect, what had formerly been professional associations became statutory corporations. The *Reichskartell der bildenden Künste* (Reich Cartel of the Visual Arts) became the *Reichskammer der bildenden Künste* (Reich Chamber of the Visual Arts). The *Reichskartell der deutschen Musikerschaft e.V.* (Reich Cartel of German Musicians) became the *Reichsmusikkammer* (Reich Chamber of Music). The *Reichstheaterkammer* (Reich Chamber of Theater) retained its name. The *Reichsverband der deutschen Schriftsteller e.V.* (Reich Association of German Writers) became the *Reichsschriftumskammer* (Reich Chamber of Literature). The *Nationalsozialistische Rundfunkkammer e.V.* (National Socialist Chamber of Radio Broadcasting) became the *Reichsrundfunkkammer* (Reich Chamber of Radio Broadcasting). The *Reichsarbeitsgemeinschaft der deutschen Presse* (Reich Society for the German Press)

* These groups united in a single body all the branches of any given field of activity. Management *and* labor, employer *and* employee, professional *and* blue collar worker were brought together in the same corporate organization. This precluded any possibility of strikes or collective bargaining (translators' note).

became the *Reichspressekammer* (Reich Chamber of the Press). A new *Reichsfilmkammer* (Reich Chamber for Film) was formed.

In contrast to most previous associations representing professional or other interest groups, these Chambers made membership obligatory for anyone working in their particular fields. The members, who were all members by decree, did not have the right to govern themselves or their own affairs but were governed instead. They were not able to elect their own officials or to make their own decisions. The constitution of the Chambers provided that whoever was Reich Minister for Popular Education and Propaganda would also be the president of the Reich Chamber of Culture, the umbrella organization for the individual Chambers. As president he would appoint his deputies and administrative heads (§11).[27] He also appointed a president for each individual Chamber as well as that Chamber's presiding council (§13). In addition, he was to draw up by-laws for the Reich Chamber of Culture and approve the by-laws of the individual Chambers (§19). He was empowered to annul decisions made by the individual Chambers and make final rulings himself (§22).

By virtue of this "Führer principle," which had now been extended to the cultural sector, a central office could decide who would be accepted, rejected, or expelled. A negative decision could be made if there were "indications that the person in question lacks the reliability or suitability necessary for the exercise of his profession" (§10). The government thus had a ready instrument for the exclusion of all those who were politically or philosophically "unreliable" or "unsuitable." Such exclusion amounted in every case to a permanent disbarment from the profession. The Chambers could also set "conditions governing the conduct, the opening, and the closing of establishments operating in the field of their jurisdiction and prescribe regulations affecting crucial issues within this field, especially those relevant to the nature and form of contracts between groups under their supervision" (§25). "Measures based on §25" provided for "denial of claims for compensation in cases of expropriation" (§26).

On the authority of these regulations, the National Socialists would later plunder art stores and galleries, expropriating "degenerate art" without any compensation. These regulations meant also that in the field of cultural activity, contractual freedom, a freedom guaranteed under civil law, was annulled. Also, the presidents of the individual Chambers could impose fines on disobedient members as well as on nonmembers who "although not members, engaged in any activity falling under the jurisdiction of a particular Chamber" (§28). Paragraph 29, which obliged the judiciary to give legal assistance to the executive branch of the state, was perhaps the most outrageous of all: "The

courts and administrative authorities will provide legal and administrative support to the Reich Chamber of Culture and the individual Chambers."

This paramilitary chain of command was binding for "anyone involved in the creation, the reproduction, the intellectual or technical processing, the dissemination, the preservation, the sale, or the promotion of the sale of cultural products" (§4). A cultural product is defined as "1. any artistic creation or performance that is made available to the public, 2. any other intellectual product that is transmitted to the public by means of print, film, or radio" (§5).

In the visual arts, these regulations made membership in the Chamber obligatory for anyone engaged in the professions or activities falling under any of the following five subdivisions of the Chamber: Dept. III—Architecture, Landscape Architecture, and Interior Decoration; Dept. IV —Painting, Graphic Arts, Sculpture; Dept. V—Illustration, Design; Dept. VI—Art Promotion, Artists' Associations, Craft Associations; Dept. VII—Art Publishing, Art Sales, Art Auctioning. A number of other professions and activities, not actually named and peripheral to and insignificant for the art world, were included under these five headings. Wood turners, stonecutters, potters, and art metal workers, for example, came under the subheading of sculpture. Gilders, painters of porcelain and china, and painters of building interiors came under painting. Cabinet makers were classified under architecture. Basket weavers, wickerworkers, leatherworkers, bookbinders, hand weavers, knitters, and lacemakers were classified as designers.[28]

In 1938, the Reich Chamber of Visual Arts had about 42,000 members. The active members included about 13,750 architects, 520 landscape architects, 500 interior decorators, 3,200 sculptors, 10,500 painters and graphic artists, 3,500 illustrators, 1,000 designers and textile designers, 230 copyists, 1,500 art and antique dealers, and 360 dealers in prints. At the Chamber's convention on February 12, 1937, the president stated that its organizational work was now complete.

Das Recht der Reichskulturkammer (The Law of the Reich Chamber of Culture), published in annual instalments, regulated every conceivable detail down to the fees charged by textile designers and the opening times for an antique dealers' fair. In addition, the Chamber kept records of such private matters as membership in Masonic lodges and in Rotary Clubs. These records extended far back beyond 1933. One of the Chamber's major tasks was establishing proof of Aryan descent, a prerequisite for membership.

The Chambers were highly effective instruments of control and intimidation, and at the same time they destroyed, both in fact and in the consciousness of their members, any trace and memory of union organizational methods and

bargaining power. Like the pseudounion of the Reich Workers' Front, they included both those working independently and those working for others, both employers and employees. Consequently, they prevented the promotion of specific interests, though of course the entrepreneurs and employers retained leadership in the Chambers just as they did in their businesses. Goebbels had this to say about the principle on which the Chambers were founded: "The state is gradually evolving from a constitutional state . . . into a state based on a working community. . . . To fulfill its tasks, the Reich Ministry for Popular Education and Propaganda therefore needs associations of 'the press,' 'radio broadcasting,' 'literature,' 'theater,' 'film,' 'music,' and 'visual arts,' not associations of management and labor, which emphasize the collective economic interests of these two groups but gloss over the essential differences between professional groups."[29]

Both the artist and the postcard salesman become public officials. Their work becomes a kind of "public service," even though no wage or salary is paid for it. Now as before, the individual had to earn his own living. The only social benefit for artists was an old-age pension introduced by Goebbels and called "Artists' Reward." It provided one more incentive for good behavior. "Organization along professional lines—a central tenet of conservative and especially of religious social theory—provided the basis for a political order totally subordinated to functional efficiency."[30]

In 1934, during the early organizational phase of the Chamber of Culture, some serious differences arose when a few "revolutionary" National Socialist cultural officials clashed with the Cultural League over the League's ruthless procedures. The controversy centered on whether certain branches of modern art, specifically the Expressionists and artists like Nolde and Barlach, were representative of contemporary Germany's "indigenous Nordic" art. The defenders of these artists, basing their case on German art of the Gothic period, declared the ecstatic element and the tendency toward "destruction of form" to be truly Germanic artistic impulses that were now being revived in Expressionism.[31]

Goebbels seems initially to have sympathized with these proponents of the Gothic in German art. This group even published its own magazine, titled *Kunst der Nation (Art of the Nation)*. Rosenberg, however, saw it as his particular mission to preserve the folkish ideology in its purest form. His protégés were arch-Germans like Hendrich, Stassen, Fidus, Fahrenkrog and other bombastic enthusiasts of race and blood. This conflict over future "art in the Third Reich" that had arisen within the National Socialist movement could only be resolved by a decision at the highest level. Art was already so much a part of the political struggle that it could not now be relieved of the responsibility heaped upon it, nor could differing points of view, much less antagonistic

ones, be tolerated in it.

Hitler intervened in the dispute, which had led to a deep division between Rosenberg and Goebbels. In his speech at the Party convention in Nuremberg in 1934, Hitler spelled out what the standards of the future would be. In the late summer of 1934, the last great crisis threatening the consolidation of National Socialism was overcome by staging the purges associated with the so-called Röhm *putsch*. After the assumption of power in 1933, the call for a second revolution had been voiced with increasing urgency, particularly in the ranks of the SA. This second revolution would do away with the bourgeois social structure, which had survived the National Socialist takeover intact. Hitler's "people's army" was clamoring for the promised social revolution, which Hitler, having formed an alliance with the haute bourgeoisie, now refused to consider. He was thus caught between the demands of his original constituency and the conservative position of the top military commanders, whom he needed for the realization of his military objectives. Faced with this dilemma, Hitler moved against his old party comrades in the SA who had now become a liability. On June 30 and July 1, 1934, hundreds of SA leaders, including Röhm himself, who was the chief of the SA and Hitler's personal friend, along with other undesirables, were murdered in a carefully planned massacre. The official story was that a *putsch* planned by Röhm had been crushed before it could materialize. What Hitler meant to do and actually accomplished was to make the mass movement that brought National Socialism to power harmless. The originally planned SA state now became the SS state.

After the death of Reich President Hindenburg, whose office Hitler had been able to usurp, Hitler had reached the height of formal power. The army swore allegiance to the "Reich Chancellor and Führer," and Hitler now saw himself in a position to proclaim the end of the revolution. At the Party convention of 1934 he announced: "There will not be another revolution in Germany in the next thousand years."[32]

Hitler's promise, made on this same occasion, to settle the dispute in the art world, has to be seen in this context. In his speech, Hitler mentioned "two dangers" that National Socialism had to overcome at this point. First, the iconoclastic "saboteurs of art," the "Cubists, Futurists, Dadaists, and others," were threatening the development of art under National Socialism. "These charlatans are mistaken if they think that the creators of the new Reich are stupid enough or insecure enough to be confused, let alone intimidated, by their twaddle. They will see that the commissioning of what may be the greatest cultural and artistic projects of all time will pass them by as if they had never existed."

That statement, which reflected Rosenberg's views, was aimed at the friends of Expressionism as well as Goebbels.

But then Hitler spelled out in detail the other danger that confronted National Socialism: "Second, however, the National Socialist state has to guard against the sudden appearance of those retrograde types who think they can make an 'old-fashioned German art,' concocted from their own romantic visions of the National Socialist revolution, into a binding legacy for the future." Hitler did not mention any names, but everyone knew he was referring to the arch-Germans and the proponents of a traditional nationalist (*alt-völkisch*) philosophy. He went on to describe them in these terms:

> They never were National Socialists. Either they inhabited the ivory towers of a Germanic dream world that even Jews thought ridiculous, or they marched along dutifully in the crusading ranks of a bourgeois renaissance. . . . After our victory . . . they hastened to descend from the exalted ranks of their bourgeois parties . . . to offer their services as political thinkers and strategists to a National Socialist movement that had been mobilized, as they thought, by nothing more than the beating of drums. But they were unable to comprehend the vastness of the change the German people had undergone in the meantime. So they are now offering us railroad stations in the Renaissance style, street signs and typewriters with genuine Gothic letters, lyrics adapted from Walther von der Vogelweide, fashions modeled on Gretchen and Faust, paintings à la Trumpeter of Säckingen, and two-handed swords and crossbows as weapons.[33]

The last point probably was the decisive one in a system that was economically and politically geared to an arms build-up and to war and that therefore had to maintain perfectly functioning methods of domination. It was obvious that neither of the two philosophies of art competing for the government's favor was of any use in turning art policy into a tool of social engineering. Neither the Expressionists nor the enthusiasts of folkish art had enough mass support to justify declaring either one of them the official art of the state. On the contrary, the plebiscitary movement against modern art had just proved that it was the rejection of this art, not support for it, that had been able to mobilize the masses. Support for the other side was probably of no greater socio-cultural significance. The political views of the artists involved were of no consequence in this issue. Even if all the Expressionists had been old Party members like Emil Nolde, they would still have suffered the same rejection as artists, but they probably would have been spared political persecution. Conversely, a rigorously National Socialist attitude did not guarantee the folkish artists the official recognition they hoped for either. Even well-known old "fighters" and ideologists like Paul Schultze-Naumburg,

however significant their contributions to the cause, were not rewarded for their years of service to the movement. They simply disappeared from view. The new men were technocrats.

Once the consolidation phase was completed, all considerations of special interests could be put aside because all opposition had been destroyed. Cultural policy could now be taken out of the hands of relatively independent spokesmen for the cause who were not responsible to the official hierarchy. The regime could now act through administrative and official channels, and it did so.

One of the administrative instruments it devised to end any further discussion of artistic issues, discussion that Hitler had already effectively cut off, was the infamous "Decree concerning Art Criticism" issued on November 11, 1936. The Minister of Propaganda used the first person singular in this document:

> I granted German critics four years after our assumption of power to adapt themselves to National Socialist principles. . . . Since the year 1936 has passed without any satisfactory improvement in art criticism, I am herewith forbidding, from this day on, the conduct of art criticism as it has been practiced to date. From today on, the art report will replace art criticism, which, during the period of Jewish domination of art, totally violated the meaning of the concept of 'criticism' and assumed the role of judging art. The art critic will be replaced by the art editor.

This new terminology had farreaching consequences.

> The art report will be less an evaluation than a description and appreciation. . . . The art report of the future presupposes reverence for artistic activity and creative achievement. It requires an informed sensibility, tact, purity of mind, and respect for the artist's intentions. In the future, only those art editors will be allowed to report on art who approach the task with an undefiled heart and National Socialist convictions. . . . I therefore decree that in the future every art report will be signed with the author's full name. The professional regulations of the German press will require a special approval for the position of art editor, and this approval will depend in turn on proof of truly adequate training in the art field in which the editor in question will work.[34]

Regardless of his *de jure* status as a working individual, the critic now became a *de facto* public functionary. This decree forbade art as a means of public discussion and communication; art was made instead into an aid to contemplation, empathy, and spiritual edification. The decree not only affected the reception of art but also had a con-

tinuing influence on its production. If it was the art editor's task only "to appreciate" and not "to evaluate," then the artworks he examined from this point of view had to be free of problematic elements that might provoke criticism and debate. We saw earlier in our discussion of how selections were made for the Munich exhibits that National Socialism wanted art to be unproblematic and "finished." The decree of November 27, 1936, was another means of achieving this end.

The closing of the modern section of the Berlin Nationalgalerie, like the prohibition of art criticism, was accomplished quietly through administrative channels. This part of the museum, which housed the best collection of modern art in Germany, was closed a few weeks after the last spectators and participants at the Olympic Games of 1936 left Berlin.

Then came the final attack on modern art, this time in full view of the public, which, like the war crimes, the concentration camps, and the murder of the Jews, still comes to people's minds the world over when they think of German fascism. To the extent that the art confiscations of 1936–37 were carried on publicly, they seemed to be a repetition of the preparations for the "exhibits of infamous art" staged in 1933–34. At that time, to all appearances at any rate, the regime had sought and received the spontaneous judgment of a mobilized public as justification for its actions. The situation was totally different in 1936–37 when the Reich Chamber of Culture initiated, directed, and executed the attack on German museums, collections, and galleries.

Moreover, the attack was legitimized by a decree that had the force of law. The command read: "On the express authority of the Führer, I hereby empower the President of the Reich Chamber of Visual Arts, Professor Ziegler of Munich, to select and secure for an exhibition works of German degenerate art since 1910, both painting and sculpture, which are now in collections owned by the German Reich, by provinces, and by municipalities. You are requested to give Professor Ziegler your full support during his examination and selection of these works. Dr. Goebbels."[35]

Ziegler, who had been unknown until 1933 but then gained a reputation in the Third Reich as a painter of nudes (he was dubbed the "master of German pubic hair"), succeeded the architect Hönig as president of the Reich Chamber of Visual Arts at the end of 1936. He appointed a commission to help him in his duties. The commission was made up of the following: Count Klaus Baudissin, an SS officer who, on his own authority as director of the Folkwang Museum in Essen, had already cleared that museum of its modern holdings; Hans Schweitzer, who had assumed the Old German name of "Mjölnir" (the hammer) and who held the title "Commissioner for Artistic Creation"; Wolf-

gang Willrich, a racist illustrator and pamphleteer; and Franz Hofmann, a former art critic for the *Völkischer Beobachter*. Armed with Hitler's authorization, this committee of five ignorant fanatics visited every major German museum and confiscated from the storerooms practically all the modern art in Germany.

The committee members overstepped the limits of their authorization by seizing works dating from earlier than 1910 as well as works by non-German artists. They took, among others, works by Alexander Archipenko, Georges Braque, Marc Chagall, Giorgio de Chirico, Robert Delaunay, André Derain, Theo van Doesburg, James Ensor, Paul Gauguin, Vincent van Gogh, Albert Bleizes, Alexej Jawlensky, Wassily Kandinsky, Fernand Léger, El Lissitzky, Franz Masereel, Henri Matisse, Ladislas Moholy-Nagy, Piet Mondrian, Edvard Munch, Pablo Picasso, Georges Rouault, and Maurice de Vlaminck.

Since no records were kept of these plunders and since many collection inventories were destroyed in the war, the extent of the damages could not be determined in detail until after the war.[36] The following figures reflect the losses from the most important museums and include the plunders of 1933–34 as well as those of Ziegler's commission. These figures are not broken down into individual genres: Berlin, Nationalgalerie—505 works; Kupferstichkabinett of the Nationalgalerie—647; Bielefeld, Städtische Kunsthalle—127; Bremen, Kunsthalle—165; Breslau, Schlesisches Museum—560; Chemnitz, Kunsthütte—275; Dresden, Kupferstichkabinett—365; Dresden, Staatliche Gemäldegalerie—150; Dresden, Stadtmuseum—381; Düsseldorf, Kunstsammlungen der Stadt—900; Erfurt, Museen der Stadt—591; Essen, Folkwang Museum—1,273; Frankfurt, Städtische Galerie and Städelsches Kunstinstitut—496; Hamburg, Kunsthalle—983; Hanover, Landesmuseum—270; Jena, Kunstverein and Stadtmuseum—273; Karlsruhe, Staatliche Kunsthalle—145; Kiel, Kunsthalle—152; Köln, Wallraf-Richartz-Museum—341; Königsberg (Prussia), Städtische Kunstsammlung—206; Leipzig, Museum der bildenden Künste—245; Lübeck, Museum Behnhaus—210; Mannheim, Kunsthalle—584; Munich, Bayrische Staatsgemälde-Sammlung—125; Munich, Graphische Sammlungen—145; Saarbrücken, Staatliches Museum—272; Stettin, Städtisches Museum—307; Stuttgart, Staatliche Galerie—382; Ulm, Stadtmuseum—162; Weimar, Staatliche Kunstsammlungen—381; Wiesbaden, Landesmuseum—231; Wuppertal, Städtische Bildergalerie—403. The total number of confiscated works is estimated at 15,997.

If we break the number of confiscated works down by artists—and only the best known names will be listed—we come up with the following figures:[37] Ernst Barlach 381; Max Beckmann 509; Heinrich Campendonk 87; Lovis Corinth 295; Otto Dix 260; Lyonel Feininger 378; George

Guide to the exhibit
"Degenerate Art,"
p.15 (Otto Dix).

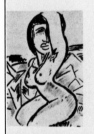

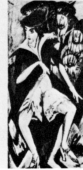

Guide to
the exhibit "Degenerate
Art," p. 17 (Works
by G. Rouault, M. Pechstein,
E.-L. Kirchner).

Grosz 285; Erich Heckel 729; Karl Hofer 313; Ernst-Ludwig Kirchner 639; Paul Klee 102; Oskar Kokoschka 417; Käthe Kollwitz 31; Alfred Kubin 63; Wilhelm Lehmbruck 116; Franz Marc 130; Gerhard Marcks 86; Paula Modersohn-Becker 70; Otto Müller 357; Emil Nolde 1,052; Max Pechstein 326; Christian Rohlfs 418; and Karl Schmidt-Rottluff 688. The campaign against "degenerate art" took in work by 1,400 artists in all.

Works by 112 of these artists were selected to show the public—as Ziegler said in his speech opening the exhibit—what "monstrosities" the "madness, insolence, incompetence, and degeneracy" of modern art had produced. As we have already mentioned, these paintings and sculptures were shown in contrast to works displayed in the Great German Art Exhibition in Munich in 1937.

Paul Ortwin Rave, who was present at the exhibit of "degenerate art," later described it as follows: "The exhibit was housed in a few halls located in the old gallery building of the Hofgarten arcades and usually used by the Archaeological Institute for its collection of plaster casts. The works that Ziegler's commission had selected and confiscated in the preceding weeks were crowded together here in the long, narrow rooms that were made even more claustrophobic by partitions. The mode of display was deliberately detrimental to the works, and the lighting was terrible. . . . The paintings were hung helter-skelter, as though fools or children had been in charge. The walls were plastered from floor to ceiling with paintings. There was no semblance of order, and paintings were stuck in wherever they would fit, peering out between sculptures standing on the floor or on pedestals. The works were provided with inflammatory labels, commentaries, and obscene jokes."[38]

The exhibit was organized—if this term is permissible at all in this context—into nine groups that were listed in the *Guide to the Exhibition of Degenerate Art*.[39] The italics in the quotations below appeared in the original.

Group 1 offers "a general survey, from a technical point of view, *of barbarous methods of representation*." It shows "the *progressive destruction of sensibility for form and color*" in the works of Otto Dix, Oskar Schlemmer, Ernst-Ludwig Kirchner, and others.

Group 2 presents "revelations of German religiosity," a phrase that a "press pandering to Jewish art dealers once applied to this kind of hocus-pocus." Works by Emil Nolde dominated this section of the exhibit.

The paintings shown in Group 3 "offer conclusive proof of the *political origins of degeneracy in art. Artistic anarchy is used here to preach the need for political anarchy*." This category included works of social criticism that portrayed hunger, misery, and want, and that caricatured those who profit from the poverty of the masses.

In Group 4, there were examples of " 'art' as a tool of

Marxist propaganda against military service." There were "views of mass graves"; and "German soldiers were depicted as idiots, sexual degenerates, and drunks." This section focused its attack on Otto Dix and George Grosz.

For the artists of Group 5, "the whole world appears to be one huge *whorehouse,* and humanity is made up of nothing but *prostitutes* and *pimps.* . . . We see picture after picture in which libertines of the 'propertied class' and their harlots are contrasted with exhausted, malnourished 'proletarians' who drag themselves along in the background. . . . The prostitute is represented as an ideal of morality!" Expressionist works were dominant in this section.

The artists of Group 6 had as their goal "the systematic *eradication of every last trace of racial consciousness.*" Here the "*Negro* and the *South Sea Islander* clearly represent the *racial ideal* of 'modern art.' " In this category, German fascism pilloried Expressionist sculpture.

Group 7 showed "that what used to call itself 'modern' art, in addition to presenting the Negro as the racial ideal, also worshiped its own special *spiritual ideal,* namely, the *idiot,* the *cretin,* and the *paralytic.* . . . The human figures in these works truly bear more resemblance to gorillas than to human beings."

Group 8 was a "representative selection from the endless supply of Jewish trash . . . that no words can adequately describe." Finally, Group 9, characterized by "total madness," represented the "height of degeneracy." It was made up of highly abstract and Constructivist pictures by Willi Baumeister, Jean Metzinger, Johannes Molzahn, Kurt Schwitters, and others.

The final section of the guide to the exhibit compared a number of works of modern art with superficially similar products done by the mentally ill. The guide attributed higher artistic value to the pathological works. In this context, the guide quoted a passage of unparalleled cynicism

Guide to the exhibit "Degenerate Art," p. 32 Works by W. Baumeister, J. Molzahn, M. Ernst.

Two details from the exhibit "Degenerate Art."

from Hitler's speech dedicating the House of German Art. After exalting the "inspiringly beautiful human type" that could be admired at the Olympic Games "in the proud, glowing splendor of its physical strength and health," Hitler asks the rhetorical question:

> And what do they fabricate? Deformed cripples and cretins, women who inspire nothing but disgust, human beings that are more animal than human, children who, if they looked like this, could be nothing but God's curse on us! And these cruelest of dilettantes dare to present this to today's world as the art of our time, as the expression of what our time produces and of what gives it its stamp. Let no one say these artists depict what they see. Among the paintings submitted for this exhibition, there were many works that would actually lead us to believe that there are people who see things differently than they are, that there really are men who see the present-day figures of our people only as degenerate cretins—men who are determined to perceive, or, as they would say, to experience, meadows as blue, skies as green, and clouds as sulphur yellow. I do not intend to debate whether these individuals do in fact see and perceive in this way. But in the name of the German people, I mean to forbid these pitiable unfortunates, who clearly suffer from visual disorders, from attempting to force the results of their defective vision onto their fellow human beings as reality or, indeed, from serving it up as 'art.'

Since this art could not be allowed to be the expression and result of a society controlled by National Socialism, Hitler went ahead to warn its creators of the consequences such work might have. "There are only two possible explanations. Either these so-called artists really see things this way and believe they are representing things the way they are. If this were so we would only have to determine whether their faulty vision is due to a mechanical failing or to a congenital defect. In the first case, we can do nothing but feel sorry for the afflicted; in the second, it would be the responsibility of the Reich Ministry of the Interior to consider preventive measures that would spare later generations from inheriting such dreadful visual defects. The other explanation is that these 'artists' themselves don't believe in the reality of what they depict but have other reasons for imposing this hoax on the nation. In this case, they are liable to prosecution under criminal law."[40]

The sterilization and euthanasia programs later enacted by the state were announced here for the first time in a cultural context. This speech also leaves no doubt that a final reckoning was in store for the denounced artists and their work. Any decision announced by the chief of state with such vehemence was bound to win public approval, and Rave was no doubt correct when he summed up the motives

of the large crowds that attended the exhibit of "degenerate art." "Droves of people came to see this exhibit day after day. There is no point in trying to tell ourselves that some few of them perhaps came to say goodbye to works of art they loved. It is clear that the propagandistic purpose of dealing a death blow to the genuine art of the present had essentially been accomplished."[41] The plan of enlisting the masses against modern art and for National Socialist policies had been realized.

The illegal plunderings that far overreached Goebbels's order to "secure" works of modern art continued well into 1938 and were finally legally sanctioned on May 31 of that year. Paragraph 1 of the "law" reads in part: "Products of degenerate art that have been secured in museums or in collections open to the public before this law went into effect . . . can be appropriated by the Reich without compensation." Paragraph 2 states: "The Führer and Chancellor of the Reich has ordered such appropriation. He will have authority over items that become the property of the Reich."[42]

While some of the confiscated and "appropriated" works continued to be displayed throughout the Reich in a traveling exhibit, a Commission for the Utilization of Confiscated Works of Degenerate Art was formed. In cooperation with corrupt and, in this case, purely Aryan art dealers who sensed a chance for profit, the commission picked out works that would be of international interest and sold the most important ones abroad. Hermann Göring appropriated some of the most beautiful and valuable paintings, particularly works by French Impressionists, to decorate his private Germanic-style residence, Karinhall. The remainder of the collection, which was stored in Berlin, was deemed "unusable," designated "the dregs of degenerate art,"[43] and burned in the courtyard of the Berlin Central Fire Department on March 20, 1939. The destroyed works included 1,004 oil paintings and sculptures as well as 3,825 watercolors, drawings, and prints.

From the works selected for sale on the international market, a collection of 125 pictures was auctioned on June 30, 1939, by the Swiss art dealer Fischer in Lucerne. There were 15 pictures by Corinth, 3 by Liebermann, 8 each by Marc, Hofer, and Kokoschka, 7 each by Barlach and Nolde, and 4 by Lehmbruck, as well as important works by the non-German painters Braque, Derain, Chagall, Pascin, Modigliani, Ensor, Gauguin, van Gogh, and Picasso. Opportunities of this kind are extremely rare, and the offerings made at the Lucerne auction caused considerable stir in the international art world. The van Gogh self-portrait that had been in Munich sold for 175,000 Swiss francs and went to New York. The Picassos went to Brussels. Other works were acquired by museums in other countries. After the outbreak of war, the 36 remaining works were sold for the ridiculously

low total price of 2,900 Swiss francs.

That was, for the time being, the end of modern art in Germany. After the liberation from National Socialist rule, museums and cultural officials attempted to recover the exiled works of "degenerate art" in their effort to provide some documentation for the art history of the twentieth century. But since the "degenerate art law" of May 31, 1938, had not been annulled in the three Western zones of occupation and the new owners of the works in question still had a valid claim to title, only a fraction of the lost works could be bought back at great expense and effort. In time, gaps were filled, as far as possible, with new acquisitions. The situation was different in the Soviet zone. There, whatever expropriated art was still accessible was reconfiscated and returned to its original owners.

Up to this point we have concentrated on the phenomenology of "art in the Third Reich" and of "degenerate art." The one was, as it were, exchanged for the other after 1933. Along with presenting the most important events, I hoped to make clear that the "conflict" had been consciously planned and instigated as a technical measure toward consolidating power. The negation of modern art was intended as a means of defaming the Weimar Republic associated with it. At the same time, the image of the Third Reich was built up as a positive contrast. The regime had been able to capitalize on the fact that modern art was by no means integrated into the total society. On the contrary, the majority of the German population responded to it with nothing but incomprehension and rejection. The regime attempted, with great success, to convert this incomprehension and rejection into hatred. The goal was to achieve the greatest possible unity in hatred for and negation of the Republic.

As we have seen, negation had to be replaced by positive integrating factors once the removal of the "offending element" from the social arena had made negation pointless. This positive phase, which involved the promulgation of an affirmative pictorial tradition, took place in the years 1937–38.

"The battle for art" was by no means a National Socialist invention. The slogan and the issue had been of central concern in German cultural life for decades. But the National Socialists were the first to make this battle for art a focal point of political conflict and to define an individual's position in it as evidence of his approval or rejection of National Socialist political goals and principles. This issue became a touchstone for determining who were the friends and who the foes of the Third Reich.

Paul Schultze-Naumburg expressed precisely this view in 1932 in his book *Kampf um die Kunst (The Battle for Art)*: "A life-and-death struggle is taking place in art, just as it is in the realm of politics. And the battle for art has to be fought with the same seriousness and determination as the battle for political power."[44]

This statement, which at first glance seems exaggerated and, indeed, absurd in view of the actual importance of art in the overall social structure, assumes reality only if art and art criticism are used as weapons in a political struggle. The assessment and evaluation of modern painting had given rise to considerable conflict long before World War I. After the revolution of 1918–19 this conflict became aggravated, and, even though it was not carried out in political terms, it helped shape the political fronts. The National Socialists, with the help of Rosenberg's Combat League, further deepened the rift between these fronts.

The rise of modern art since the 1890s had accentuated the alienation that broad sectors of the socially declining

middle and lower-middle classes felt toward "their" traditional culture. Ever since the founding of the Second Reich in 1871, accelerating industrialization had increasingly undermined the status and cultural identity of these classes, an identity derived from the uncontested possession and enjoyment of a culture that cut across class lines and belonged to society as a whole. The preservation of a cultural heritage based on German Classicism—the heritage of Goethe, Schiller, and Beethoven, to mention only the most prominent names—was regarded as the duty of the entire nation. Only fifty years later, it became clear that this humanistic culture no longer provided norms and guidelines for the national and social behavior of a rising capitalistic aristocracy created by business and industry. The proletarianization of millions of artisans and farmers destroyed a national culture shared by all classes and created what the middle-class intelligentsia regarded as a frightening lack of culture among large and steadily growing sections of the population.

To combat this loss of culture, the middle-class intelligentsia attacked the degenerate mode of life adopted by the *nouveaux riches* who had taken over the habits and cultural style of the aristocracy and, in some cases, were trying to outdo their models.

The stylistic trappings of this upper-middle class became increasingly neo-Baroque and feudal. This aesthetic style was felt to be alien, self-indulgent, luxurious, and élitist, and it was criticized in these terms. Since the critics' "diagnosis" focused exclusively on a spiritual, not on a social "virus," the only "therapy" they could suggest was a renewal of the "spirit," a renewal of culture. The language and arguments here are drawn from Max Nordau, one of many theoreticians of cultural decline and a self-appointed "educator" of the nation. Nordau, in his book *Entartung (Degeneration)*, published in 1893, was the first to apply the concept of degeneration to culture.[45]

There is no need to discuss protofascist ideologies in detail here. More than enough studies of this kind have already been done and have encouraged the mistaken idea that National Socialism was primarily an ideological phenomenon, that it was rooted exclusively in ideas. In literature of this kind, as much attention has been given to the works of writers like Paul Lagarde, a Göttingen Orientalist,[46] as to those of popular prophets, like Julius Langbehn, whose anonymous book *Rembrandt als Erzieher (Rembrandt as Educator)*[47] was a best-seller.

One ideologist of this kind was the Englishman Houston Stewart Chamberlain, who became a German citizen and made a great impression on the proponents of cultural renewal with his many pseudoscholarly books.[48] As an old man, Chamberlain met Hitler in 1923 in Wagner's former residence, Wahnfried. At that time, Chamberlain made a

prophetic statement. "My faith in the German people had never faltered for a moment, but I must confess that my hopes had sunk very low. In an instant, you [Hitler] changed my state of mind. The fact that Germany can produce a Hitler in its time of greatest need attests to its vitality."[49]

These and other ideologies were quite unimportant in the actual makeup of German fascism, even though German fascists liked to quote them. But they did provide society with a kind of mirror that reflected a deformed consciousness as a sound spirit. They also had an integrating effect on groups and classes that subscribed to conflicting views. These ideological works, which were immensely popular, offered the masses a framework of self-identification within which latent political feelings could be contained. Associations like the *Dürerbund* (Dürer League), a kind of cultural cartel with more than 300,000 members and reflecting a "leftist" position, and the *Alldeutsche Verband* (Pan-German Association), reflecting a rightist viewpoint, were early forerunners of the mass organizations that would help bring German fascism to power.

The call for a healthy, generally acceptable culture, whether based on national, folkish, or racial concepts, used the visual arts as a point of departure for criticism and rejection as well as for defining future goals, even though those goals were defined in terms of the past. Langbehn's book *Rembrandt as Educator*, which was later followed by another book, *Dürer als Führer (Dürer as Leader)*,[50] uses an artist as a symbolic figure and guarantor of a unified culture. The underlying idea of the book is that the era of scientific learning is on the wane and must be replaced by an era of artistic and aesthetic learning. Rembrandt, who is not discussed *per se* in this book, is exploited as a symbol for a unified world view that Langbehn thinks will supersede the fragmenting, compartmentalizing, and "specializing" structures of science and history.

The problem is, in short, how to reconcile social differences resulting from socially unintegrated means of production. This kind of reconciliation, however, does not strike at causes but at results. For this reason, it cannot remove these differences but can only conceal them behind aesthetic disguises.

The artistic vision of the world, to the extent that it aims at creating modes of communication from "being" to "being," from "the innermost self" to "the innermost self," and from the "soul of the people" to the "soul of the people," deals with enduring and eternal substances. Consequently, art, which guards access to these substances, must be just as enduring and eternal as the substances themselves. If the artistic vision is the only legitimate mode of perception in the world, then art is the genuine foundation of that vision. This kind of thinking leads to the rejection of modern art

and to the derogatory identification of this art with fashion, which is the very essence of the unstable and transitory. "All fashions pass, and as soon as a fashion has passed, it will be most despised by those who went along with it before.... Fashionable trends in art, even the best of them, only touch the surface. Artists and art lovers who follow them achieve very little; only the great creative currents are truly productive." Art is, as Langbehn represents it here, what is enduring and lasting. It has nothing to do with change and fashion, with what is regarded as the supposedly negative principle of modern society and culture.

Max Nordau, anticipating Hitler's rantings, also identified "the strange representational methods of modern painters, the methods of the Impressionists, the dot makers or mosaists [the reference is to the Pointillists], the tremblers and flickerers, the screaming colorists" as a contemporary "degeneration," in this case, of the nervous system and the retina.[51]

A view that argues in this way and imposes this burden on art makes it a cure-all that can heal the national "substance." The reverse side of this view is aggression toward any art or art products that do not seem to fulfill, or even promise to fulfill, this role of cure-all but that, on the contrary, flatly refuse to take on such a burden. This view would also maintain that such art not only neglects its true mission but even contributes further to the paralysis of whatever substance remains. Mere rejection or negation is therefore not enough. Art of this kind has to be fought tooth and nail.

It is not our purpose here to examine National Socialist arguments against modern art and for a new "substantial" art either doxographically or in terms of their conceptual history. We shall focus instead on how underlying social conflicts that were coming to a head lent great latent political power to this ideology. The First World War and the revolution of 1918–19 had temporarily resolved these conflicts. Because alienation was so real, the culturally oriented programs to combat it had some basis in reality, no matter how distorted the consciousness behind those programs and no matter how unreal the language they employed. The cultural movements drew on energies that increased in proportion to the growing social alienation.

Since the late nineteenth century, a highly differentiated art that could only be understood with the aid of commentary won increasing dominance in the art world. This phenomenon made clear how great the division was between culture and the majority of the people and underscored the increasing social disintegration produced by the capitalistic distribution of property.

Alienation gave rise not only to the vision of an integrated culture but also to an alienated culture and to modern art, which, by its very nature, could not have an integrating

function. The National Socialists were quick to realize this. In their attacks on each other, both cultures displayed the narrowmindedness of those who substitute cultural slogans for political debate. The proponents of modern art staged a "battle for modern art"; its opponents, a "battle for art." These two slogans were used as titles for many cultural polemics written in those decades.

Commenting on an exhibit of Wassily Kandinsky's works in 1913, the *Hamburger Fremdenblatt* was already using a jargon that would later appear in National Socialist pamphlets.

> Confronted with this horrible smear of colors and this tangle of lines, one does not know what to admire more: the monumental arrogance with which Mr. Kandinsky asks us to take his shoddy work seriously; the gall of the *Sturm* gang [*Der Sturm* was the title of an avant-garde art magazine], who have sponsored this exhibit and who proclaim this barbaric painting to be the revelation of a new art of the future; or the despicable craving for sensation of the art dealer who has opened his gallery to this mad jumble of color and form. Finally, compassion wins out, compassion for this insane painter who can no longer be held responsible for his actions. Some of his earlier paintings show that he was able to produce beautiful and genuine art before darkness descended on his mind. At the same time, we are pleased to see that this kind of art has finally reached the point where the 'ism' it was moving toward all along is clearly revealed, namely, idiotism.[52]

This passage anticipates almost all the ploys that would later be used against modern art: accusations against the fraudulent artist and the corrupt art dealer, as well as the cynical excusing of the artist on the ground of alleged schizophrenia. The only elements lacking are anti-Semitism and anti-Bolshevism.

Loud protest was voiced not only by critics but especially by painters who felt their own market threatened by the successes of modern art. The writings of Theodor Alt and of the Worpswede artist Carl Vinnen, both published in 1911,[53] drew the most attention. Vinnen's *Protest deutscher Künstler (Protest of German Artists)* contained the signatures of 120 sympathizers. The artists Vinnen attacked responded that same year with a pamphlet entitled *Im Kampf um die Kunst (In the Battle for Art)*. Even in this early case, which could serve as a model for later National Socialist practice, we can see how a conflict limited to a specific interest group was taken out of the hands of those concerned and made into a problem affecting the entire society. The Lex Heinze of the German Reichstag and the resolution against the "degeneration" of art passed by the Prussian House of Representatives on April 12, 1913, provide ample illustration of this mechanism.

The partisans of modern art stated their position primarily in Herwarth Walden's magazine *Der Sturm* (1910–1932) and presented their works in exhibits of the same name. Oskar Kokoschka described the "art dictator" Herwarth Walden as follows: "As a totally committed spokesman for modern art, he had, in a few years, so effectively promoted his views of art that all the various 'isms' were taken seriously in Germany."[54] The term "ism," used both in the singular and in the plural, became a rallying cry and an insult.

Up to and well into the First World War, the acceptance of modern art was stalled by the administrative machinery of the official academies and state art institutions, as well as by the conventional tastes of the ruling coalition of crown and capital, tastes that even "educators" like Nordau scorned. In the liberal postwar atmosphere, modern art could flourish unimpeded, and it also received increasing support from public funds.

The opening of the modern section in the Berlin Nationalgalerie by its director, Ludwig Justi, represented a major breakthrough in the recognition of modern art. This opening took place in August 1919 and was therefore closely linked to the November Revolution in terms of time, place, and theme. The National Socialists would later repeatedly exploit this alleged affinity for their own purposes. Here in Berlin, in Germany's most prominent museum for international art of the modern period, work that had previously been shown only on the fringes of the official art scene and in privately organized exhibits was now officially honored. The modern section was installed in the former Palace of the Crown Prince, and it was, as we have seen, the first museum that German fascism marked for total liquidation.

The modern section paid tribute not only to the classic modern artists like the Berlin Secessionists Liebermann, Corinth, Slevogt, Trübner, and their French contemporaries Manet, Monet, Cézanne, and Renoir, for whose recognition in Germany the famous critic Julius Meier-Gräfe had struggled so long, but also to the "revolutionaries of yesterday." Among these were the painters of the Dresden artists' association Die Brücke: Heckel, Kirchner, Otto Müller, Pechstein, and Schmidt-Rottluff as well as Nolde, Rohlfs, Marc, Macke, Lehmbruck, Nauen, Oskar Moll, and others. There were also works by Picasso, Braque, and Juan Gris. For the first time, all the artists whose names still represent the essence of modern art were exhibited. Never before had such a varied and extensive collection of modern art been assembled.

It should be added that the museum administration was not content to maintain a static collection. The organizational concept of the museum was remarkably flexible and, through new acquisitions and loans, allowed the collection to keep up with the most recent trends in art.

What the Berlin Nationalgalerie had done encouraged a number of other German museums to take similar steps. Several special exhibits helped consolidate these newly won gains. The most important of these exhibits were the International Art Exhibit of Dresden in 1926, the Great Art Exhibit of Düsseldorf in 1928, and the exhibit of the *Deutsches Künstlerbund* (German Artists' League), the umbrella organization of the Secessionists, in Hanover in 1928.

Modern artists saw themselves fully exonerated. They seemed to have achieved a full identification with their epoch, no matter how great their subjective distance from it was. The recognition they had won enabled them to make virtues of the transitoriness and incomprehensibility of which they were accused. El Lissitzky and Hans Arp's book *Kunst-Ismen (Art-Isms)*, which appeared in Zurich in 1925, typifies this attitude. Lissitzky's cover for the book lists the various art trends one above another in a column, omitting the suffix "-ism," which is then printed once in large letters next to the column, thus symbolizing once and for all the universal claim for the principle of transitoriness embodied in this suffix. This configuration is flanked by the dates 1914 and 1924, which span the period treated. The cover reads *Film-, Constructiv-, Ver-, Pnoun-, Compression-, Merz-, Neoplastic-, Pur-, Dada-, Simultan-, Supremat-, Metaphysic-, Abstractiv-, Cub-, Futur-, ExpressionISM.*[55]

The provocative element often contained in modern art— and art frequently defines itself as a kind of provocation —can, if those addressed by it are not identified, strike all those to whom the work is incomprehensible as nothing but provocation. For the masses that do not understand modern art because it deliberately excludes them from its audience, insult is added to injury when they are accused of stupidity. In this respect, modern art represents a perennial problem not only in its relationship to National Socialism but also to society itself, a problem that had considerable impact on art discussion among political leftists.

As a result, a second polarity developed in twentieth-century art history. Although the existence and social function of this polarity have received little attention up to now, it had far-reaching consequences for policy on art from 1933 to the present. Reactions to World War I, to the social struggles of the postwar period, and to the pre-Fascist period of 1928 to 1933, produced a politically committed and realistic style of art that offered a third alternative to traditionalism and modernism. This style rejected petit- and haut-bourgeois traditionalism as well as the *l'art pour l'art* aestheticism of the moderns. The artists of this school saw it as their task to use art deliberately as a medium of political information and education and to rediscover and reclaim the classical themes of painting (e.g., landscapes, portraits, and still lifes) for the underprivileged masses

that had always been excluded from the enjoyment and benefits of art.

Obviously, these artists did not indulge in experiments that might have cost them their comprehensibility and accessibility. For the most part, they stayed within the limits of socially relevant modes of vision, though they also made use of some, such as photography and pictograms, that had previously been considered non-artistic. They did not strive for innovation for its own sake, but their work still contained innovative elements. By the same token, there was no uniformity in the choice of artistic methods. The spectrum ranged from Constructivist and Dadaist approaches to montage and to naturalistic and neo-objective tendencies.

The best known painters of social protest are George Grosz, Otto Dix, and Käthe Kollwitz, who has become the classical figure of socially committed art. But there were many other painters of this school who were concentrated primarily in the cities and who formed local groups that were sometimes political in nature. John Heartfield, Otto Nagel, Oskar Nerlinger, Rudolf Schlichter, August Wilhelm Dressler, and Ernst Fritsch were in Berlin; Otto Griebel, Hans and Lea Grundig, Eugen Hoffmann, Wilhelm Lachnit, and Curt Querner in Dresden; Karl Schwesig and Gert Wollheim in Düsseldorf; Grete Jürgens and Ernst Thoms in Hanover; Gert Arntz, Heinrich Hoerle, and Franz Wilhelm Seiwert in Cologne; and Alexander Kanoldt, Carlo Mense, and Georg Schrimp in Munich. There were also unaffiliated painters like Carl Grossberg, Franz Radziwill, and Christian Schad.

The majority of these artists, and many others who tried to develop a progressive realism, fell victim to National Socialist purges. The suppression of these painters has been more permanent than that of the avant-garde modern painters, who, in contrast to the socially oriented artists, were completely and officially reinstated after 1945. Only the German Democratic Republic has given them a place in its tradition and regards them as major contributors to the development of socialist art, and only in the German Democratic Republic do they represent a real alternative to the two other modes of German art in the twentieth century.

It is not surprising that the theoreticians of socially committed art entered the debate on "ism-art" in the twenties. Writing on modern art in the *Rote Fahne*, the publication of the German Communist Party, Alfred Durus, the magazine's editor, describes the withdrawal of "ism-art" from the material world of society as a whole. "The 'isms,' however varied and however antagonistic toward each other they may be, share a rejection of life, a progressive separation from reality, a process of becoming more and more abstract, an antirealistic and antimaterialistic attitude, and a basic tendency to eliminate from art human beings and

objects of the material world."[56]

Precisely because this ideological problem grew out of an objective problem—namely, the social alienation reflected in the alienation of art from the masses—political antagonisms could find expression in the battle for art. The National Socialists wanted an art that did not reveal alienation but disguised it. The methods employed to do this ranged, as we shall see later, from displays of false harmony to open terrorism. The socialists, on the other hand, expected art to aid them in their political struggle to overcome alienation—the conflict between capital and labor.

The difference between the two camps is most obvious in their assessment of the revolution of 1918–19. German fascism claimed that this revolution was socialist and that it was responsible for the often desperate conditions prevailing under the Weimar Republic. The fascists argued that socialism had been responsible for inflation and unemployment, as if modes of production and distribution of property during this time had not been purely and exclusively capitalist. They failed to mention that other capitalist states, too, had been afflicted by inflation and unemployment. Only the socialist Soviet Union had been spared these problems. The NSDAP did not lay the blame for social misery at the door of the bankers and major industrialists who had been primarily responsible for it and whom the National Socialists wanted as allies. Instead, they passed the guilt on to the Socialists who had tried hardest to strike at the roots of that misery, even though they had never wielded any executive power whatsoever in the state.

It was a simple matter to use modern art to "prove" this theory. Indeed, the revolutionary attitude of modern art—even though limited to the aesthetic and cultural realms—had itself created the conditions that made such use and misuse possible. Then, too, the chronological as well as causal links with the collapse of the Second Reich, with Germany's defeat and surrender in World War I, with the proclamation of two republics, and, finally, with the establishment of a parliamentary, representative democracy, could all be interpreted to show that the essence of modern art was equivalent to the spiritual "selling out" of the nation and to the bankruptcy of national greatness.

Such attempts to mobilize social and national feelings—to the extent that these feelings were channeled against an illusory revolution—were intended to stifle all possibilities of a real revolution, a genuine reversal of basic social conditions, like the one that had just taken place in the founding of the Soviet state. Because Germany did not have a Bolshevist economy, the National Socialists used the phrase "*cultural* Bolshevism" to discredit *emotionally*, and by an appeal to an all-inclusive cultural concept, what could not be *rationally* criticized in the Weimar state. This strategy was effective both for individuals and for whole social

groups whose self-image may have run counter to what the NSDAP stood for.

Hoping to achieve just such results, the NSDAP had founded the Combat League for German Culture, which we have already mentioned. This League was disguised as a nonpartisan cultural organization whose central administration headed up local subordinate groups representing different fields of specialization. The purpose of the League was "to carry National Socialist ideas to circles not ordinarily reached by mass meetings" and to act as a "gathering place for intellectuals with national and folkish convictions."[57] As we have seen, the attempt to integrate apolitical groups by way of the debate on art and the mobilization of a widespread antiart attitude was largely successful. Selections from the *Deutscher Kunstbericht* from 1927 to 1933 were collected in a pamphlet titled *Im Terror des Kunstbolschevismus (Under the Terror of Art Bolshevism).*[58] This frequently cited publication documents the details of the ideological struggle for control over attitudes toward art and is a vivid example of National Socialist bluntness. Also, a detailed "scholarly" summary of the philosophy of art and of art criticism in the National Socialist press for the "years of struggle" 1920 to 1932 is available in the form of a doctoral dissertation.[59] This dissertation reveals with great clarity the various stages in the genesis of the plan to capitalize on the cultural isolation of large segments in the population.

Through the medium of culture, the antirevolutionary classes were won over to the "National Socialist revolution." The National Socialists were able to pretend that the illusory revolution of 1918 had been annulled and canceled out by the illusory revolution of 1933. A revolution in the superstructure (i.e., in art, in government, etc.) was followed by a counterrevolution. This metamorphosis in the externals made it possible for the inner structure of the system to survive all the crises it underwent.

The Left, on the other hand, tried to make clear that the socialist revolution had been suppressed in 1918–19 and that no real change had taken place in the structure of society. Capitalism was therefore still responsible for prevailing social conditions, and modern art was, consequently, not revolutionary, no matter how revolutionary it seemed and wanted to seem. George Grosz and Wieland Herzfelde wrote in 1925: "It is erroneous to believe that if someone paints circles, cubes, or psychically profound tangles, he is revolutionary in comparison to, let us say, Makart. Take a look at Makart. He is a painter of the bourgeoisie. He paints their yearnings, their history, what they stand for. And you? Are you anything more than pathetic hangers-on of the bourgeoisie?"[60]

In conscious opposition to the modern school, which defines itself exclusively in terms of its own autonomy, socially

committed artists demanded that art serve social goals. These goals can only be realized if art can be understood by everyone and is transformed into a means of self-awareness and class awareness, into an organizational means of self-identification for the masses previously deprived of culture.

It was in this spirit that Käthe Kollwitz, who did not belong to any political party, wrote in 1922: "My work is not, of course, *pure* art in the sense that Schmidt-Rottluff's is, for example. But it is art. . . . It is all right with me that my work serves a *purpose*. I want to *have an effect* on my time, in which human beings are so confused and in need of help. Many feel the need to help and be effective, but my way is clear and obvious. Others follow unclear paths. . . . Our times are like the times of the Anabaptists, times when, as now, a new age was proclaimed and the thousand-year Reich was said to be imminent. Compared to the work of all these visionaries, my own strikes me as clear."[61] Here, too, the claim of modern art to be the sole expression and interpreter of the present is decisively rejected. But unlike Grosz and Herzfelde, Kollwitz takes into full account the subjective distance that separates many modern artists from the political circumstances of the time.

Bertolt Brecht criticized the view of nonobjective painters who felt that things have to be seen differently from the way they appear. "If we want to teach that things should be seen differently, we have to use things to teach this. It is not enough, after all, that things simply be seen 'differently,' in a way that is different. It is not enough that this way be merely different from every other way. It must be correct; that means appropriate to things. We want to master things, in politics and in art. We don't just want to 'master' in the abstract."[62]

In the debate as to what was truly revolutionary in art, the Expressionists made the most convincing case. Their work was revolutionary in two respects: It represented a "purely spiritual" and nonmaterial revolution in art and at the same time a political revolution against the materially determined quality of the bourgeois order. These two points provided the framework for heated debates on Expressionism on both the political Right and Left. On both sides, these debates ended with a rejection of Expressionist art. The arguments and theses presented were worlds apart, and we have brought them together here not for the sake of similarity but of contrast. We will consider them briefly now to understand the inner "logic" of the battle for art, a battle that was the outward manifestation of an underlying social struggle.

In matters of art, the opposition within the NSDAP was made up primarily of young artists, critics, and art scholars. Expressionism, they claimed, was typically German and Nordic in its emphasis on expression. This emphasis

contrasted sharply with the classicism and attention to form typical of Romance art. The young "leftist" and intellectual wing in the NSDAP had, so to speak, grown up with Expressionism and had taken part in its struggle against the hollow culture and philistinism of the feudal haute bourgeoisie. Influenced by the slogans of the cultural "educators," they saw the Expressionist struggle as a spiritual renewal and as a return to the Germanic heritage. The thought that the national revolution of 1933 was reflected in the works of painters they despised as *"Gartenlaube* artists and literary painters"* was intolerable for these young rebels within the party. Using recognized German painting of the past as evidence, they tried to legitimize contemporary Expressionism and to trace its traditions and forerunners.

The most prominent spokesman for this position was Alois Schardt, the newly appointed director of the Berlin Nationalgalerie's modern section, which had come under attack by the NSDAP. Schardt tried to rehabilitate discredited contemporaries by demonstrating their ties to the Germanic past. The National Socialist government had insisted that the modern collection be rearranged. Caspar David Friedrich and Blechen were displayed on the first floor. On the second were masters of the late nineteenth century, such as Hans von Marées and Anselm Feuerbach. Nolde, Barlach, Lehmbruck, Feininger, and artists belonging to Die Brücke and Der Blaue Reiter were exhibited on the top floor.

In his lecture "What Is German Art?" Schardt presented his theoretical justification for his position. The specifically Germanic and German folkish element, he said, was the ecstatic or prophetic element. For this reason, there was a direct link between the nonobjective ornamentation of the German bronze age and Expressionist painting. The decline of German art began in 1431 when naturalism began to impinge on expressive art. Everything created after the first third of the fifteenth century and up to the nineteenth century in Germany was of only historical and documentary value and was essentially un-German.[63]

The arguments that were used in support of modern art were obviously identical with those used by its opponents in their ultimately successful attempts to destroy it. Because of the irrationalism that characterized both factions involved, the debates over National Socialist cultural policy ended in a deadlock over theory. The rejection of Expressionism—not the recognition of it that many intellectuals in the art field, completely misunderstanding the government's political strategy, hoped for—ultimately emerged as the

* The *Gartenlaube* was a weekly publication (1853–1943) noted for its sentimentality and mass appeal. Its title has become synonymous with kitsch (translators' note).

more expedient "final solution" to the art problem.

For the Left, the fact that German fascism had liquidated modern art, and particularly Expressionism, meant a further complication of the problem already raised in the twenties by writers like Grosz and Herzfelde. The stand taken up to now had to be reassessed if the Left wanted to attract additional allies from the field of culture to join in the common struggle against German fascism.

Writing in the emigrant newspaper *Das Wort* in 1938, Werner Ilberg distinguishes between what he calls "the two branches of Expressionism." The second of these became, from about 1923 on, one of many "surrogate vehicles . . . that served to disguise the true character of the Weimar Republic." Expressionism degenerated into a "progressive mannerism." "But under Hitler . . . its original character asserted itself again: The dissolution of the traditional, the rigid, and the conservative was intolerable for fascism. The reaction of Hitler the reactionary shows that he sensed a summons of something new and better in the works of the Expressionists."[64]

Durus speaks in a similar and, if anything, sharper tone of Herwarth Walden, Ernst Bloch, Rudolf Leonhard, and other apologists for Expressionism who remained in Germany even though they had joined the antifascist cause: "It is a mistake to assume that Expressionism and the other 'isms' amounted to nothing more than the leftover assets of an artistic bankruptcy." Expressionism, Durus said, had, of course, "contained mutually contradictory progressive *and* reactionary elements from the beginning. The struggle that early Expressionist artists in the Dresden Brücke and the Munich Blaue Reiter had staged against the capitalist mechanization and reification of art, against formalist academicism, and against naturalism was progressive. But the Expressionists' advocacy of mysticism and neoreligiosity in the name of an alleged renewal of artistic content was reactionary, as was their 'bombarding' of science and of human powers of cognition." Ultimately, however, Expressionism is a kind of formalism that "emanates" from capitalism "every day, every hour, every minute." Durus closes with the following statement, which could also be applied to Expressionism: "We will not see an end to formalism until capitalism is laid in its grave."[65]

This ambivalence of Expressionism is reflected in the fact that a number of its adherents, such as the poet Gottfried Benn and the painter Emil Nolde, supported National Socialism, while others, such as Bertolt Brecht, Johannes R. Becher, Ernst Bloch, and Herwarth Walden, joined the socialist camp. The painter Heinrich Vogeler, who had first made a reputation for himself in art nouveau but then moved toward social commitment, ascribed a political function to the "historical phenomenon" of Expressionism: "It opens your eyes. You see the absolute hopelessness of

bourgeois art in its last stages." A number of Expressionist artists, Vogeler says, have drawn the consequences from this insight. "Some put aside their paints, apprenticed themselves to the revolutionary workers, and took part in the cultural and political enlightenment of the progressive intelligentsia. Others turned their art to the service of the masses and prepared the soil in which a new art will grow."[66]

In view of all this, the rejection of modern art by German fascism cannot be seen as an accident but rather as the rejection of a "principle." This interpretation is confirmed by the fact that the political Left, too, was critical of modern art and said that it was not rooted in the consciousness of the people. This corresponds to Hitler's assessment: "Of all the questionable products of our so-called modern art, less than 5 percent would ever have found their way into collections owned by the German people if a politically and philosophically oriented propaganda that has no connection with art *per se* had not swayed public opinion and, indeed, forced these works on the public by political machinations."[67] Hitler's theory of alleged subversion is, of course, untenable. It was, however, the élitist character of modern art that provided a party representing itself as a populist mass movement with a justification for attacking this art. The National Socialists could be sure the masses would approve of the government's destruction of modern art, and this approval was especially crucial in the first phase of National Socialist consolidation.

We still have to consider one last aspect of the battle for art. The National Socialists kept repeating that modern art was "Bolshevist," "Jewish," and "cosmopolitan," but these accusations were not leveled specifically at the paintings of the few Communists or Jews among modern artists. If we survey all the arguments brought against modern art, arguments whose aggressive force was fueled by different social conflicts, we find clearly anticapitalist attitudes that can be directly traced back to the "cultural apostles" at the turn of the century. They, too, saw the causes of "degeneration" in a modern economy based on industry and the exchange of goods.

The catchword "fashion," which would later play such an important role in Hitler's polemics, first turned up in connection with "ism-art." In National Socialist polemics we find the paradoxical verbal linking of Bolshevism and capitalism, concepts that are mutually exclusive. The introduction to the catalog for the Great German Art Exhibition of 1937, which we have quoted before, states: "In the Weimar Republic, genuine art fought a desperate battle against a Marxist-anarchistic disintegration precipitated by major capitalist interests." The appearance of the term "capitalist" here, even in this absurd use, is a late and automatic verbal posturing that reflects the earlier anticapitalist attitude of German fascism. Even before the assumption of power, the

NSDAP had put this attitude aside when the Party repudiated the Strasser faction. Any remaining traces of it were totally eradicated along with Röhm's SA.

Some relics of this attitude continued, however, to appear in discussions of art. These relics were purely verbal and had no programmatic meaning, but they still reinforced the social mood that the attack on modern art created, and they played a role in developing a mass base for National Socialism. The polemics focused primarily on the alleged link between modern art and inflation, for which the Bolshevists could hardly be held responsible. Under the heading "Origin and History of the Red Epidemic in Art," Wolfgang Willrich, an extremely willing and aggressive activist of the National Socialist movement, discussed the relationship between capital and art after the First World War.

> As soon as the *Rentenmark* [the currency introduced in 1923 to stop inflation] was issued the capitalists preferred to invest their money in securities rather than in art, as they had done during the inflation. The inflationary period had brought with it an increased production of and exchange in trash art, and it was not easy to quash this flourishing business. Those conceited geniuses of the boom who had been cultivated to satisfy the exaggerated demand for modern art during the inflation and who mass produced art, delivering "bumper crops for exhibit" (this phrase is taken from a panegyric to Pechstein!), these artists existed and continued to demand work. The bloated publishing business could not maintain itself despite increasingly desperate efforts to do so. It finally suffocated in its own filth, but by then it had, unfortunately, ruined German art and artists.

Willrich thus links modern art to degenerative tendencies in capitalism, which in turn create the premises for the "degeneration" of art. Willrich goes on in this vein: "Even Mr. Westheim [a prominent art critic] notes how 'corrupting the filthy flood of success' was, how art salons multiplied and how paintings were traded like securities that were 'safer than money,' how the price of 'a Liebermann' rose from 3,000 Marks to ten million francs, that of a Kirchner from 300 Marks to over two million francs."[68] Quite apart from any factual correction these claims may require, we still have to concede a point of which this author was not even aware, namely, that art prices are always "inflationary" in that they do not represent any measurable values. In terms of its market price, art, like paper currency not backed by gold, is "worth" something only as long as its value is upheld by public confidence in it. The price of any other goods always stands in a calculable relationship to the value of production costs, even though the dimensions of

that relationship may be unjustified. This can, of course, be the *de facto* case with art, but it cannot be allowed to become the case by definition. Art policies in the Third Reich did not fundamentally alter this.

The word inflationary as used by the National Socialists in this context aimed at implicating the visual arts in the inflation of German currency that set in at the beginning of the 1920s. The opponents of "ism-art" blamed pure lust for profit for the proliferation and the rapid succession of art styles. Hitler himself repeatedly elaborated on this idea. He noted that in modern art's perception of itself there was no longer a German, French, or Japanese art. There was only "modern" art.

> Consequently, art as such is not only completely disassociated from its national origins but is also the product of a given year. This product is deemed "modern" today and will, of course, be unmodern, that is, obsolete, tomorrow. The ultimate result of such a theory is that art and artistic activity are made equivalent to the work of our modern garment industries and fashion ateliers. In both cases, the underlying principle is to produce something different every year. First, Impressionism, then Futurism, Cubism, perhaps even Dadaism, etc. . . . There had been a so-called modern art in Germany until the National Socialists assumed power. This meant, as the word "modern" implies, a different art almost every year . . . ; [but] art should not be ruled by fashion.[69]

This view was widely expounded by others as well. The rejection and denunciation of fashion was not limited to what we might call the excesses of fashion. This denunciation was much broader and had to do with the fact that fashion in modern times affects all sectors of the market and does not refer exclusively to fashions in clothing, which have been a part of human life for centuries. The National Socialists rejected fashion absolutely, not only in the realm of art. For them, it represented what was ephemeral and subject to change in time. That they felt this way is not surprising in a state in which as many people as possible were to be uniformed both in the literal and figurative sense.

The connection between fashion and the rise of modern commodity production was often noted, particularly where fashions in clothing were concerned. They are blamed on "Jewish dealers in ready-made clothing who work together with industrialists in spinning and weaving and are aided by the world of prostitutes."[70] The concept of fashion is used to link modern "ism-art" to certain phenomena of the contemporary commodity market. The experimental element that is crucial to a modern market economy is also to be eliminated from the sphere of art, as we have already seen from the guidelines for the Great German Art Exhibi-

tion: "The time of fashionable and short-lived artistic trends that have been charitably called 'styles' but that were in reality experiments characteristic of a doomed world is now a thing of the past."[71] This statement reflects the demand, already quoted, for "finished" and "unproblematic" art. The National Socialists rejected the experimental character of much modern art. They rejected the aesthetics of the sketch, the *non finito*, the capturing of fleeting, mobile thoughts, the mere effect. They emphasized that "the interest in sketches in public exhibits, sketches that were generally advertised as strokes of genius . . . dates from the time of the Secessions [i.e., from the beginnings of modern art]."[72]

Finally, this same author makes a connection between "ism-art" and advertising but questions the value of this art for contemporary advertising. The art report on the Exhibition of the Graphic Arts in Advertising held in Berlin in 1936 states: "This exhibition proves that Dadaist, Futurist, Cubist, Expressionist and other modern forms of advertising art have outlived their usefulness in applied graphics."[73] The author goes on to make some relevant observations on the aesthetics of presenting a product.

> In packaging, the connection between content and form is most obvious when the contents of a package promise material enjoyment, regardless of whether those contents will evaporate into thin air, like tobacco smoke or perfume, or whether they are baked goods, chocolates, cordials, or other luxury goods that the master graphic artist can make appear as necessities to large numbers of potential customers by awakening a sense of anticipation in them. But too frequent indulgence in the same pleasure dulls the senses. The same principle applies to the work of the graphic artist and its long-term effectiveness. If the form is not changed, the effect will diminish.

The dependency of the artist in applied graphics on "luxury goods" and on the need to find new ways of advertising them—a mechanism that is correctly perceived here but incorrectly evaluated—is made to appear in a negative light even in the context of an exhibit sanctioned by the regime. In the field of applied arts, too, art is still art only if it has permanence, despite the need for perpetual change to which it is subject. Hence, to call the artist working in applied graphics an artist at all is a contradiction in terms.

"Ism-art" was thus condemned for being completely in the service of commercial calculation. The few quotations we have examined suggest that modern art, because of its multiformity and the rapid changes in its external appearance, not only advertises itself in accordance with bourgeois marketing principles but also embodies a principle that serves advertising and is, in fact, comparable to advertising as such.

We should keep in mind that the denunciation of fashion and advertising was a thoroughly justified reaction to the social misery of the initial and final years of the Weimar Republic. In such a social context, the use of constantly changing aesthetic appeals in the advertising of consumer goods could only be understood as a provocation of the indigent masses who were too poor to purchase these goods. But since the National Socialists continued this kind of polemic after 1933 and used it to discredit modern art, we will have to inquire further into the motives behind this "anticapitalism."

It was not capitalism as such, of course, that came under the attack of the antifashion campaign and its sorties into the world of art. The target was instead that specific aspect of capitalism that we could call consumer capitalism. Because most Germans did not have enough money in the 1920s to be "fashionable" consumers, the National Socialist rejection of fashion had the effect of erasing bitter memories of those hard times. But on the other hand, since the German fascist government drastically reduced the production of consumer goods so that it could step up weapons production and increase its industrial potential, there was no excess supply of consumer goods that needed to be advertised. Advertising was not only unnecessary but would have been downright damaging for the psyche of a nation in which the vast majority of the population could afford only the barest necessities.

The amosphere of a free market, of the desire for and the enjoyment of consumer goods, had to be eradicated, even on the aesthetic level. This also applied to art, which had, in some vague way, been part of that atmosphere or possibly just an aesthetic analogue of it. One final reason for the strategy used by the National Socialists in the battle for art may have been the intention, of which they themselves were probably not fully aware, of destroying the memory of the preceding period and of painting it in the darkest colors in an attempt to suggest a totally new beginning that could not be dimmed by shadows from the past.

Along with "ism-art," which no one could understand anyhow, those equally incomprehensible causes of social unrest—Bolshevism *and* capitalism—also had to appear defeated. If everyone was to *see* and be convinced that the National Socialist assumption of power had put an end to the defects of the Weimar state once and for all, then modern art had to disappear from the scene for good, as did Jews, gypsies, Jehovah's Witnesses, and homosexuals as well as the political opposition, the destruction of which was the underlying motive of this entire campaign.

PART 2

STRUCTURE

In this section we will describe the structure of painting under German fascism. We will proceed differently here than we did in the historical section and will focus more on the special features of this painting, on its specific and unmistakable characteristics. Historical and structural perspectives are not, of course, mutually exclusive but complement each other. In our historical considerations, we have already said a great deal about structural aspects of National Socialist painting; and, conversely, historical perspectives will still prove essential in our structural inquiry. We hope to work out something like an *historical structure* for the painting of this epoch.

We have already mentioned the direct precursors of "art in the Third Reich." The relationship of this art to traditionalist painting is twofold. On the one hand, we are dealing here with a continued reliance on old techniques, types, and iconographies. These factors no longer lead a subcultural existence, as it were, but are officially encouraged now; and, if we ignored the existence of the modern school, we could even speak of a direct and unbroken continuity. On the other hand, the conditions under which traditionalist painting had functioned on an organizational level were restored. If we assert in this connection that a kind of painting was revived in which *content* was the central focus, we mean to include in that statement both concrete works and what we could call the principle behind them.

This by no means excludes the possibility that themes may be chosen that are far from traditional. The key point is that they can be classified within the traditional categories of genre painting. In addition to animal paintings or landscapes we now find war paintings, U-boat paintings, and SA paintings, and we see emerging once again the old phenomenon of the specialist who focuses on one field. The paintings of Paul Herrmann, who specialized in portraying the ceremonies commemorating November 9,[74] are excellent illustrations of this.

Pictures that show a decidedly militarist or fascist bent have in the past been cited as proof that National Socialist painting represented a true innovation in the history of art, however abhorrent we may find that innovation. The fact is that National Socialist painting does no more than follow the traditional principle of depicting the more or less spectacular aspects of the world around us, whether the subject matter chosen is a living room or an NSDAP office, a gleaner in the fields or a soldier throwing a hand grenade. Genre painting, the legitimacy of which had been called into question by the modern school, was taken for granted in National Socialist art.

> The main purpose of genre painting is now, and always has been, to increase our appreciation of everyday things. Interiors, scenes from private life, the world

of plants and animals observed with loving care to detail, romantic and lyrical motifs, motifs from the world of fable and fairytale, these are the subjects of genre painting. Landscapes continue to have a nearly religious significance. . . . And, finally, the importance of portraits remains unquestioned. . . . One important task of genre painting is the portraying of types, the rendering of German individuals representative of their tribes and callings.[75]

Painting, then, was consciously conceived of as genre painting and the new National Socialist iconographies take the form of genre paintings.

From this point on, we will use the term "genre painting" to mean painting that can be classified according to the aspects of the world it portrays and that has class-defined functions to fulfill. The fact that genre painting as such had lost importance in the artistic world before 1933 makes it easy to overlook that National Socialist painting was based on the genre tradition. As a result, the painting of the period 1933 to 1945—burdened as it was by the political crimes of the government—has not only been deemed a special case and retrospectively denied a place in the history of art, but it was also regarded by the modern school all along as a contemptible deviation in the evolution of art. No one inquired into its modes or origins because its origins no longer had a place in the consciousness of modern artists and art historians.

The process of eliminating genre painting from the history of art has been traditionally interpreted in terms of the battle for modern art. The emphasis was on promoting the modern school, not on attacking tradition. The task at hand was to justify the spectacular innovations of modern art, represented first by the French Impressionists, then by painters like Van Gogh, Gauguin, Munch, and others. These modern artists, having broken out of the constraints of genre painting, could not be forced back into a conceptual system whose principles they had just made obsolete. They had to create new laws for themselves and therefore introduced the concept of modernism, which postulated perpetual innovation. On the organizational level, this involved the founding of splinter groups called Secessions. In France, those turned away by the Salon had long since formed a group that elevated the term designating them as rejects (Les Refusés) to a title of honor. A rewriting of art history was to provide the basis for an historical understanding of modern art.

With this rewriting of art history the importance of the epoch, which exercized a relativizing influence on concepts of style, gave way to a new emphasis on individual genius. Artists of the past whose works, at first glance, seemed to violate the standards of their epochs were declared pre-

cursors of the modern school. It was in this context that painters like El Greco, Goya, and Magnasco were rediscovered or reevaluated. Perhaps the most important figure in this process was Julius Meier-Gräfe, whom even the National Socialists called "the pioneering spokesman for this entire clique."[76] Cornelius Gurlitt characterized Meier-Gräfe's work as follows: "Meier-Gräfe could not resist hunting through art history for the precursors and allies of the kind of art he was celebrating. He found just such a figure in El Greco . . . who was now suddenly proclaimed a master of the highest genius, despite the fact that earlier critics had considered him a madman."[77]

The art history of the nineteenth century in particular was reexamined and rewritten to highlight the individual, the genius, and the original creator rather than the old categories of schools and genres.

Thus, in violation of all historical reality, the nineteenth century was redefined as an epoch of the individual genius, of the lonely, tragic, sublime artist. It was seen as the century of Caspar David Friedrich, Philipp Otto Runge, Alfred Rethel, Anselm Feuerbach, Hans von Marées, and Arnold Boecklin. The famous 1906 Berlin Exhibit of the Century with its "discoveries" set an influential example in this direction.

The process of eliminating a large portion of visual art from art history extended back to the first half of the nineteenth century. To be sure, a history of Baroque painting does not mention the names of all the artists who could be classified as Baroque, but all the styles and movements of that period are included. Only the third-rate artists are eliminated, even though their works are similar in form and content to those of first- and second-rate artists. The historiography of art in the nineteenth and twentieth centuries, however, sovereignly and unhesitatingly ignores at least 90 percent of the artworks created in this period. The reason for this is not that these works are second- or third-rate but that they are inconsequential from a modern point of view.

This process of excluding certain art works from memory is of considerable importance not only for art history but also for the self-image of modern bourgeois society. The Third Reich's policy toward art expressed a reaction against this process and an effort to reverse it, but this effort had no lasting effect. The rehabilitation of modern art was completed, at the very latest, by the first "Dokumenta" exhibit in Kassel in 1955.

This process, which has still not been historically assimilated or even noticed, and which brought about the triumph of the modern school while at the same time postulating the total autonomy of art and artists, took place with the inevitability and logical consistency of historical necessity.

Bourgeois society seems to have obliterated, almost violently, every memory of an earlier evolutionary stage in its art history. Genre painting no longer fulfilled its needs of expression.

The continuity of genre painting from the nineteenth century on provided the art and art ideology of National Socialism with the legitimation they sought, but genre painting itself is by no means an invention of the nineteenth century. It represents instead the reception, across the span of more than two hundred years, of the high point of Dutch and Flemish painting in the seventeenth century. In the first decades of the nineteenth century and to some extent even earlier, most European countries had developed a kind of painting that, in the range of its themes and in the simplicity with which they were rendered, shows a more or less direct affinity to Flemish art, and particularly to Dutch art, of the seventeenth century.

This link to Dutch and Flemish painting was, on the whole, regarded with approval, but it was lost sight of later. The reception of artists from the Golden Age of Dutch painting introduced a socially explosive element into the art world in the first half of the nineteenth century, a weapon that was turned primarily against the ruling academies and the historical painting they fostered. The realism of Dutch painting, in addressing itself to circumstances in the *real* world, stood in opposition to those painters who were usually in the service of a court and who were satisfied to proclaim the *ideal* in the realm of intellect and art.

New interests marshaled the Dutch painters against the court's exclusive claim to art. Art history was mobilized against prevailing conditions. As one writer put it:

> If we compare Dutch art of the seventeenth century with French art of the same period, the difference between them is like that between a popular festival in the highest sense of the word and a court celebration. Where the Dutch painter was free to pursue a style and subject matter that were in harmony with his talents . . . , the absolutist French crown, appropriating all talents to itself, pressed all creative effort into the same mold, regardless of whether or not this mold allowed the individual to do his best work. . . . The grandeur of art in Louis the XIV's reign, just like the grandeur of the monarch himself, was based on appearances alone.[78]

The themes that had long dominated aristocratic art were gradually replaced by subjects drawn from the homely, everyday life of common people. The third estate and the fourth estate, or working class, as well, began to be portrayed sympathetically in art. Art was undergoing a massive and historic change that was removing it not only from the exclusive purview of the old ruling powers—Church

and court—but also from that of the new idealistically oriented élite of the upper middle class.

The controversy over which material was most suitable for art—religion, history, or the subjects chosen by genre painters—a controversy which was meant to discredit genre painting's claim that it depicted the entire real world, was not resolved until the advent of Impressionism at the end of the century. The price of this resolution was, of course, the loss of reality. The often cited dispute, later revived in the Third Reich, on whether asparagus or the Madonna was the more appropriate subject for art ended with the victory of asparagus.

Genre painting conquered the art world at the beginning of the nineteenth century with the same overwhelming force that would later mark the triumph of modern art. The national, or folkish, element that National Socialist ideology attributed to genre painting and contrasted with the infamous internationalism of modern art is a fabrication. Genre painting had risen to dominance everywhere in Europe as well as in America, but national elements were not intrinsic to it. The immanent realism of genre painting was not indebted to any great extent to any particular nation or race. On the contrary, the rise of genre painting accompanied the ascendancy of bourgeois society and of its means of production everywhere, even in Russia, where there was no middle-class art tradition.

It seems as if the idea of an all-inclusive form of painting that would transcend all classes, an idea realized two hundred years earlier in the Netherlands, was now to be rediscovered and revitalized both throughout Europe and beyond its borders. It was as if forest, field, sea, city, and dwellings were now objects of which aesthetic possession could be taken, just as economic and political possession could be taken of what they yielded.

If we want to arrive at a basic definition of genre painting, we will do better to go back to its origins in Dutch and Flemish painting of the seventeenth century rather than turn to the National Socialist version of it or even to the middle-class painting of the nineteenth century. If we want to describe historically differing situations by means of constants common to all those situations, we first have to establish empirically reliable constants relevant to the phenomena in question—in this case, the phenomenon of genre painting. The differences and stages we can observe in the time span under consideration and that are, of course, essential to dating individual paintings, must be put aside until we have defined our constants. We will now briefly outline these constants and show how they are based on criteria already established in the course of our discussion and on the relationship of these criteria to concrete historical premises.

It is generally accepted that genre painting originated in

the Netherlands during the seventeenth century. We usually examine, classify, and think of the painting of this era in terms of the category of genre. The organization of standard studies of this period demonstrates this point amply. There are numerous studies on the genesis and history of individual genres. But there are no comprehensive inquiries or even statistical studies on the nature and extent of genre painting in the Netherlands. Sociological background information for the art of this period is scant.[79] We still need to examine the conditions that account for the rise of Dutch painting after 1600.

Once the Church and central court stopped commissioning art, determining its nature, and absorbing it, art production as it existed elsewhere in Europe under the heading of Baroque was cut off. Wherever the dominant influence of Church and court was missing both in terms of organization and in terms of clear and established ideas on style and content, completely new modes governing the relationship between art and society had to be found.

Not only did a new style of art have to be developed but also new organizational forms that in turn brought about radical changes in form and content. The artist no longer dealt with a known patron who, in the context of generally accepted concepts of value, could exert a concrete influence. Instead, he was faced with an anonymous group of potential buyers whose wishes and desires the art market attempted to meet.

The proliferation of consumers forced the artist to assess the demand and modify his product accordingly so that he could be sure of a permanent market. Up to this point, the rules and regulations of the old guild system had been as binding for the artist as they had been for any other trade. By imposing rigid technical, thematic, and iconographical standards and by strictly limiting areas of professional activity, the guild system had been able to minimize competition, but at the same time it had discouraged mobility and diversity of any kind. A work of art, like any other product, could be replaced by another of comparable value. But now every painter had to try to make his product irreplaceable, a situation that forced him to specialize. Within his field of specialization, however, his products had to be reproducible and of equal value if they were to be recognized and bought as the work of a particular producer.

As a rule, art dealers saw to it that the market functioned this way. Not only did they encourage one trend or another by their purchases, but they also frequently acted as publishers who had a direct say in what artists produced. Because of this changed economic basis, which was not restricted to the art sector but was also typical of a dominant capitalist system with its beginning industrialization of publishing and manufacture, painting developed into an open system of individual genres. Even at this stage, we see

the beginnings of industrialized art production in which different specialists, such as painters of landscapes, figures, and animals, worked together on joint projects.

This kind of differentiated painting is comparable to the mass production of clothing. A wide range of products is marketed with an eye toward optimum realization of their exchange value. Several versions of the same basic product are put on the market at the same time with the intention of making the buyer want them all. The motivation for presenting the same product in different guises is to satisfy the highly varied aesthetic tastes of a differentiated society.

These external economic factors affecting genre painting, comparable to those affecting any other product, are accompanied on the subjective level by a liberation from art's old task of conveying central and essential messages. Art no longer promulgates either worldly or other-worldly systems, nor does it claim possession of the whole truth. In his *Aesthetics*, written at the time when Dutch genre painting was being rediscovered in Germany, Hegel describes the seventeenth-century situation in the Netherlands as follows: "Chance and external factors completely determined the material . . . that art chose and formed."[80] "There is room for everything in art, for every sphere of life and every phenomenon, for the greatest and the smallest, the highest and the lowest, for the moral, the immoral, and the evil. Art feels . . . more and more at home in the finite aspects of the world, accepts them, and gives them their full due; the artist is at ease in them when he presents them as they are."[81]

Hegel is speaking here of art in its middle-class as well as in its court-related organizational form, but in his subsequent discussion, he bases the principle of modern art solely on a description of the historical advent of Dutch genre painting. He places this painting in a world-historical context when he compares it with great compositions in which realistic details "are still held together and carried by a religious concept," details such as "processions, servants, passers-by, ornamentation in dress and on containers, the wealth of portraits, architectural works, and landscapes, the views of churches, streets, cities, rivers, woods, mountain ranges." Hegel then goes on to say: "This central concept is missing now. The bond that held these various objects together is broken, and these objects in their specific nature and changing appearance are now perceived and painted in the most varied ways."[82]

For Hegel, the disappearance of a central concept amounted to the end of art in its highest form and opened the way for artistic subjectivity. This process is also linked to the rise of bourgeois society and to the reduction of all interaction to the relativizing level of exchange value. According to Hegel, the loss of objectivity is accompanied by a gain in subjectivity. With this new subjectivity, the artist can give shape to everything "that can come to life in the

human heart" by portraying all the environment "in which man is capable of feeling at home"[83]—in his house, on the farm, in the city, in the forest, on the water, and among his fellowmen. These are the themes of the new art form of genre painting.

As empirical and systematic studies have shown, genre painting is almost entirely static. Once its organizational principle has been worked out there is little latitude for surprising innovations. Once man has explored everything in which he "is capable of feeling at home"—and that includes everything that he can appropriate to himself—he then tries to hold onto what he calls his own. Genre painting could be understood as an articulation of total immanence in that it focuses exclusively on what already exists and has been achieved; it is not capable of opening new vistas. The structuring of painting into individual genres, analogous to the structuring of merchandise into brand names, also stood in the way of development and change. An artist's subject had to remain constant enough in appearance that any painting by that artist could be recognized as his work. A flower painter is and remains a flower painter as long as he can sell his product. He may depict his subject in hundreds of aspects, but all these paintings can still be reduced to the same subject. This situation hardly puts a premium on innovation.

It is the virtue of the genre painter always to remain himself, to go on painting the same subject in the same manner. The fact that the same painter will often specialize in two or more subjects does not contradict this. An artist may expand the range of his offerings to appeal to a wider market, or he may change his specialty to meet or create a specific demand. These special cases only confirm the general principle.

A further indication of the static nature of genre painting is that it has no inherent style. This is so because it lacks "progressiveness." The case is just the opposite with modern art, which is oriented completely around the concept of style, whether the different styles it produces are seen as a temporal sequence or as parallel to each other. With genre painting, however, we usually speak of a kind of realism or naturalism and mean no more by it than the straightforwardness and recognizability of its subjects. We even hesitate to subsume this work under the broad heading of Baroque because the all-too-human qualities of it convey a sense of permanence and timelessness.

Genre painting, once it had taken full possession of reality, had fully matured and was essentially conservative in technique and format. The sociologist Arnold Hauser describes this characteristic of genre painting as follows: "This view of art is embodied in genre painting of domestic scenes, and this kind of painting became the characteristic form of all modern bourgeois art. No other form gives as

adequate expression to the bourgeois soul with its limitations and its yearning for the profound. This form results from restriction to the smallest format and, at the same time, from the highest intensification of spiritual content within this narrow frame."[84] Genre painting was not intended for galleries, although it soon found its way into them. It was meant instead for private collections and particularly for bourgeois households in which it reflected a way of life familiar to the inhabitants.

Given the economic premises and "spiritual content" of genre painting, the supply of it and the demand for it had to be massive. Painting that adheres to the principle of genres is bound to have a democratic, general character that cuts across class lines. Its inherent frame of reference is as broad as the concept of nation or people is understood to be in any given case. At the same time, this kind of painting, by containing elements that appeal to specific classes, permits a buyer to distinguish himself from other classes through the choice of *his* aesthetic environment. But these differences are small and often apparent only to the initiated. Painting of this kind is hardly likely to trigger social confrontations like the ones that modern painting unleashed. The system of genres, as a system of integral variants and by virtue of its comprehensive ability to integrate the most diverse social groups, vividly illustrates the principle of unity in variety.

Another characteristic of genre painting that follows from this touches on the manner of observation it invites. Whether genre paintings show a herd of resting cattle or a brawl in a tavern, they have a "contemplative" quality that does not encourage active involvement. Instead, they assume an intimate setting from the perspective of which the observer peers into the surrounding world of the paintings. They create the impression of being painted for enjoyment during leisure time. As a rule, they do not depict the work or organization of society. They do not illustrate the creation of wealth but wealth that has already been created. The enterprising, exploitive, and violent sides of the bourgeois in this epoch are barred from painting. Indeed, painting seems intent on compensating for these qualities.

This historical phase in the evolution of capital, a phase that is concomitant with the flowering of genre painting, was not yet characterized by the self-reproduction of capital through the creation of surplus value but by the original primitive situation in which capital was amassed in the most varied ways. Dutch wealth was accumulated by robbing competitors like England and Spain, by appropriating feudal rights and positions, and, above all, by exploiting colonies and monopolizing their products in world trade. This early capitalist reality, which had precious little to do with domestic virtues, is not revealed in the art of this period. Genre painting therefore presents only a partial

reflection of reality, not a full picture of circumstances as they really were. Its realism is only relative and requires interpretation.

This quality became more pronounced as genre painting declined into a trivial art adapted to the tastes of the petite bourgeoisie. In this phase, a "dwindling of material" is all too obvious. Arnold Gehlen writes:

> By 1900 at the latest, all conceivable subjects had been exploited, some for centuries. Genre painting had portrayed everyday life in all its variety; the still life had explored various details selected from this variety. There were animal paintings, sport paintings, views of villages, views of houses, views of doors. Every art had been the subject of painting. Buildings had been depicted from within and without. Runge had painted poems. Artists had followed tourists to the tops of mountains, workers into their factories, hunters to the field, children to school, travelers to the Orient. Every last thematic possibility had been exhausted. The sea painting had emancipated itself from the rural scene. There were landscapes, seascapes, cloudscapes. The sea had become a subject apart from ships, the individual wave a subject apart from the sea, and, in Leibl's work, the blouse a subject apart from the girl wearing it. . . . The only hope was a completely new concept of what was permissible in painting.[85]

The constantly growing mass of details depicted in painting reflected less and less of the world's totality. This became increasingly clear in National Socialist art, which is, as of now, the last phase in the reception of genre painting. This art adhered to all the criteria of genre painting and to its "systematic" character, despite all the variations it displayed. Under German fascism, the inadequacy of the subjects and themes in painting became so striking in view of the advanced technology of production and government that we must assume equally striking explanations for this phenomenon.

If Dutch genre painting hid and compensated for the violent aspects of early capitalism, then the harmlessness of by far the greatest part of National Socialist painting can be interpreted analogously in its relation to the late capitalist excesses of its time. Jürgen Kuczynski had good reason for singling out as a particularly significant characteristic of German fascism its relapse into primitive accumulation (expropriation of Jewish capital within Germany and annexations abroad), which was thought to have been a phase long outgrown in the history of capitalism.[86] Sohn-Rethel has also attempted to characterize German fascism as a regression to another, somewhat more recent stage in capitalist development, the stage when the production of surplus value was accomplished in absolute terms,

by increasing the length of the work week.[87]

Both these kinds of fascist regression come together and reinforce each other in German fascism, intensively and extensively, in domestic and foreign politics. The manipulators and the manipulated in this unlikely situation were to join together in refining their sensibilities through contemplation of the beauties of the world, beauties falsely attributed to that world as microcosmic immanence. Genre painting, by dividing up the richness of experience into special fields and separate details, necessarily leads, the more anachronistic it becomes, to a compartmentalization of experience. Details raised to the absolute blur the total picture of conditions as they are—this is, of course, the function they are meant to have—and, at the same time, contribute to the general atmosphere of terror.

In describing the genre of war painting, the essay "Maler und Zeichner schauen den Krieg" ("Painters and Illustrators Take a Look at War") reveals this function.

> The great range of the soldier's experience and the vastness of the task that war reporters in a propaganda company have in reflecting military events offers painters and illustrators the most exciting of challenges. The wealth of colors, the unparalleled exquisiteness of living things, the all-pervasive harshness, the unique seriousness of war all open an inexhaustible field to the palettes, chalks, pencils, and agile fingers of painters and illustrators.

This approach gives even war an idyllic quality. The essay goes on to describe a representative of this kind of war art:

> His heart is joyfully caught up in the fullness of his experience, and he is informed with the passionate enthusiasm, the frenzy of the diligent and single-minded artist. He strives to capture the crisp and varied action, the authenticity of experience, the telling moment, the essence of the soldier's life.[88]

The painting of German fascism no longer reflected reality but presented it in such a way that it paralyzed consciousness.

The Program

"Art in the Third Reich" took the form of revived genre painting, and the longer it was in existence the clearer certain tendencies in it became. Since the depicting of irrelevant details was the actual task of genre painting, these details had to be sufficiently inflated to satisfy the requirements of German fascism's self-image.

In a 1941 essay, what is termed the "National Socialist renewal" of painting and its "new pictorial content" is described with so much naiveté, accuracy, and self-revelation that extensive quotations seem appropriate.[89] The author holds onto genre as the structural characteristic of contemporary painting, but he attempts to infuse it with substantial significance. He begins with a sally at the socially committed realist artists of the Weimar period.

> They [German artists] are no longer painting absinthe drinkers and roulette players, consumptive circus riders, marionette-like ballet dancers, vapid masks, or heavily made-up prostitutes. They are no longer interested in the grim uniformity of slums, urban desolation, and dives. They don't even claim the right to depict scenes of hopeless misery with undertones of sharp criticism, implied accusation, or heart-felt compassion in an attempt to rouse the social conscience of the observer. . . . They want to be spokesmen for the positive side of life.

The author fails to indicate, of course, that it is less a question of what they "want" to do than of what they "have" to do—which is to conform to the state's orders for window-dressing. After this statement of principle, which is reminiscent of the last Kaiser's remark that he approved of art "when it elevates us and does not descend into the gutter" (1901), the author goes on to list and describe the genres.

> Since any renewal is essentially concerned with human beings, it is natural that the *German figure* [italics in original] is a highly favored theme in our modern art. Guided by a true instinct, our artists find their models primarily among those fellow citizens who are, as it were, still sound by nature. They set to work where closeness to the native soil, the restorative powers of the landscape, the protection of the race from impurities, the force of deeply rooted tradition, and the blessings of beneficent labor have kept the human substance healthy. It follows from this that our contemporary painting frequently portrays the faces and figures of *men who follow the old callings close to nature*: farmers, hunters, fishermen, shepherds, and woodcutters. Along with these figures, we find portray-

als of simple artisans because they, too, ennobled by the discipline of plying their trades, are models of edifying integrity. It is not surprising that women and girls from the same spheres of life are also represented. Together with their male partners, they form the rugged stock of our people. The sight of them is particularly impressive as we seek to show the immense importance of our folkish substance. Because woman, as soon as she becomes a mother, partakes of the sacred mysteries of the natural order and because a nation dedicated to the future values motherhood above all else, mother and child have become a cherished theme in modern German art.

Artists stress above all else the role of the *mother as the guardian of life*. Race and character, the most precious qualities of life, are in her care. . . . Our new attitudes find similar expression in portraits of children, which, with their rich variety of movement and color, are also favorite subjects of contemporary German art. It would be a needless limitation if our artists working in this area restricted themselves programmatically to the single figure. Instead, they delight in repeatedly depicting simple German types in their social and material surroundings, in the context of their families, in their shared work, in the company of the domestic animals that serve them and are entrusted to their care, animals that themselves so directly reveal the secret of health, the law of the natural order. Everything that partakes of the dignity of the basic human condition is gratefully recorded: the family circle that gathers either at home or in the field for its midday meal, a boy resting in the shade with his goats, a father with his little son in front of him in the saddle. . . . Again and again we see the farmer on his land. We see him plowing, sowing, reaping, and gathering his winter's wood. We see him against a background of earth and sky with the fruitful soil under his heavy shoes, a modest but proud ruler over his dutiful animals and his own well-tended fields . . .

Where there is so much feeling for the soil in which we are rooted, the *pure landscape* is bound to be an object of artistic interest. . . . These landscapes are *representations of the fatherland*, portraits of native regions in their quintessential individuality, in their inner variety, in their changing character, in the typical forms of their settlements, in their light and atmosphere. . . . Sometimes we see in a landscape painting what is unique in a particular landscape, what stands by itself, sometimes a representative segment from the vast whole of the entire fatherland. . . . Sometimes it is a piece of the Reich that demands our loyalty, sometimes our all-nourishing mother earth that yields her best to us, certain of our undying allegiance.

The portrayal of the female nude will always be the artist's most ambitious undertaking. . . . German painting of today sees the nude primarily as a challenge to depict life in its full vibrancy. In nudes, the artist tries

to show the healthy physical being, the biological value of the individual as a precondition of all folkish and spiritual rebirth. He concentrates on the body as nature wanted it, on perfect forms, on pure configurations of limbs, on firmness of flesh worthy of thoroughbreds, on glowing skin, on innate harmony of movement, on obvious reserves of vitality, in short, on a modern and therefore palpably athletic classical ideal. . . . For the new Germany, any healthy variety of happiness is a welcome contribution to our program of promoting national zest. Our country is particularly intent on cultivating such happiness where it promises to enhance the performance of men and women in their basic duties of combat and fertility. . . . From this perspective, all those activities in which the beautiful human form has a right to full exposure—sun bathing, swimming, dancing, and athletic exercise—have a particular appeal for art. . . . The expression of simple and profound being is the common characteristic of the many figures, faces, groupings of houses, and landscapes that appear in our pictures. This kind of expression is, of course, inherent in the *still life*, which brings together, as we might expect, objects that have always been essential to rural life.

To this ideologically annotated list of the themes typical of genre painting the author adds what he calls the theme of "group portraits and modern monumental painting born from the spirit of the national community." He notes as particularly significant the fact that "the triptych, whose overt symmetry has always carried sacral and devotional connotations, is enjoying a revival today."

This inventory of "painting in the Third Reich" concludes with a list of the following particularly relevant themes that are new in genre painting:

Pictures of marching columns and youth groups, battles in the World War, reapers in the field, . . . heroic workers at the glowing forge, and formations of ships putting out to sea. . . . Our readiness to affirm the world of today and our renewed penchant for enterprises of great magnitude have given rise to something truly new in the field of our genre painting, namely, the heroic landscape of *engineering activity* in a revitalized Germany. The scenes we encounter here show work on our new highways, on dams, on the huge factory complexes that will bring about our economic liberation. These works of art quite deliberately glorify projects that are made possible only by the free cooperation of all the nation's classes under a unified command. They therefore also glorify a German nation now organized down to its last member.

It is clear what strain the author and his language must undergo to make his "substances" credible to the reader. It

takes a major effort to convince a modern, industrialized society that its models can be found in the social no-man's land the rural world has become. The desire or the obligation to lead people out of their alienation, as it is expressed in paintings of "absinthe drinker," "slums," and "dives," and into a proclaimed unity with "a background of earth and sky" already implies a high level of alienation. Indeed, such a "background" is bound to accentuate alienation all the more.

At the opposite extreme from these subjects taken from modern life are the themes of traditional genre painting: the landscape, the farmer, the hunter, the shepherd, the artisan and his craft, the mother, the child, mother and child, the apple, the pear, the bouquet of flowers, the domestic animal, and the young girl. But in contrast to earlier genre painting, in which "chance and external factors completely determined the material" (Hegel), this new genre painting was weighed down with the task of proclaiming essential truths and making binding prophecies. Every child and every cow was now supposed to embody "the sacred mysteries of the natural order." This meant that children or cows—once they were painted—could no longer be what they were. They became masks of the proclaimed substance, masks that made up the face of the National Socialist system.

By now it must be clear that painting under German fascism had nothing to do with realism, no matter how much it depicted the material world. Objectivism is not realism if the objects depicted are not themselves drawn from the reality of the present. And indeed, as far as we know, National Socialism did not apply the term realism to its art products. We can assume that realism, because of its linguistic form, had been classified among the other discredited and rejected "art-isms." The term had already been used in socialist discussion of art and literature and was therefore unsuitable for the National Socialists. Finally, it was the realists that had been the first victims of the art purges.

A speech by the *Reichsjugendführer* (Reich Youth Leader) Baldur von Schirach reveals what the official view of the artist's relationship to his subject matter was:

> God forbid that we should succumb to a new materialism in art and imagine that all we need do is mirror reality if we want to arrive at the truth. The artist who thinks he should paint for his own time and please the tastes of his time has misunderstood the Führer. Everything this nation undertakes is done under the sign of eternity! The point of all human striving is to wrest timeless accomplishments from the stream of time. Art, too, is a struggle of mortal beings to achieve immortality.[90]

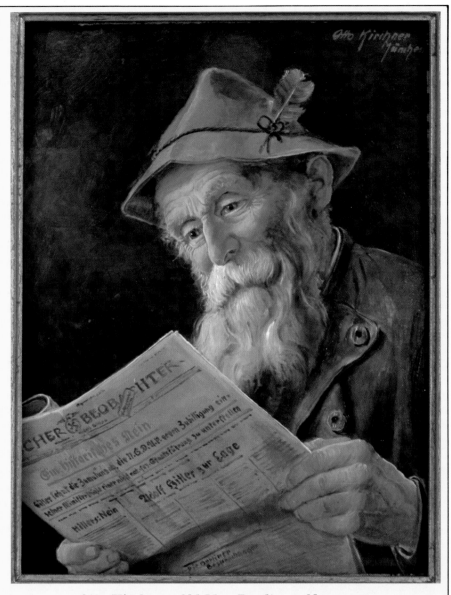

Otto Kirchner, *Old Man Reading a Newspaper.*

Eduard Thöny, *French Tank*.

Sepp Hilz, *Late Autumn 1917*.

Adolf Wissel, *Kalenberg Farm Family*.

Wilhelm Petersen, *The Family*.

Udo Wendel, *The Art Magazine.*

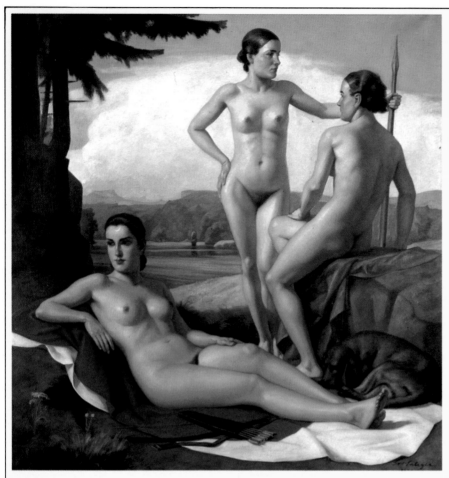

Ivo Saliger, *Diana at Rest.*

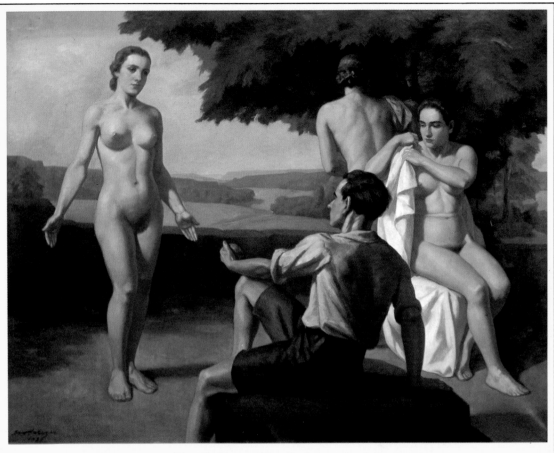

Ivo Saliger, *The Judgment of Paris*

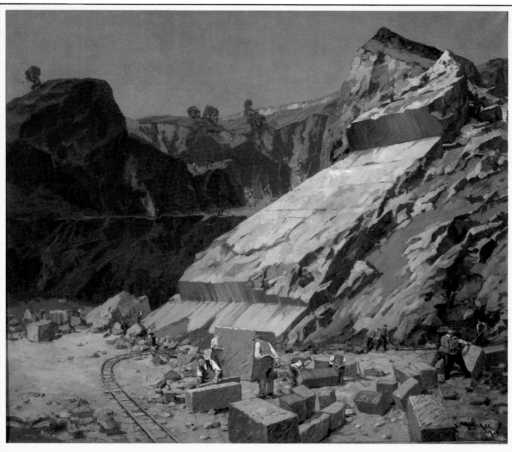

Erich Mercker, *Marble for the Reich Chancellery.*

Ferdinand Staeger, *SS on Guard*.

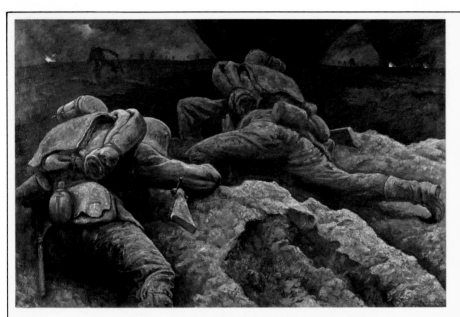

Otto Engelhardt-Kyffhäuser, *The Volunteer*.

Rudolf Otto, *Ready for Battle*.

Werner Peiner, *The Horsemen of the Apocalypse* (from a cycle).

Werner Peiner, *The Horsemen of the Apocalypse*
(from a cycle).

Werner Peiner, *The Siege of Marienburg* (sketch for
a cycle of tapestries).

Werner Peiner, *Frederick the Great at Kunersdorf*
(sketch for a cycle of tapestries).

Werner Peiner, *Battle at Leipzig* (sketch for a cycle of tapestries).

The denial of historical time as the *a priori* locus of artistic activity and, indeed, of all human activity, characterizes National Socialist painting as removed from all reality and, therefore, as antirealistic. For time, even if it is identified in its lowest emanation as mere taste, still remains the foil of all truth.

Substantialization

If genre painting, instead of being oriented to specific times and places as its nature demands, is forced to convey substantial truths, the shift in emphasis is bound to have formal consequences. There will inevitably be a contradiction between the origins of genre painting and the new demands made on it, a contradiction that is in fact inherent in National Socialist painting and that we will now examine more closely.

Artists under National Socialism tried to meet these demands in two ways. Some of them changed or corrected the visual conceptions they were accustomed to working with only minimally or not at all and merely gave their paintings titles suggested by the new "substances." These titles intended to show—as the ideology demanded—that a nude was no longer a nude, a factory no longer a factory, a landscape no longer a landscape. This explains the immense proliferation of titles that attempted to imbue the subject matter of paintings with symbolic profundity even though the subjects themselves remained perfectly obvious. In this way, the essentially unpretentious art of genre painting was to achieve the status imposed on it and legitimize itself.

Landscapes with no particular qualities that would justify the titles given them were labeled *Cloud of Doom* (H. Holleck-Weithmann); *Liberated Land* (F. Haselbach); *Adagio Maestoso* (K. Leipold); *Young Light* (H. Schrödter); *Heaven and Earth* (F. Halberg-Krauss); *Fruitful Land* (H. Bastanier); *Sunset Embers* (G. Traub); *German Summer Day* (E. Frommholt); *Evening Shadows* (G. Traub); *East Prussia* (R. Holst); and *Midsummer Night* (A. Müller-Wischin).

Some farm scenes are entitled *German Earth* and *Spring* (W. Peiner); *The Plow* (G. Ort); and *Steaming Furrow* (M. Bergmann). Mountain scenes are called *Stony World* (A. Müller-Wischin); *High in the Blue* (J. Widnmann); *The Enduring and the Ephemeral* and *Mountain World* (H. Hodiener). Paintings depicting forests or groups of trees were entitled *The Oaks of Eriskirch* (H. Lotter); *Forest Home* (J. B. Godron); and *German Oaks* (R. Holst). A seascape is called *Wind and Waves* (A. Bachmann).

Particularly striking is the use of titles referring to seasons and times of day. These titles are meant to establish

a relationship between landscapes and the "laws of the natural order," and they attempt to invest the pictures with more meaning than they have. The cyclical and cosmological idea that was revived in the nineteenth century, particularly in C. D. Friedrich's paintings of the seasons and times of day, once again emerges here. A cyclical typology titled "Images of the German Land" and made up of six landscapes called *High Peaks, Rolling Hills, Flatland, Sea Landscape, Little Brook,* and *River Landscape* was painted for a dining room in the new Reich Chancellery.[91]

Furthermore, the attribute "German" was attached to all conceivable natural phenomena—the earth, oaks, summer days—none of which occur exclusively within any political, national, or racial borders. Fertility was liberally attributed to the "German soil" as though it were an ontic quality independent of agricultural means of production, and landscape paintings that had no identifiable regional features were nonetheless associated with specific regions merely by labeling them Hessian, Westphalian, or East Prussian. This expresses not only the new regionalism of art in the Third Reich but also the "tribal idea" that was promoted after political federalism had been abolished[92] and that presupposed specific areas of settlement. In general, verbal flourishes, often laden with pathos, were used to express in words what was not contained in the painting itself.

Paintings depicting the rural population had titles similar in character to those of landscapes, and these titles were applied indiscriminately to both people and animals. Some paintings of farmers were called *Home from the Fields, Resting, Evening* (O. Martin-Amorbach); *German Farmer* (H. Tiebert); and *Farmer Breaking Bread* (C. Gerhardinger). Animal paintings, mostly of cattle and horses, were entitled *Morning Call* (M. Bergmann); *Autumn, Resting, Home from the Fields* (F. Stahl); *Ready for Work* (H. Zügel); *June Sun* (J. P. Junghanns); *Spring* (M. Bergmann); *Victorious Rooster* (J. Wichmann); *Standing Guard* (M. Kiefer); and *Steiermark* (H. Zügel). Paintings of people and animals together were called *Work* (F. X. Stahl); *Hard Work* and *Through Wind and Weather* (J. P. Junghanns); *Home from the Fields* (R. Scheller); *Blood and Soil* (E. Erler); *In the Allgäu* (H. O. Hoyer); and *Farm Family* (F. Spiegel).

Here again, the cosmos with its eternal rounds of days and seasons and their effects on agricultural work is overburdened with significance, and geographical determinants are seen as binding for human beings and animals. Work appears on the archaic level as a collective physical effort of men and animals. Finally, authoritarian attitudes are extended to the animal world. This genre became the most favored form of visual expression for the slogan "blood and soil," which reflected on the verbal level the very essence of regained national substance.

Titles like *The Eternal Musketeer* (W. Sauter) and *At Dawn* (G. Lebrecht) lifted paintings of soldiers and war themes out of their real temporal context. Paintings of warships were called *German Guards on the North Sea* and *England Bound* (Claus Berger). Pictures of flowers and grass were given titles that expanded their significance: *Autumn* (T. Roth); *Floral Splendor* (W. Thaler); *Sunlight on the Green* (L. Bartning); and *The Month of May* (E. Aichele). A picture of a girl was called *Upper Bavarian Youth* (C. Gerhardinger); that of a woman, *Spring* (A. Kampf). Still other female portraits received the titles *Summer* (A. Kampf) and *Blessings of the Earth* (W. Willrich). A portrait of a child with a kid was labeled *Village Spring* (R. Popp).

In an iconography whose subject matter borders closely on reality, as is the case with paintings of industry, titles take on an even more pronounced mythological character, because National Socialism did not see work as the process of fulfilling society's needs but instead declared it a "value *per se.*"

If it is forbidden to see the pursuit of specific goals and interests as the motivation for work, then the places in which "work *per se*" is performed can be nothing more than monuments to "work *per se.*" This attitude is expressed in the description of a factory: "It towers over time like a fortress of the Holy Grail, like a smithy of the entire nation, in which a proud awareness of our own strength, a self-confident drive toward power, and an active spirit of community are combined in ceaseless labor."[93] The places in which this absolute work is performed take on elemental qualities usually associated with nature. Consequently, paintings of industrial subjects make the physical means of production—the very thing that lies at the heart of the conflict between labor and capital—into a mythical construct that embraces both worker and entrepreneur. The worker is, of course, represented as a "follower," the entrepreneur as a "leader." A picture of an industrial plant is labeled *United Steel Works*, another *Fortresses of Our Time* (R. Gessner). A painting showing construction work on an *autobahn* is entitled *The Führer's Highways* (C. T. Protzen). An industrial landscape is transformed into a *Realm of Blast Furnaces* (E. Mercker). A painting of an ironworks is given the National Socialist title *Germany's Smithy* (E. Mercker). A view of a shipyard is made into a symbol for the fact that *The Homeland Works* (W. Henning).

The title of a group portrait showing Hitler speaking in a beer hall during the early days of National Socialism shows how far the metaphysical dressing up of easily identifiable subject matter could go. The painting is entitled *In the Beginning Was the Word* (H. O. Hoyer).[94]

More harmless but no less revealing are the titles given

Wilhelm Wilke, *Templin Canal.*

Paul Beutner, *The Melody.*

Gustav Traub, *Mountain Spruce.*

Herbert Böttger, *Sunflower.*

Magnus Weidemann, *Forest Lake in Winter.*

Werner Peiner, *Autumn in the Eifel Region.*

Werner Peiner, *German Earth*.

Erich Erler, *Far Reaches*.

Hugo Hodiener, *Permanence and Change.*

Eduard Handel-Mazzetti, *Mountain Landscape.*

Eduard Handel-Mazzetti, *Honorable End.*

Hanns Bastanier, *The Roofs of Potsdam.*

Otto A. Hirth, *Campielle.*

Michael Mathias Kiefer, *Sentries.*

Julius Paul Junghanns, *Spring Evening.*

84. Walter Gasch, *Castle Gnadstein.*

Franz Xaver Stahl, *Smithy*.

Franz Xaver Stahl, *Rest*.

Julius Paul Junghanns, *Plowing*.

Max Bergmann, *Morning Call.*

Thomas Baumgartner, *Farmers at Mealtime.*

Anton Lutz, *Upper Austrian Farm Family.*

Ivo Saliger, *Country Engagement Party.*

Georg Siebert, *German Family*.

Hugo Zimmermann, *Leisure Time*.

Albert Henrich, *Country Still Life*.

Paul Gebauer, *Self-Portrait with Wife and Hired Hands.*

Gustav Stosskopf, *Alsatian Farmer Drinking Wine*.

Bernhard Dörries,
Girl in a White Dress.

Rudolf Grunewald, *East of the Sun and
West of the Moon.*

Anton Leidl, *Portrait of a Woman.*

Hans Schachinger,
Farm Family from the East Mark, 1940.

Hans Jakob Mann, *The Homeland Calls.*

Otto Engelhardt-Kyffhäuser, *Last Rest before the
German Border.*

Paul Mathias Padua, *The Führer Speaks.*

Josef Vietze,
Collection of Winter Clothes in Prague.

Adolf Reich, *Woolen Collection in a Munich District Group.*

Arthur Kampf, *The People's Contributions 1813.*

Franz Triebsch, *Leonardo da
Vinci Painting the "Last Supper."*

Hermann
Otto Hoyer, *In the
Beginning Was the Word.*

to paintings in the last genre we will consider here. The representation of numerous and mostly unclothed female figures is not allowed to be what it in fact is: the painting of nudes. It attempts to escape the usual settings chosen for nudes—baths, bedrooms, boudoirs, and bordellos—by invoking the cosmic powers of the daily cycle. Nudes are called *Night* (R. Klein); *In the Morning Light* (J. Mahainz); *Daybreak* (R. Heymann); *Morning* and *Summer Evening* (R. H. Eisenmenger); *Awakening* (E. Kirr, R. Beutner); *Resting* (R. Klein); and *Quiet Hour* (E. Liebermann). Sometimes paintings of nude girls are given a Mediterranean or exotic flavor by the use of titles like *Frascati* (R. Schuster-Woldan); *The Coral Necklace* (G. Palmié); *Nocturno* (A. Abel); and *Capriccio* (K. Truppe).

The secret locales of nudism are also diligently revealed: *In the Arbor* (J. Schult); *By the Lake* (G. Palmié); *By the Water, Lonely Heights* (E. Liebermann); and *On Sunny Heights* (C. Gerhardinger). In all paintings of this kind, as in J. Engelhard's *Bathing in a Mountain Lake*, the observer found the "ideal biological forms" that provided the "precondition of all folkish and spiritual rebirth."[95]

Naiad at the Spring (E. Liebermann); *Danae* (J. Engelhard); *Terpsichore* (A. Ziegler); *Psyche* (R. Heymann); *Venus* (J. Kluska); *Aphrodite* (O. Graf); and *Nausicaa* (J. Pieper) all proclaim the kinship, discovered by National Socialism, between Greek and Germanic culture. We also find a girl *Lost in Thought* (L. Bechstein) and one *In the Spring of Life* (J. Schult). Others sing *A Folk Song* (R. Eisenmenger) and an *Evening Song* (H. Happ) in the nude. There is also an *Hour of Relaxation* (B. Müller). Finally, a *Peasant Venus* (S. Hilz) and a *Peasant Beauty* (O. Martin-Amorbach) along with another peasant *Vanity* (S. Hilz) make up another genre in themselves. In these paintings, the ambience is somewhat more concrete, but it is highly unlikely that any Bavarian cottages were ever

Sepp Hilz in
his atelier with his model
"Annerl" posing for the
painting *Peasant Venus*.

graced by such scenes. National Socialist emphasis on
healthy rural traditions saw to that. Ultimately, the viewer
is not left with a girl but with *Girlhood* (H. Hanner), an
idealization that prevents any real girl from being appre-
ciated in her own individuality.

Given the ideological premises we have outlined, a simple
nude had to be trumped up into a "primal image" of woman,
of life. One way of achieving this was to give the paintings
pretentious titles. Nude painting, however, found a second
possible way for dealing with the problematic situation
genre painting was in. In landscape painting, the new
demands could be satisfied by titles alone; but in nudes,
these demands affected the treatment of the subject matter
itself. A *Naiad at the Spring* stood at too great a remove
from empirical reality. This false subject called for a pre-
tentious rendering, which appeared not only in the unreal
environment the painter chose but also in the presentation
of the figure itself. Since "naiads" and "peasant beauties"
did not belong to men's real experience of women (these
paintings are not self-portraits by women but were all
produced by men), they became objects of male fantasy
that was given free rein in voyeurism. The figures therefore
create the impression that, in spite of their declared solitude,
they are conscious of being exposed to secret observation.
They concentrate on assuming pleasing and seductive poses
and always seem to be in *Expectation* (J. Schult) of a
secret visitor. They are never shown in a natural or
authentic situation, as they had been in Impressionist paint-
ings, but are, as is particularly apparent in groups of nudes,
put together piece by piece, figure by figure. In paintings
of groups the same model was generally used for all the

figures and was shown from all angles and in all poses: front and rear views, reclining, kneeling, and sitting.

Genre painting has an element of genuine realism, and in the course of the numerous receptions of genre painting, this realism, the premises and limits of which were already visible in the seventeenth century, underwent two changes.

1. Even if we assume that the genres survived succeeding epochs unchanged, genre painting lost its genuine content in the context of the changing historical situation. To the extent that time left it behind, it could no longer be what it had been in its beginnings, and it lost its original attitude toward reality. In National Socialist art, this kind of deterioriation is most obvious in the gulf between the themes chosen and the actual historical state of the world. Genre painting became thematically anachronistic.

2. Once genre painting had lost its original capacity to take possession of reality, it was forced to pretend that its now falsified content adequately reflected reality. This had consequences for both form and content. In order to justify its claim to realism, genre painting had to adopt whatever interpretation of reality was current in a given epoch—the interpretation held by those representing dominant opinion.

Hegel had noticed this difference between the paintings of the seventeenth century and those of his own period.

> We have good genre paintings in this year's art exhibition, too, but their artistic level is nowhere near that of similar Dutch paintings. Even in content they do not achieve the same freedom and lightheartedness. There is, for example, a picture of a woman going into a tavern to scold her husband. The result is nothing more than a portrayal of nagging, spiteful people. When the Dutch paint tavern scenes at weddings and dances, at feasts and carousals, everyone is shown in high spirits, even if there are arguments and brawls. Women and girls are present, and a feeling of freedom and exuberance informs every detail. This spiritual gaiety of justified enjoyment that infuses even paintings of animals and takes the shape of satiety and pleasure, this fresh, open, spiritual freedom and liveliness in conception and execution constitute the higher essence of these paintings.[96]

Hegel uses the phrase "justified enjoyment" to illuminate the central difference. There can be no justification for enjoyment if the paintings are an apology for the fact that the masses have not yet attained freedom and if there is a Fourth Estate that is excluded from enjoyment. Genre painting representing peasant and petit-bourgeois life becomes malevolent if the life of those classes is looked down upon and excluded from the historical perspective of its period.

The most obvious indication of the anachronistic quality of genre painting—the very quality that later made it

interesting for German fascism—is that it could not hold its own against modern painting. A theory of genres, for which Hegel at least implicitly supplied the foundations, suggests that individual genres as well as their elaboration into a comprehensive system are evidence of a concrete socio-historical link between the artist and his social environment. If this is so, then the genres will reflect the reality of the circumstances giving rise to the genres in question. Only under these circumstances will the elements of content and form come together in unity. As we have seen, Dutch painting of the seventeenth century provides an excellent example of this. A work always keeps alive the conditions from which its genre originated, but those conditions will no longer be perceptible when art becomes traditionalist, forgetting the social complex of the genre's origins and its primary social function. Form and content will then either part ways or enter into heterogeneous symbioses. Theoretically, this has the following consequences. If content is emphasized to the exclusion of form, the paintings continue to present themselves as genre paintings even though, as such, they have lost their original justification. They forfeit reality—the social relevance of form. If form is emphasized to the exclusion of content, the paintings will become autonomous and forfeit the social relevance of content. In practice, no symbiosis, regardless of its shape, will be able to reestablish the original quality of the genre, and it will only give the paintings the obvious unevenness and falseness that Hegel ascribed to a lack of "justification."

If we trace the vein of art that was characterized by adherence to genre and that had, for the most part, lost "form" as early as the nineteenth century, we will once again find an explanation for its failure in Hegel. "These days we have to look at pictures that reveal at a glance, despite all the resemblance they have to human beings and actual individuals, that the artist has no idea what the human being and the human complexion are, nor does he know what the forms are in which human beings express their humanness."[97] Here Hegel comes close to the observation that a child can no longer be a child, a cow no longer a cow, because they are obliged to be something other than what they are in reality and in their own reality. In the early nineteenth century, the subjects of painting were not yet burdened with substantiality, but the fact that they had to provide relaxation and amusement by being cute, idyllic, or sentimental was enough to distort them.

As the quotation above indicates, Hegel had already noticed an element of distortion in animal paintings, and we will now attempt a closer definition of "substantialization" by examining animal paintings and the transformation they underwent in the twentieth century. Because of the long tradition behind them (Friedrich Volz, 1817–1886; Rudolf Koller, 1828–1905; Anton Braith, 1836–1905; Anton

Mauve, 1838–1888; Hermann Baisch, 1846–1894; Heinrich von Zügel, 1850–1941; and others), animal paintings won a prominent place in National Socialist painting. Zügel was particularly influential in this genre,[98] and the remarks on Zügel in Kroll's art history provide us with a clear insight into the National Socialist approach to art.

> In Zügel's work, too, the animal continues to be the major hero. Here, too, animal paintings become monuments of mood, infused with evocations of our homeland. In the 1890s, Zügel's brush strokes became freer and his colors brighter and more glowing. But he retains his love for plastic individual form. This master refused to draw the final consequences suggested by Impressionist painting. Was he afraid to lose the substance of his beloved animals, the soul of his cattle and sheep? Bright spots of light dance on their hides. . . . But the light does not infringe on the substance or destroy it. A brutal struggle between the demands of the law, of Impressionist aesthetics, and Zügel's love for animals ensued. . . . He came under attack by the advocates of pure Impressionism, but he held his ground and reclaimed for animal painting what it had long since lost and what it had once had in the work of Dutch painters like P. Potter and Albert Cuyp: the sweeping lines of monumentality. Zügel's struggle grew out of his love for Germany, his love for his native soil, and his works became symbols of a life-giving and a life-sustaining primal force.[99]

The very quality that the National Socialists called "degenerate," the Impressionists' delight in color apart from the object, was the historically appropriate mode for animal paintings, too, and Zügel himself initially subscribed to it. His later insistence on the "substance" of his animals is a reaction that did not bring him closer to Potter's or Cuyp's work but that robbed his work of reality in terms of his own time. For, as Hegel expressed it, paintings of this reactionary kind "will necessarily, in the total impression they create, appear as something insignificant because we have left such external objects and content behind." It would be intolerable "to look at them with the expectation that they could really be totally satisfying."[100] These paintings forfeit their own quality precisely because they remain genre paintings, and they can do so only by laying claim to "monumentality" and seeing themselves as epic "symbols of primal forces." This process of struggling to maintain itself while constantly losing ground characterizes genre painting from the end of the nineteenth century on.

Later painters went far beyond Zügel in burdening their work with "substance," and animal paintings of monumental nature became the rule. Paul W. Harnisch's *Cowherd*, which shows a young man together with a massive bull,[101] is an early example of this. Particularly important in this context

Paul Wilhelm Harnisch,
The Cowherd (c. 1905).

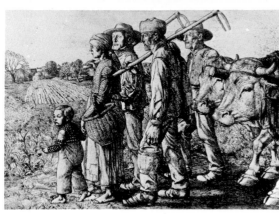

Fritz Boehle, *Farmers Returning
from the Fields* (1897).

are Fritz Boehle's paintings and etchings,[102] which monumentalize both human figures and animals. At the same time, Zügel's own school intensified the tendency toward "symbolic representation." Max Bergmann's *Morning Call*, Franz Xaver Stahl's *Smithy*, and Julius Paul Junghanns's *Plowing* exemplify this.

Michael Kiefer's paintings of eagles represent the ultimate phase of animal painting and approach the National Socialist use of emblems that stand for an all-embracing claim to rule. Kiefer's *Circling Eagle* over the Alps, his *Sentries* over Helgoland, and his *Nordic Sea* symbolize the German armed forces' supremacy on land, at sea, and in the air.

In this area, too, there were precursors, such as the painting *Sea Eagle* by the Swede Bruno Liljefors. Hitler awarded this painting, which was done in 1897, the first prize for the best work of art at the 1937 International Exhibit of Hunting Art in Berlin.[103]

The tendency we have just examined here in animal paintings can be just as easily traced in all the other genres.

Bruno Liljefors,
Sea Eagle (1897).

In landscape painting it is first apparent in a Karl Haider painting that takes its title from Goethe's well-known poem "Über allen Gipfeln ist Ruh" ("Peace Reigns over the Mountain Tops") and culminates in Karl Leipold's "magical" panoramas of land and sea, such as his painting *Let There Be Light*. In paintings of farmers, this tendency is evident in Ferdinand Spiegel's portraits of gnarled mountain farmers, which, in the tradition of Albin Egger-Lienz,[104] elevate this genre to the status of the monumental. Another example of this conception of the farmer is Oskar Martin-Amorbach's *Sower*. This painting obviously follows the tradition of J. F. Millet's *Semeur*, but at the same time this "monument" to back-breaking rural labor has been transformed into a monument to the farmer himself or, more correctly, into a monument to a metaphorical act of sowing. This painting served a programmatic function when it hung in the Bayreuth House of German Education, the central office of the National Socialist Teachers' Association. This association was entrusted with "sowing" the National Socialist philosophy.[105]

Fritz Mackensen's *Worpswede Madonna*[106] shows as early as 1914 that the theme of mother and child had acquired metaphysical status long before the Third Reich equated mother and child with a central "folkish substance." Graf Kalckreuth's painting *Summer*, which portrays a pregnant farm wife,[107] shows that the motif of the expectant mother in a natural setting also appeared early.

In conclusion we can say that the loss of contact with reality manifested itself in genre painting in two ways:

1. by adhering to the genre principle of immanence in spite of changed historical and social circumstances, and

2. by attempting, in reaction to changed historical and

Albin Egger-Lienz, *Life* (1912).

Albin Egger-Lienz, *Mountain
Farmers Mowing* (c. 1908).

social circumstances, to transcend immanence and reach the
absolute. If a sentimentalized, early nineteenth-century
representation of a farmer had already lost its justification,
then an attempt to reclaim justification by portraying a
farmer as a "symbol of primal forces" is all the more
doomed to failure. Adherence to the past takes on a note of
insistence and ultimately ends in gross distortion. Both
factors mentioned here—each by itself and each affecting
and intensifying the other—contribute to the rapid deterio-
ration of a positive relationship between art and reality.

An art that was increasingly antirealistic in form and
content, though at the same time highly representational,
was not the invention of institutionalized German fascism.
It was instead just as "fascistoid" as the powerful economic,
political, and cultural forces whose visual needs it had been
representing since long before World War I. But together
with these forces, it found its perfect political equivalent in
the Third Reich, as the biographies of individual artists
prove. R. Hamann and J. Hermand[108] have provided a
detailed account of these broad tendencies as they led up to
National Socialism in the cultural sector. What they describe
as the "nationalistically monumental phase" joined forces
with traditionalist genre painting after the assumption of
power in 1933 to form an unlimited monopoly and estab-
lished itself as a timeless and absolute form of art.

The Iconography of Work, Man, and Woman

Now, having established some of the general characteristics of National Socialist art, we will turn to a few central iconographies and develop a more detailed picture of "art in the Third Reich." Our subject will be the representation of work and of those who perform work. National Socialism prided itself on what it called its "reorganization of work" after it had succeeded in destroying the workers' movement and the old working-class parties. The question that follows from this and that we will seek to answer is how is work, as it relates to society and, of course, to the workers themselves, depicted in art? Also, what is the role of women as reflected in art? This inquiry will take us into a critique of ideology in a far broader sense of that term than has ever been attempted before.

Although work played a major role in the ideology of German fascism, and even though entire exhibitions were devoted to the theme of work, contemporary work—and industrial work in particular—was only rarely depicted in art. The preferred theme for art was the work of the farmer, whose ideological role we have already touched on. The farmer was not, of course, shown using a tractor, a combine, or a seeder, machinery without which agriculture under an autarchical aegis would be impossible. He is shown instead plowing with a team of horses, mowing with a scythe, and sowing by hand. The motto behind all such art is "The Tougher the Sod, the Brighter the Plowshare."[109]

The crafts are also preferred over industrial work as subjects for art. Weavers at hand looms, tinsmiths, and blacksmiths are depicted. Woodcutting is also an acceptable theme in art, but it too is portrayed in its more primitive stages; or, as in Sperl's *Clearing Land*, it is seen as nothing more than the hopeless physical drudgery of human beings pitted against impersonal nature.

And in those few cases when man's technical creativity and his ability to use that talent for transcending the given limits of the natural world appear as artistic themes, we do not see modern man himself in the process of changing the world. We see instead, as in Hans Adolf Bühler's *Wieland*, a naked figure from Germanic mythology. This kind of painting is not likely to convey the idea of productivity as a social force.[110] There are only a few paintings that concretely depict industrial work and human beings involved in that work. Most of them are in the tradition of Adolph Menzel's *Rolling Mill*, painted in the 1870s. One of the paintings that helped perpetuate this tradition was *In the*

Rolling Mill by the Düsseldorf artist Arthur Kampf. Kampf
made use of this same theme in another monumental paint-
ing that received considerable attention under National
Socialism.[111]

As we have noted before, however, industry as the scene
of anonymous production was a popular theme. In paintings
of this type the factory itself is the focal point, not the
people who work in it. They appear at best as a kind of
backdrop for the all-powerful machinery. Work, which in
reality cannot exist without workers, is thus equated with the
industrial plant and all distinctions dissolved. Another ex-
ample of this genre is the painted reportage of the most
spectacular activities of the Third Reich. Numerous scenes
at *Construction Sites* depicted major projects in the arms
industry and in the construction of public buildings, but
they did not as a rule show the activities of construction
workers themselves. Buildings seemed to spring up by them-
selves as if "at the Führer's command."

The approach is different in paintings of the stone
quarries from which the materials for major buildings were
extracted primarily by forced labor. The portrayal of the
suffering inherent in such work seems intended as a
deterrent and warning. Typical examples of this genre are
The Quarry by Albert Janesch,[112] *Marble for the Reich
Chancellery*[113] and *Granite Quarry Flossenbürg* by Erich
Mercker,[114] and, by Wilhelm Dachauer, *Granite Quarry at
Mauthausen*,[115] "where prisoners laden with heavy blocks of
stone were driven up and down the 186 steps every day."[116]
In this kind of "cultural work," which depended on the ex-
istence of the most infamous concentration camps and was
celebrated by painters as the basis for a *New German Archi-
tecture*,[117] the alliance between art and barbarity took its
most extreme form.

As a rule, however, work and workers were depicted
quite differently in the Third Reich. An example of this is
a painting by Hans Schmitz-Wiedenbrück, which was shown
at the Great German Art Exhibition in Munich in 1941 and
was frequently reproduced.[118] The painting is a triptych
titled *Workers, Farmers, and Soldiers*. A report in *Art in the
Third Reich* has this to say about the painting: "One of the
most impressive paintings in the exhibition is a large
triptych by Hans Schmitz-Wiedenbrück. The effectively
composed central panel showing members of all three
military branches and the side panels showing figures of
a farmer and of a worker movingly symbolize the spirit of
comradeship that joins all those who fight and work to-
gether in this war."[119]

The triad of worker, farmer, and soldier as equals in
social production is a frequent theme and could almost be
called a *topos* of National Socialist ideology. "In the flaming
blast furnaces, in the smoking chimneys of factories, and
in the roar of the shipyards, the artist sees the same national

will to life that, in other settings, animates the soldier in battle and the farmer behind the plow."[120] Or, as the same author wrote elsewhere: "The figure of the worker, which only in recent times, with the rise of the technological age, has emerged in our cultural history, has not taken on its sociological identity until now. The working man, degraded by Marxism into a rootless proletarian, has become, in the communal context of our nation, a soldier of technology who forges weapons for the fighting man at the front. The best substance of our race is embodied in him, just as it is in the farmer and in the soldier."[121]

Schmitz-Wiedenbrück's triptych reflects the same spirit as this quotation. It expresses the community of interests that unites the three groups depicted. These groups, in keeping with the ideology of a "national community," make equal contributions to the same common task, even though they work in different sectors.

The artist tries to demonstrate the equal share all three groups have in social production and the equal status of the three sectors by making all the figures the same size and by placing them on approximately the same level. Because of this, their heads are all at more or less the same height. Furthermore, the choice of the triptych as the form for this painting indicates that the picture means to express not only the equality of the three groups but also the idea that they embody "the best substance of our race." The triptych, borrowed as it is from the realm of religious painting, where it is associated with salvation and redemption, lends any subject rendered in this form the sacred aura of its origins.[122]

The worker, farmer, and soldier thus appear as an ennobled and sublime group not only because they represent three select callings among many others but because, to the extent that they express the "best substance of the race," they are emblems of the Germanic race itself. Anyone who belongs to this race, regardless of social status, partakes of a nobility that raises him high above other races both within Germany and beyond it. At a time of the crassest social inequality, the illusion of equality was to be imposed on the German people; and at the time of their deepest humiliation, a false image of their greatness and supremacy was to be awakened in them. This was a particularly vicious tactic that was to make the German people arrogant toward other "races" and incapable of solidarity with other nations.

At the same time that Schmitz-Wiedenbrück's painting emphasizes unity and equality, it also conveys strong indications of an obvious hierarchy within the community. The worker and the farmer are marginal figures in a literal and figurative sense, both because of their position on the sides of the picture and because of their relationship to the military troika to which they are subordinate and for which they provide a frame. The central panel in a triptych is

always the dominant one.

This dominance is further accentuated by another artistic device. The central group is thrown into still sharper relief by the clever and conscious use of a technique commonly used in art to evoke pathos, namely, the view from below. In discussing this technique, we may find it useful to refer to a painting with a similar triad in it, Johann Heinrich Füssli's *Oath at Rütli* from the year 1779.[123] This publicly commissioned painting is a typical expression of the revolutionary pathos of its time. In symbolizing not only the struggle against foreign rule but, above all, the people's liberation from tyranny, it strikes the same note as the somewhat later *Oath of the Horatii* by Jacques Louis David.[124] Füssli deliberately chose a perspective from below —the observer's point of view is on a level with the floor of the painting—to foreshorten the upper bodies of the figures and lengthen their lower extremities. This gives the picture its characteristic dynamic quality, which seems to lift the figures from the floor, thus creating the impression of invincibility and triumph.

Schmitz-Wiedenbrück's painting attempts to achieve the same effect, but the pathos it conveys is no longer a revolutionary one. It is instead a signal of counterrevolution. The perspective from below as it is used in figure painting is taken from the techniques used since the Renaissance in drawing classical statuary. Since these statues were usually mounted on pedestals it was inevitable that they were seen and drawn from below. The resulting naturalistic effect was no more than a consequence of the fact that the artist was positioned at the feet of the statue and had to look up at it. However, the Renaissance worship of classical art added an overlay of the sublime to this naturalistic effect. This perspective symbolized a view of antiquity that seemed, to the Renaissance, the only appropriate one.

From the many possible examples illustrating this perspective, we can single out Hendrik Goltzius's *Hercules Farnese*. The observer looks up at the statue from the same level as the two figures shown in the picture.[125] The perspective from below was later used primarily in illusionist wall and ceiling painting, but wherever it continued to appear on canvases it retained an element of its original use in depicting statuary. It places the observer at the feet of the painted figures, which then appear to rise monumentally above him. Schmitz-Wiedenbrück's *Soldiers* are placed on a rise in such a way that their boots appear to be at the eye level of the observer. This is, of course, an accurate reflection of fascist reality in the sense that a kick in the face is a constant threat.

In keeping with this statuary iconography, the perspective from below has still further implications. The figures are not shown in realistic or realizable actions. Instead, they pose like isolated figures of statuary that never seem

Joh. Heinrich Füssli, Sketch for the *Oath at Rütli* (1779), Zurich, Kunsthaus.

Hendrik Goltzius, *Hercules Farnese* (1617).

to function within a coherent, artistically created system of reality but exist only in relation to something outside themselves and for observers looking up at them. Like statues, the *Soldiers* give the impression of not being subject to external, objective circumstances but of determining those circumstances themselves. Or, as National Socialist jargon would express it: They act out of their own inner law and rule by virtue of their inborn superiority.

The panels of the triptych portraying the worker and the farmer invite a totally different interpretation. Here the point of view lies much higher, almost exactly on a level with the faces of the figures. While the military figures look out over the observer's head, the worker and the farmer look the observer directly in the eye. The figures and the observer move, as it were, on the same level. The heroic, autonomous pose that results in part from the perspective from below is lacking in the portrayal of the worker and farmer.

Still another difference—either intended or accidental—can be found in the racial characterizations shown in the different panels. According to the "racial scholar" Günther,[126] the middle group is purely "Nordic." The worker, however, shown as "a passive, obedient subject," is of an "East Germanic" type; and the farmer represents a "Phalian" type that is "lethargic in both psychic and physical makeup." A comparison of the physiognomies in the painting with Günther's photographic illustrations of these types makes this clear. The worker and the farmer are better suited to work; the Nordic types, however, are cut out for leadership.

It is also obvious that the depiction of the worker and the farmer, though not naturalistic, at least draws on elements of the empirical world. It is conceivable that a miner or farmer might actually assume the postures Schmitz-Wiedenbrück has given them.

The picture attempts to demonstrate "national unity" by showing the racial equality of the figures in it, but this message is overshadowed by an obvious display of the soldiers' claim to leadership. This claim places the marginal figures of the worker and farmer on a plane with the "compatriots" viewing the painting. The painting is not only a description of National Socialist ideology. Its imminent clues to social identification also convey directly to the viewing public—constantly threatened by the fascist boot—what its role is.

But the painting reveals even more. We have already seen that the central group is shown in a quasi-autonomous and completely unreal pose. By contrast, the marginal figures display at least some relation to empirical reality. But in terms of the clothing, tools, and equipment shown, just the opposite is true. The personifications of the three military branches—army, navy, and air force—are accurate down to the last detail and can be precisely dated as phenomena

of their immediate present. They accurately represent the state of military technology in the 1940s. This is particularly true of the pilot who represents the most modern military branch and whose equipment is shown in minute detail. The worker and the farmer, however, seem timeless and removed from the concrete present. The way they are portrayed bears no relation to actual methods of production. No farmer at that time went barefoot and led his bull, arm in arm, as it were, to water; and no miner used a pick instead of a jackhammer. The full extent of the worker's and farmer's present productivity is not shown, but the full extent of the military's destructive capacity is.

The temporal discrepancy between painting and reality that characterizes all National Socialist art lies at the very heart of this painting. This dual temporal perspective tries to convince the observer that work and the conditions in which it is performed—the conditions under which the worker lives—are permanent and unchanging, that progress has no place in the social conditions of work, that no improvement in the means of production is possible, and that the worker can produce more only by working *longer*, not *differently*. The exploiter's principle is symbolized by showing that he disposes over all the inventions of modern technology. Political domination and the means of maintaining it cannot be obsolete in any way. Progress in this area keeps pace with the acceleration of exploitation.

The productive spheres of the worker and farmer could not be denied. The worker and the farmer produce the entire social wealth, the basis for all social activities and advances. But they do not appear in the center of this triptych and do not assume the central place they in fact have in society. They merely provide a framework. We have to ask, "A framework for what?" They are the suppliers, and here we have to ask, "For whom?"

In this painting the worker and farmer flank and supply the three military men who carry a flag with a swastika on it. This represents reality in a very concrete sense. These three military figures represent the arms industry and the military. As such they are socially unproductive and consume the social wealth that the worker and the farmer produce. They are the worker's and farmer's exact opposite, for what one group produces, the other uses up and destroys.

This is an unspecific and general statement, but in the context of German fascism, it has further implications. Posing in the center of the triptych, the military figures are presented as the sole reason and purpose of production. They embody the principle behind the waste and destruction of the social product. Their autonomous pose, borrowed from monumental statuary, lets them appear immune to all the circumstances of real life. In this, they symbolize a principle, not just a situation. Not the slightest detail sug-

gests that they are waging a justified defensive war. On the contrary, they are the picture of aggression. They are conquerors carrying their flag into foreign territory. They have overrun the defensive positions of the enemy; we see the remnants of barbed-wire barricades in the background.

The picture makes it clear that these military figures symbolize a principle that has been declared the motivation and purpose of production. The painting refers less to the concrete war that was raging at the time the picture was made and that could be seen as underlying the formulation of the painting, than it does to the "order" of society *per se* as defined by National Socialism.

The aspects of fascist ideology that have already become apparent in our analysis also take cosmological form in visual allusions to the "eternal" immanence of the four elements. The explicit depiction of these elements was a favorite theme in the Third Reich. The three branches of the military "naturally" embody the elements of water, air, and earth; and these same elements are essential to the work of the miner and farmer as well. Fire, too, "resides in the earth." It glows in the miner's lamp, is latent in coal —which is needed for steel production—and, finally, takes the form of firepower in military offensives. The cosmos of the four elements is supposed to symbolize the cosmos of the National Socialist production system.

As a National Socialist writer put it, "The working man has become, in the communal context of our nation, a soldier of technology." To the extent that his work supports the arms build-up and war, he has to become a "soldier" and take his place in the army of the "folk community." As a "soldier," he has to "serve" without any claim to wages proportional to his contribution. He has lost the freedom to move about at will and to enter into contracts. He receives commands he has to obey. He is a forced laborer without any rights. His sole purpose in life is to serve a government that is not in any way limited by the demands and rights of the working force. In short, he serves capital, which is in league with the NSDAP, and the maximal accumulation of capital.

To obscure the social difference between work, which creates value, and capital, which appropriates value, a value *per se* was attributed to work. The worker was to be satisfied with the enjoyment of value *per se* that work provided him; the entrepreneur was to be satisfied with surplus value. Work was elevated to a value *per se* not *in spite of* but *because of* the fact that it produced surplus value.

The organization book of the NSDAP states:

The fact that a worker in a community works for Germany without being paid for this work teaches him that the true meaning of work does not lie in the wages

that it brings him but in the spirit in which it is done. The elevation of work to the status of service teaches him that work is not a curse but an honor. He also comes to see that mental and physical work are not at odds but that the value of work is determined instead by the inner attitude with which it is performed. Therefore, the main elements of education for the Work Corps are a military bearing, a closeness to the soil, a positive attitude toward work, and a communal spirit.[127]

The workers' role in work *per se* is most forcefully expressed in Ferdinand Staeger's *sursum corda, We Are the Work Soldiers*. These soldiers are "representatives of a socialism that honors work by having every young man begin his adult male life with a shovel in his hand."[128] Precisely because work was a value *per se* but at the same time had to create total surplus value, it had to be organized along military lines and "kept in step." Another picture by Staeger, titled *Political Front—Impressions of the Party's Day of Honor, Nuremberg, 1936*, places the workers' "front," the Reich Work Corps, far behind the military and party units. This entire painting is dominated by monumentally rigid armies that swallow up the major portion of the nation's wealth.[129]

A year after his triptych *Workers, Farmers, and Soldiers*, Hans Schmitz-Wiedenbrück again presented this same theme at the Great German Art Exhibition of 1942.[130] Capitalizing on the success of the previous year's triptych, Schmitz-Wiedenbrück initiated a genre in this vein. A number of genres originated in this way. In this second work, Schmitz-Wiedenbrück intensifies even more his presentation of cynical ideologies.

A contemporary description of this painting reads:

Probably the most striking work in its intellectual conception and composition is Schmitz-Wiedenbrück's *Nation at War*. In a stagelike foreground, we see, starting on the left, a monumental figure of an industrial worker. Behind him other workers are grouped. In the center foreground of the painting, a mother with her sleeping child is enthroned. In her hand, she holds a military post office letter, which symbolizes the link that fate has created between the front and the homeland. North German farmers and, between foreground and background, a miner holding his lamp and standing on blackened earth fill out the picture of the home front. In the background, soldiers on foot and on horseback pass by in visionary form, their columns overarched by a rainbow.[131]

This painting is not a triptych, but the composition is tripartite nonetheless. Here, however, the soldiers have been taken out of the center and are used as a background for the

Hans Adolf Bühler, *Wieland*.

Oskar Martin-Amorbach, *Out to Harvest*.

Carl Baum, *Rider*.

Carl Baum,
Plowers.

Johann
Vinzenz Cissarz,
Farmer Plowing.

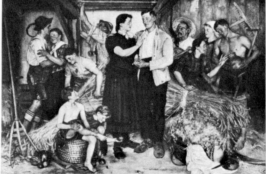

Sepp Hilz, *Farm Trilogy—Servant Girls, Cornucopia, Hired Hands.*

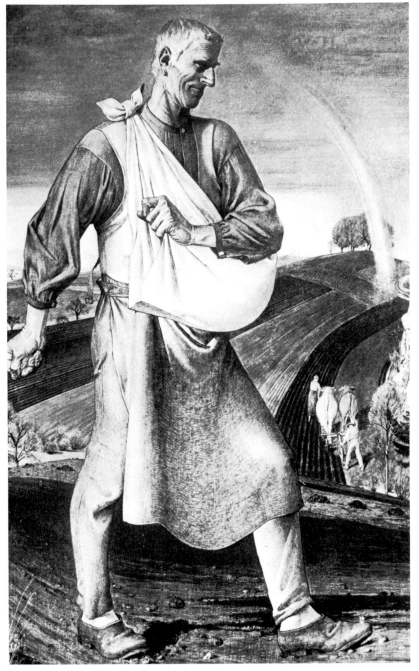

Oskar Martin-Amorbach, *The Sower*.

Hans Schrödter,
Wood Cutters.

Franz Eichhorst, *Man with Backpack.*

Hans Jakob Mann, *Weavers.*

Elisabeth Voigt, *Spinning Room.*

Anton Kürmaier,
The Shoemaker.

Hans Steiner, *A Sampling from the Blast Furnace.*

Arthur Kampf, *In the Rolling Mill.*

Arthur Kampf,
Rolling Mill.

Erich Merker, *Autobahn Bridge at Teufelstal.*

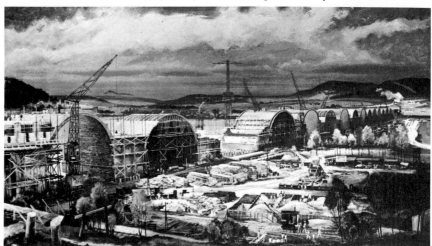

Carl Theodor Protzen, *Construction of the Reich
Autobahn Bridge at Jena.*

Wilhelm Dachauer, *Granite Quarry in Mauthausen.*

Hans Schmitz-Wiedenbrück, *Workers, Farmers, and Soldiers.*

Albert Janesch, *The Stone Quarry.*

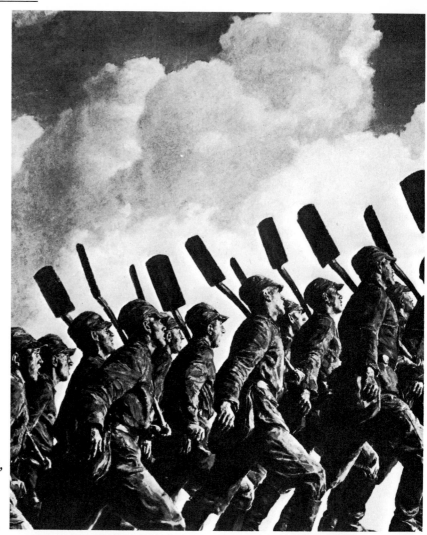

Ferdinand Staeger,
*We are the Work
Soldiers* (title
supplied by the painter
in 1974: Work Corps).

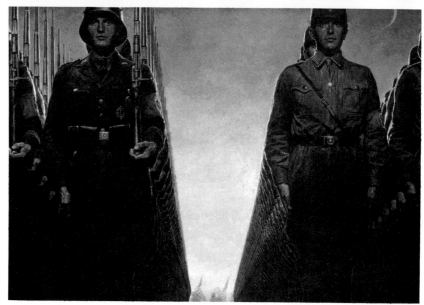

Ferdinand Staeger,
*Political Front—
Impressions of the
Party's Day of Honor,
Nuremberg, 1936* (title
supplied by the painter
in 1974: *The Front*).

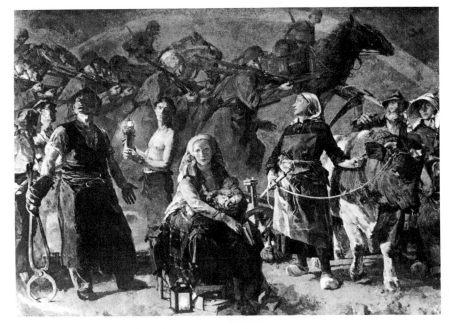

Hans Schmitz-
Wiedenbrück, *Nation
at War*.

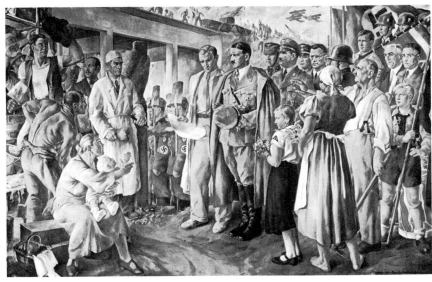

Georg Poppe,
*Portrait of the
Führer in the Frank-
furt Physicians'
Corporation.*

Franz Eichhorst, Front Wall, Murals in the Berlin-Schöneberg City Hall.

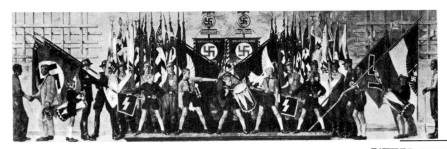

127

Franz Eichhorst,
Workers.

Franz Eichhorst,
Farmer and *Farewell*.

Franz Eichhorst,
Tank Defense.

Franz Eichhorst,
Machine Gun Nest.

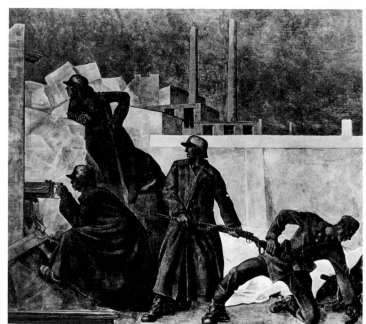

Franz Eichhorst,
Street Fighting.

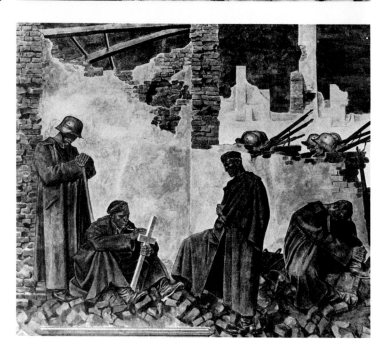

Franz Eichhorst,
Retreat.

Artnur Ressel, *Expectant Mother.*

Richard Heymann,
In Good Hands.

Erich Erler,
Blood and Soil.

Johann Vinzenz Cissarz, *Time of Ripeness.*

Karl Diebitsch, *Mother.*

Richard Heymann, *The Heir.*

Heinrich Eduard
Linde-Walther, *Motherliness.*

Richard Heymann, *Ripe Fruit*.

Sepp Hilz, *Peasant Bride*.

Fritz Burmann, *Looking out to Sea*.

Johannes Beutner, *Time of Ripeness.*

Wolfgang Willrich,
Blessings of the Earth.

Wilhelm Hempfing, *Summer.*

Ivo Saliger, *Mars and Venus*.

Josef Pieper, *Europa*.

Karl Schuster-Winkelhof, *Europa*.

Otto Roloff, *Leda.*

Ivo Saliger, *Leda.*

Paul Mathias Padua, *Leda and the Swan*.

Karl Ziegler, *Leda*.

Adolf Ziegler, *Judgment of Paris*.

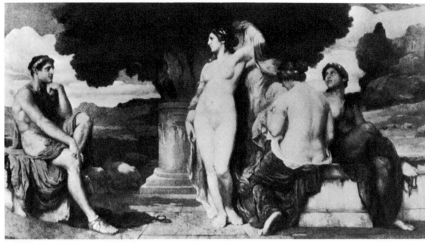

Georg Friedrich,
Judgment of Paris.

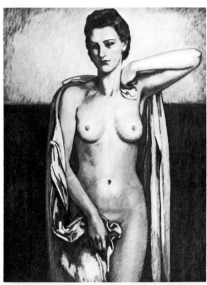

Ernst Liebermann, *The Slave.*

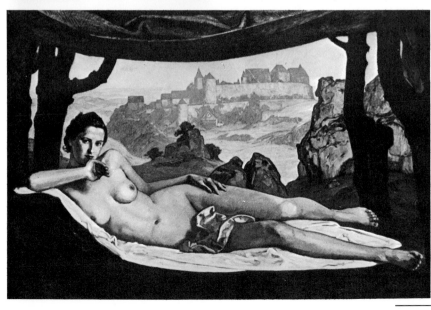

Ernst Liebermann,
Lonely Heights.

Robert Schwarz,
Swimmer.

Johannes Beutner,
Pause during the Harvest.

Sepp Hilz, *Peasant Venus.*

Oskar
Martin-Amorbach,
Peasant Grace.

Raffael Schuster-Woldan, *Reclining Nude*. Hanns Hanner, *Sisters*.

Ernst Zoberbier, *The Tides*.

Ernst
Liebermann,
By the Water.

Johann Schult,
Expectation.

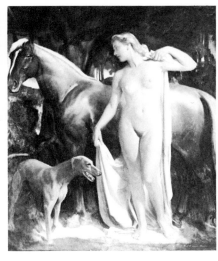

Carl Josef
Bauer-Riedeck,
Bathing Amazon.

Ernst Liebermann, *The Three Graces.*

Arthur
Kampf, *Venus
and Adonis.*

143

Georg Emig, *Diana Resting*.

Wilhelm Hempfing, *Youth*.

Ivo Saliger, *Bath of Diana.*

Georg Siebert,
Young Seafarers.

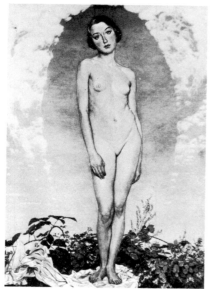

Hanns Hanner, *Girlhood.*

Emil Dielmann,
Hitler Lad.

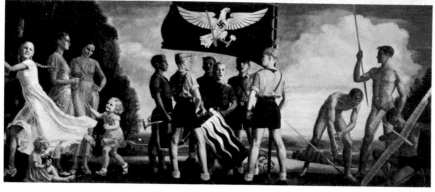

Jürgen Wegener,
German Youth
(Weimar County
Building).

Robert Gottschalk, *Children at Play*.

Walter Hartmann, *After Work*.

Harold Bengen, *Shepherd Girl*.

Anton Hackenbroich, *New Youth*.

Leopold Schmutzler, *Farm Girls Returning from the Fields*.

production sphere. They are again shown in realistic detail, but their symbolic force here is, if anything, intensified. Under the all-encompassing arch of a cosmic rainbow, they make up the horizon of all social existence and activity. They are the beginning and the end of the social world. This column of soldiers makes it impossible to conceive of a concrete situation that had a beginning and will have an end. The friezelike conception transforms the dynamic of the military column into timelessness, into a limitless "Thousand Years" in which all social dynamic will be excluded and only the dynamic of capital will prevail. Once again, work is linked with this vision and subordinated to it. In addition to the already familiar personifications of the farmer and the miner, there is a steel worker, whose presence makes still clearer the orientation of production and economy to the arms industry. Like saints in a Baroque altar, these figures, too, seem to participate in a miracle of salvation, and their faces show the same expression of ecstatic transport.

But in the midst of the productive workers—and this is a new feature the triptych did not have—a mother and her child are "enthroned." The allusion to the Madonna is obvious and lends the painting the aura of a *sacra conversazione*. The mother's presence in the production sector ennobles work and the working force by linking them to the "natural order" and suggesting that they too, like her, are blessed, sanctified, and fruitful. As the "guardian of the species," she guarantees that social conditions will remain "in order," just as they are, and will continue to reproduce themselves. The empirical reality of woman's social function, however, was in total contrast to this practically autonomous and sacred image and is a logical and complementary extension of the "image of woman" proclaimed by German fascism. In the government's program, it was woman's task to produce, with her own body, the manpower the National Socialist order would consume in both war and forced labor, the ends of which were frenetic accumulation. In her role as a National Socialist "mother of God" and reduced to total heteronomy and humiliation, she gives birth to a redeemer whose sole mission is the "redemption" of capital from its rampant crises of reproduction. She is so completely integrated into the order which she supposedly creates that she must already know, holding her husband's letter from the front in her hand, what fate is in store for her child.

The same components appear in Georg Poppe's *Portrait of the Führer* for the headquarters of the Frankfurt Physicians' Corporation (*Frankfurter Ärztehaus*). In this painting, the farmers, soldiers, and the mother and child are joined by professionals and academics. The "workers of the mind" portrayed here, presumably the patrons who commissioned this monstrous painting, are recognizable by their

fancy suits and their dueling scars.

Franz Eichhorst's murals in the banquet hall of the Schöneberg City Hall in Berlin attempt a similar synthesis. These murals are made up of individual scenes from the history of the preceding twenty-five years and culminate "in a kind of apotheosis" of the symbols of the Reich: militarized work, war, and the future generations that will carry them on.[132]

The iconography of work in the Third Reich has led us to the iconography of woman. As early as 1932, Hitler had outlined the social role and duties of woman as they would later be openly portrayed in art.

> Woman is by nature and fate man's companion for life. Man and woman are not only comrades for life but also comrades in work. Just as economic evolution over milennia has altered man's sphere of work, it has necessarily altered woman's field of activity as well. Above and beyond the need for common work stands the duty man and woman share in maintaining the human race. In this most noble mission of the sexes we find the roots of their special gifts that Providence in its eternal wisdom has granted them for all time. It is therefore our highest task to enable two companions for life and comrades in work to form a family. The ultimate destruction of the family would mean the end of all higher forms of human life. However broadly we may define woman's fields of activity, the raising of a family will always be the central goal of her organic and logical development. The family is the smallest but the most precious unit in the entire structure of the state. Work is honor for both man and woman, but a child ennobles the mother.[133]

The National Socialist organization of work, accompanied by ideologies of this kind, inevitably produced this social role and image for woman. The functionalizing of woman both physically and psychically and her sacrifice to purely utilitarian interests resulted in a specific socio-psychological constellation between the sexes. Because of woman's high degree of alienation, man could compensate for the loss of his own identity by dominating her. Women were forced into a role that robbed them of solidarity with men (including their own husbands) and thus destroyed the possibility of solidarity for an entire oppressed population. Man as worker—degraded to an object to be used in the realization of National Socialist goals—regenerated his self-esteem by, in turn, making woman an object. He was allowed and encouraged to do this.

It was woman's job to internalize men's desires. The following ad from a "personals" column in a newspaper is a good example of this. "Purely Aryan doctor, 52, veteran of Tannenberg, with domestic intentions wants male descendants from a marriage with a healthy, purely Aryan, virginal,

young, undemanding, frugal woman able to do hard work, wearing flat heels, no earrings, preferably without money. No intermediaries, confidentiality assured. Responses to AEH 151094 c/o M. Neueste N."[134]

Gerda Bormann's response was exemplary when she heard from her husband, the Reich Director of the NSDAP, that he had finally succeeded in seducing the actress "M." She hastened to reassure him: "Of course I'm not angry with either of you, nor am I jealous. You were simply overcome, just as you are often seized by an idea or a desire and then carry it out in your impetuous, resolute way. . . . I only worry that you might have upset the poor girl with your impulsive manner (at least at first). . . . So very few worthy men are surviving this fateful struggle. So many worthy women are condemned to childlessness because the men destined to be their partners died on the field of battle. Must this be? We need the children of these women!"[135]

In addition to the "frugal wife" with "flat heels," another complementary type of woman was needed to satisfy the "desire" that occasionally overcame men, as it did the Reich Director of the NSDAP. "Since millions of German men spent far more time in the barracks than with their families the state showed a ready willingsness to promote *ad hoc* sexual relationships." This willingness extended far enough to prompt changes in marriage laws.[136]

The false morality of early German fascism deteriorated increasingly after the beginning of the war.[137] Once again it was Hitler himself who sanctioned this changed morality: "If a German man must be ready to die unconditionally, he must have the unconditional freedom to love. Love and battle belong together. The civilian should be grateful to get what's left over."[138]

These attitudes obviously affected the image of woman as it developed in art. The iconography of woman in the Third Reich expressed itself in a visualization, created by men and for men, of their sanctioned sexual domination. The image of woman presented in painting, literature, and film degraded her and relegated her to a permanent position of servitude.

The most common theme in the painting of women was motherhood and its product: *Mother* (K. Diebitsch); *Motherliness* (Heinr. Eduard Linde-Walter); *Guardian of the Race* (Wolfgang Willrich); and *The Heir* (Richard Heymann). Another favorite theme is the portrayal of women in the stage of "ripeness" that precedes motherhood and is so provocative to men. *Time of Ripeness* (Johannes Beutner); *Ripe Fruit* (Richard Heymann); and *Summer* (Wilhelm Hempfing) all show women ripe to be picked and consumed.[139]

The image of woman became crasser still as nude painting gained in popularity. Impressionism had been accused of "showing the human body without any deeper interest in

the human being, of presenting only a superficial visual experience."[140] The National Socialist artist, on the other hand, focused on "perfect forms, on pure configurations of limbs, on glowing skin, on innate harmony of movement, on obvious reserves of vitality"—the National Socialist artist was interested in blatant prostitution.

The National Socialists pretended to give back to woman the dignity that she had lost in the years before their assumption of power. Schultze-Naumburg describes this situation as follows:

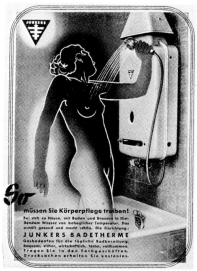

> Woman has probably never been depicted so disrespect-fully and in so unappetizing a way as in the paintings we have been obliged to put up with in German ex-hibits of the last twelve years, paintings that inspire only nausea and disgust. They convey not the slightest trace of the sacredness of the human body or of the glory of a divine nakedness. They express a ravening lasciviousness that sees the nude only as an undressed human being in its lowest form.[141]

The "unappetizing" quality that the author tries to ascribe to works by Rouault, Chagall, and Kokoschka reflects the deformity of social classes that have never had anything else to sell but themselves—their physical strength or their service. "Ravening lasciviousness" has to be sought else-where. It is not present in the works of these painters, nor do their works awaken it. An "appetizing" quality, presented in a truly "disrespectful" way, is, however, the main concern of the National Socialist painter of nudes.

This freshly scrubbed "appetizing" quality also occurs in numerous advertisements. Flirtatious girls, always different yet always the same, splash about in ads for Junker gas hot-water heaters. The men provoked by these visions are often not able to display their potency and act out the roles assigned to them. They adopt Zeus's tactics and, disguised in the form of a bull, a swan, etc., pursue their victims. Particularly popular themes of this kind were *Europa* (Werner Peiner, Karl Schuster-Winkelhof, Josef Pieper) and *Leda* (Otto Roloff, Karl Ziegler, Paul Mathias Padua, Ivo Saliger, and Josef Thorak). These are all paintings that imitate in the most general way the iconographies and formulations of the Renaissance and Baroque. But in those periods, art of this kind had a different function in the world of the courts, which had no contact with the common people, than it did in the age of public exhibits and mass reproduction.

This kind of repressive social hygiene in the relation of the sexes is most obvious in a specific iconography that was hardly new but that acquired new popularity in the Third Reich. This is the judgment of Paris, a theme that occurred in the visual arts of the Third Reich with remarkable fre-quency. The judgment of Paris is an episode from the events

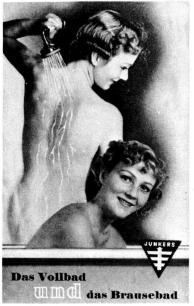

Advertisement for Junker's gas water-heaters.

leading up to the Trojan War. The three goddesses Hera, Athene, and Aphrodite disagreed on which of them was the most beautiful. They chose the Trojan prince Paris as a judge; and Paris, after hearing from each contestant what reward she would give him if she were chosen the winner, decided in favor of Aphrodite, who promised him possession of the Spartan queen, Helen, the most beautiful of mortals.

In the myth, the competing goddesses submit themselves only to the *judgment* of this man, who is, after all, only a mortal. But in the development this episode underwent in the history of art, the motif changed from one of mere judgment to one of *choice*. The reward for making a choice now seemed to be the enjoyment of the winner chosen, not the promise of a fourth woman not even present.

It is not our intention here to study the entire iconography of the judgment of Paris in the various renderings of it from Lucas Cranach to Rubens, Raffael Mengs, and on up to the present. But we do have to note the surprising proliferation of this theme in the late nineteenth century when it became the subject of paintings by Anselm Feuerbach (Kunsthalle, Hamburg); Hans von Marées (formerly Nationalgalerie, Berlin); Max Klinger (Moderne Galerie, Vienna); Albert von Keller (Städtische Galerie, Munich); Lovis Corinth (Staatliche Gemäldegalerie, Dresden); and others. The essentially narrative, pictorial, and mythological conception that dominated the Baroque tradition and that is still present in Feuerbach underwent a number of changes. Marées's rendering shows an ensemble of figures that reflect, and subordinate themselves to, the artist's formal interests, which force the content of the story into the background. Klinger's version focuses again on content, injecting the theme of a confrontation between the sexes into it. Finally, Keller's painting makes the episode into a kind of musical comedy scene in which feminine coquetry is used to woo Paris.

In general, the man assumes an increasingly important role in the paintings. He seems gradually to become the sole motivation for the offering of feminine charms, the

Anselm Feuerbach,
Judgment of Paris (1870),
Hamburg, Kunsthalle.

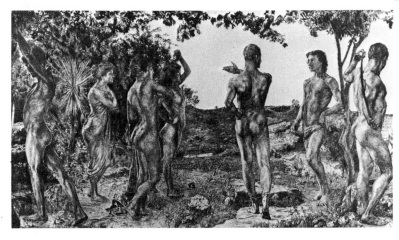

Otto Greiner,
Judgment of Paris (1892).

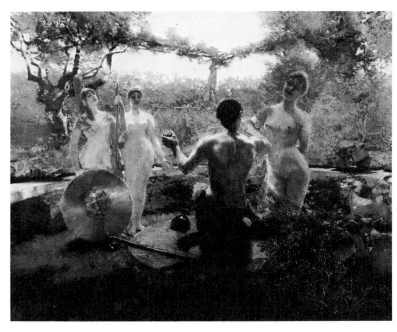

Albert von Keller,
Judgment of Paris (c.1891),
Städtische Galerie, Munich.

object of the female figures' courting. The women become increasingly and more exclusively oriented to the assumed desires of the man and finally seem intent on nothing but satisfying those desires. They hope to please him no matter what angle they present to him. This approach is most obvious in Makart's *Five Senses*, a group of paintings that lies beyond the range of our immediate discussion but in which five paintings show a female body from five different angles as it turns on its own axis.[142] The voyeuristic element peculiar to painting of this period is not one internal to the paintings but one generated in the observer as he contemplates the nude figures. The role of Paris is delegated to the observer.

Fin de siècle painting still granted woman the rudiments of sensual power in depicting her coquetry and the exag-

Hans Makart,
The Five Senses (1872–78),
Österreichische Galerie,
Vienna.

gerated display of the weapons of her sex. But the "goddesses" of Ivo Saliger, Adolf Ziegler, and Georg Friedrich are passive creatures that wait submissively to be taken. They do not seem to believe in themselves enough to think they might be able to influence Paris's decision. Even taken together, the three of them do not seem to be a match for the gaze of the man who looks at them more as a cattle dealer than as a lover would. They seem completely subject to his whim. In earlier versions of this painting, they represented a selection of female types vying for the man's attention. Now, he seems to possess them all, and they are merely waiting for him to make use of them.

The relationship between man and woman as it was expressed in paintings of the judgment of Paris in the nineteenth century could still be conceived of as a visualization of the relationship between buyer and seller of labor. But under German fascism hardly anyone was able to sell labor freely. Freedom of contract and the bourgeois principle of the equivalence of work and wages had been annulled, as we have seen elsewhere. Consequently, the seller's counterpart can no longer be called a buyer. In National Socialism, the relationship between paid labor and capital was infused with terror, and this same terror extended to the relationship between men and women. This does not mean that man as such became the exploiter of woman but only that the device of male "leadership" made the extreme exploitation of both sexes possible. The "Paris" of National Socialist painting shows no sign of enjoying what he is doing. The

terrorist principle to which he himself is subject affects his own attitude toward the goddesses.

The three goddesses seem to know that they are completely at the mercy of the man. Their timid gestures betray hardly a trace of hope that their complaisance will awaken even the faintest spark of love in their master. Thorak's sculptural group on the same theme makes their situation even clearer: They are up against no more or less than the pure will to exploit. Artists did not hesitate to call a spade a spade. Ernst Liebermann's painting *The Slave* is a literal assessment of woman's situation.

Children—the products of the work imposed on women— are obliged to remain within the context of exploitation to which they owe their existence. National Socialist pictures of children show this clearly. In Jürgen Wegener's *German Youth*, which hung in the Weimar county hall,[143] the central figures are Hitler Youth members already performing paramilitary service. Adolescent boys and girls on either side of them face each other in a way that completely violates reality. The girls wear seductive garments reminiscent of the goddess Flora. The boys, except for the glider pilot, are completely naked. The Paris motif recurs in the javelin thrower and in his relationship to the trio of girls.

Children at play appear only in games of war and are never imagined in the process of positive socialization or

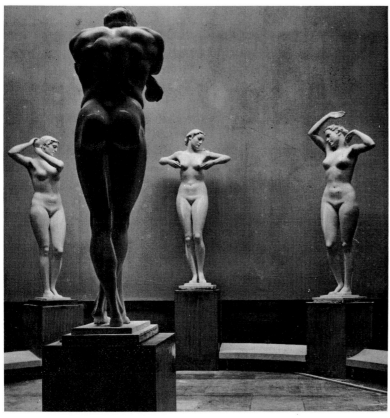

Josef Thorak,
Judgment of Paris (1941).

education. Emil Dielmann's *Hitler Lad* stands by a Christmas tree, giving the National Socialist salute to the toy soldiers of the SA units passing by at his feet. A drum, a trumpet, a swastika, and a tank fill out a picture that accurately predicts the fate in store for this generation. In only a few years these boys will be trained and ready to do their part in the Work Corps or war, thus realizing the potential ascribed to them.[144]

National Socialist Allegory and Elitist Aesthetics

Now that we have done a structural analysis of two aspects of National Socialist painting and subjected specific facets of it to ideological critique, we will move on to a third phase in our discussion. Here we will study another mode of National Socialist painting, one that did not present its subject matter in a traditionally "natural" way or with an overlay of "substance," but that nearly obliterated its obvious meaning by a complete allegorization and mystification of it. If art no longer conveys easily perceptible content—no matter how ideologically colored that content may be—but is not abstract, then we are dealing with still another phenomenon in the sociology of art.

In this third mode, "National Socialist art, which makes a passionate appeal to the people,"[145] proves once more how much scorn and contempt it actually had for the people. While modern art was reproached with despising the masses and pandering to the overrefined palates of "rootless" individuals, the allegorical and historical painting of National Socialism, in its turn, appealed ultimately only to the narrow-minded intelligentsia of the ruling cliques. Oversized and ambitious paintings of obscure and impenetrable themes made no other appeal to the people than to convince them of their own stupidity and to intimidate them.

At the same time, they provided the inhabitants of the offices and residences they decorated—this was the kind of "public display" for which they were usually intended—with the necessary sense of superiority that leadership positions required. They also provided National Socialist leaders with a profound trust in their own power to dispose over others. The new men—and many "old" ones along with them—saw themselves and their role reflected and confirmed in the mirror of a "new culture."[146] A report on the Great German Art Exhibition of 1943 says in this connection: "Here we see with particular clarity the tendency of the new German painting to break out of the narrow sphere of

satisfying individual aesthetic needs and to move into the broader, architectonic sphere of large rooms and spaces."[147]

As a rule these were commissioned works that depicted groups of people. The fact that paintings of this kind assumed an increasingly important place in exhibitions was explained very accurately as a result of "the sociological reordering of artistic life in our time." "The true and deeper explanation for this fact is that the commissioner or buyer of such a work represents a broader circle that wants to see certain demands fulfilled in art."[148]

From about the beginning of the war on, there was a movement away from the bourgeois system of genre painting, which by and large dominated the period of the Third Reich, and toward a style that we can only describe as *feudal*. This feudalistic streak has been noted and described in a great variety of National Socialist measures and institutions. It is most obvious in the legal redefinition of the relationship between "employer" and "employee" as one between "leader" and "follower," and in the transformation of wages—which, in their very nature, always reflect some degree of equivalence to work—into mere subsistence pay. In the visual arts, this feudal quality completely took over the field of architecture. In painting, it did not achieve such total control.

After the war had begun, an erosion of popular support for the regime set in and threatened to undermine its legitimacy. The government responded with increased terror directed at the masses and with an increased isolation of the ruling class in a clique that emphasized more than ever its heroic and mythical role. The new monumental iconographies are an outgrowth of this development. Their true role is evident in Raffael Schuster-Woldan's hybrid salon painting *Odi profanum*. The message comes through even clearer if we complete the Horatian line from which the title is taken: *Odi profanum vulgus et arceo* [I hate the common people and shun them].[149]

The "shunning of the common people"—the underlying motive and the ultimate goal of National Socialist policy and of the economic forces behind it—necessarily led to hatred once the end of the clique's rule was imminent. An iconography that glorifies war, soldiers, and death is the logical consequence of this idea, and implicit in this iconography is the destruction of the common people, who, according to Hitler's last assessment, "had failed the test of history and forfeited their right to a future existence."[150] Paintings like Hans Schmitz-Wiedenbrück's *Nation at War* and Oskar Martin-Amorbach's *They Carry Death with Them* speak an unambiguous language. Even before the war, artists were paying homage to this theme by retrospectives into history. Wilhelm Sauter's *Shrine of Heroes*[151] looks both to the past and to the future in portraying the dead and wounded of the First World War and of the Na-

tional Socialist "era of struggle." Lives sacrificed in the past were to justify a future sacrifice of lives in the process of realizing the "four-year plan" announced in 1936.

Not only soldiers but also German military equipment, like the destroyers sunk at Narvik, experienced an *Honorable End* (Eduard von Handel-Mazetti).[152] The common people, whom the National Socialist economy cheated out of the due of their work, were rewarded with cheap and posthumous "honor" when the war destroyed both them and their products. Typical of the cynicism the regime developed toward its own victims is the stylizing of the common soldier into a "Redeemer," as he is represented in a painting that shows a soldier, symbolic of all war victims, *Crucified* in a tangle of barbed wire and "crowned" with a loop of it.

In an effort to legitimize the present war, wars and battles were dredged up from the past. The knight in Rudolf Otto's painting *Ready for Battle*, wearing armor borrowed from Hans Thoma and conveying not the faintest spark of life, is grotesque and bombastic. The most spectacular example of this kind of art can be found in Werner Peiner's battle sequence on which the tapestries in the marble gallery of the New Reich Chancellery were modeled. As one writer put it, these tapestries were to embody "the triumphal theme of the great battles that have become milestones in German history, a theme that will proclaim the greatness and the heroic spirit of the Reich and of the political and spiritual rebirth of Germany."[153] The scenes depicted in the tapestries were the battle of the Teutoburg Forest, Heinrich I's battle against the Hungarians on the Unstrut, the siege of Marienburg in 1410, the battle against the Turks at Vienna in 1683, the battle of Kunersdorf in 1759, the battle of Leipzig in 1813, and the tank battle of Cambrai in 1917. Not only victories but also defeats, like that at Kunersdorf, were essential in this cycle. The Second World War was beginning when these tapestries were commissioned, and this war too would bring losses and make great demands on the nation's "spirit of sacrifice."

In his historical *excursus*, the reporter for *Die Kunst im Dritten Reich* emphasizes the feudal nature of this work and its commissioning. He welcomes the renewed interest in tapestry weaving, which he calls a "royal form of painting," and traces its history from the "courtly and aristocratic culture of the Middle Ages" to its "second flowering in the Baroque period" and on up to its

rise to the rank of monumental painting in the new Germany. In tapestry, the monumental art the nation had longed for for a century finally became reality. . . . Tapestry flowered in the past under the great art patrons. . . . Its present flowering is the work of the greatest art patron of all, the Führer. . . . In our public buildings, tapestry has been assigned tasks that far

exceed the scope of those it had in the Middle Ages and
in the Baroque period. Because the art of tapestry mak-
ing had suffered a long decline, painters had to turn to
the achievements of the past to rediscover the true
nature of monumental tapestry. In the Middle Ages, it
developed in a spiritual setting completely different
from that of the present.[154]

Never before National Socialism had comparable financial
means and political power been at the service of aesthetic
activity. This kind of support for the arts was possible be-
cause the benefits of labor did not accrue to the working
population either in the form of wages commensurate with
their contribution or in the form of goods that promoted
the well-being of the community. Instead the value created
by labor was accumulated by private individuals or con-
sumed by the state. The last time a similar situation had
existed in European history was under absolutism, but the
economy of that period was archaic in comparison to that
of the twentieth century. The differences in production
methods in these two periods made it possible for National
Socialism to see itself existing in a "completely different"
spiritual setting.

In an effort to legitimize annexations in the East, painters
took up the theme of historical "colonizations" from dif-
ferent phases in Germany's past. Hitler himself set the
tone: "Once long ago, German knights rode off to distant
lands to fight for the ideal of their faith. Today our soldiers
are fighting on the steppes of the East to preserve Europe
from devastation. Every single human life that is sacrificed
in this battle will make the life of future generations
safer."[155] Wilhelm Dohme's sgraffiti in the Braunschweig
"state cathedral" shows Henry the Lion and his knights

Hans Thoma,
Knight (1890).

and colonizers on their way eastward. One commentator writes: "Today we see in him a brave conqueror and far-sighted colonizer of a vast German *Lebensraum* in the East. Seven hundred and fifty years ago he began a work that Hitler is completing now."[156] Many murals exploit themes from history and sagas for National Socialist purposes. One example is Albert Burkart's Nibelungen cycle, which decorated the flag room of a military school[157] and was historical both in its subject matter and in its imitation of Simone Martini's style. Another example is Paul Bürck's Nibelungen frieze, executed in a brutalized version of Cornelius's style and located in the communal hall of the Düren metal works in Berlin.[158]

Along with themes of war and conquest, elaborate allegorical themes were developed to entertain the ruling classes and indulge their vanity, creating, as it were, a kind of casino atmosphere. Allegory, by stressing the government's alleged roots in a primal and essential substance, served to camouflage the irrational nature of that government. The subject matter was drawn from completely un-

Adolf Ziegler's *Four Elements* displayed in the sitting area in a living room of the Munich "Führer House."

real and nontemporal realms. The emphasis on the elemental forces is most obvious in paintings like Ziegler's *Four Elements*. The elements appeared not only in personified form, as in Ziegler's painting, but also in their "natural" manifestations. An example of this latter mode is Adolf Hildenbrand's four-part cycle depicting the four elements.[159] Carl Schwalbach's *Wise and Foolish Virgins*[160] projects "elemental" forces into anthropology.

Obliged to hide reality, the ruling classes fell back on allegory, and the desire to capitalize on this situation prompted many a painter to present strange ideas in even stranger forms. Thomas Baumgartner, who usually spe-

cialized in painting farmers, did *The Doctor's Battle with Death*.[161] There is no indication in the life-sized portrayal of the naked, sword-wielding hero of this painting as to what his profession is, nor do the victims being dragged off by death show any sign of the lethal diseases that killed them. The painting is a potpourri of grandiose elements borrowed from "more classical" works, primarily those of Ferdinand Hodler. A triptych by Friedrich Wilhelm Kalb hides the total unreality of its universal theme of "seeking, finding, losing" behind the personifications of *Daphne, Eros and Psyche, Eurydice*.[162] Kalb makes use of an esoteric visual language that is borrowed from the Pre-Raphaelites, in whose work it reflected the pleasure-oriented culture of the English upper classes in the nineteenth century.

In general, classical mythology, which lends itself readily to the depiction of beauty and nudity, was more popular as a source of subjects than was Germanic mythology, as represented by Georg Poppe's *Thor*. In the classical vein we find *Europa* on a bull (Josef Pieper),[163] and *Thetis* being carried through the waves on a horse (Hans Happ).[164] Diana is also shown in a number of settings and situations, such as *The Bath of Diana* (Ivo Saliger). *Diana after the Bath* (Hans List)[165] shows her pampered by her companions. In *The Start of the Hunt* (Karl Ziegler),[166] she is a dashing figure surrounded by purebred dogs. *Diana at Rest* (Ivo Saliger) and *Diana Asleep* (Paul M. Padua)[167] show her with the game she has shot. An *Aphrodite* (Oskar Graf),[168] silhouetted against sea and sky and placed among the remains of some Doric columns, is presented in a way that suggests that the Doric culture—and indeed all Greek culture—was of Germanic origin.

Pictures that often have classical labels but are nothing more than classical salon pieces belong in the same category. They usually depict erotic scenes that remain within the limits of German respectability only because they adhere to established pictorial traditions. A leading proponent of this kind of painting was Karl Truppe, whose Titianesque, Baroque compositions centered around the same theme regardless of whether they were called *Youth*,[169] *Bacchus and Ariadne*,[170] *Vanitas*,[171] *Vita vitrix*,[172] *Youth and Old Age*,[173] or simply *Nude Seen from the Rear*.[174] Pictures of this kind make concrete the *Dreams* (Franz Thiele)[175] of the petty bourgeois who had gained a position of power and respectability in National Socialism and who gave those dreams shape in art and thus realized them. In the early years of the Third Reich, themes and paintings like these, which were all too reminiscent of the sophisticated tastes of the nineteenth-century bourgeoisie, did not appear. As the National Socialist élites drew away from the people and entrusted control of the people more to their anonymous henchmen than to displays of their own persons in plebi-

DER FECHTER
von Ottmar Obermeier
aus der Porzellan-Manufaktur
Allach-München GmbH

Porcelain figure of a
fencer, Porcelain Works
SS Allach, Dachau.

Flemish (?), *Danae* (mid-seventeenth century),
Gemäldegalerie, Dresden.

Josef Vietze,
*SS Group Leader
Heydrich* (1941).

scitary spectaculars, they gave themselves up to luxury and
pleasure on a feudal scale. The folkish ideas now served
them only as an instrument for terrorizing the people, not as
a standard for their own behavior.

In this connection, we should note a certain atmosphere
reminiscent of Makart and his aesthetic ambience. Makart
had always been, along with Defregger and Grützner,
among Hitler's favorite painters. For Hitler during his
youth and for others like him, Makart had been the symbol
of unattainable social status and of a degree of comfort they
could not afford.[176] Nothing shows this more clearly than
the way leading National Socialists wanted to see their
wives and to have them painted. As a rule, these portraits
show no trace of the image of woman dictated by National
Socialist ideology. In these paintings, the specific National
Socialist typology in the form of a "BDM" girl (*Bund
Deutscher Mädchen*—League of German Girls), a "guardian
of the race," a heroine, or a Norn is never emphasized. The
image projected is that of a "lady." She is shown standing
or sitting, in either full or three-quarter figure, and wearing
a formal evening dress with decolleté.[177] This is the image
of woman that dominated in advertisements for champagne
during this period.[178] Here there is no attempt to reflect the
"eternal" values to which painting was supposed to lend
visual form. What is conveyed is a highly temporal desire
to enjoy unexpected and unearned privileges together with,
and in cultural imitation of, those who had always enjoyed
them.

This in effect answers the whole question of whether Na-
tional Socialist painting was "realistic" or not. Brecht
summed up the issue succinctly: "There are enough people
who rigorously and consistently oppose realism. The Fas-
cists, for example. It is in their interest that reality not be

shown as it is. And this is also in the interest of capitalism, even though capitalism is not as extreme in protecting this interest. George Grosz permitted himself almost as many formal liberties as Franz Marc did. Mr. Hitler rages over the fact that Marc's horses do not look like real horses, but he does not claim so loudly that Grosz's figures of the bourgeoisie do not appear as they do in reality."[179]

Metaphorically speaking, we could say that Hitler had to sacrifice Marc to eliminate Grosz. He could effectively combat Grosz's realism by attacking Marc's nonrealism. The Fascists then promoted "folkishness," but "the message was, as it were, passed down from above. It seems to call for the greatest possible simplification. Something for the people! Enough of this caviar! Something that the people, who are, after all, a bit thick, can understand. We all know the people are somewhat slow on the uptake. We have to give them what they're used to."[180] It was in this spirit that fascism restored genre painting. But it soon became obvious how great an effort was necessary to deny and eliminate every conceivable reflection of reality and history in art. Such a denial was called for by National Socialist art theory and was an inevitable consequence of the extreme need to legitimize the National Socialist regime. Popular appeal alone had long since ceased to be an effective means for visually enslaving the people.[181]

Painting had again taken up the role it had had in feudal society, a role Gehlen described as "ideational" and connotative. The nonconnotational "realistic" art that had been thrust into dominance by the "irrepressible energy of a preindustrial bourgeois society"[182] had long since degenerated and had given way to an innovative modern bourgeois mode of painting, not to a "post-bourgeois abstract" mode, as Gehlen thinks. Within a period of ten years, German fascism succeeded in reviving for its own purposes both the obsolete art of bourgeois genre painting and the opposing mode of feudal "ideational" painting. Both modes were so meaningless that the contradiction between them did not even become apparent. In the painting of the Third Reich, every positive tie to reality was destroyed.

We have already described the individual stages and forms this destruction took. Its purpose was to eliminate not only the realistic principle in art but also human consciousness about reality. Once an extreme distortion of the objective world had become "reality," the subjective world underwent a similar extreme distortion that made the perception of reality impossible.

In response to fascism and the relationship of its art to reality, discussion of a diametrically opposed relationship sprang up, a relationship that would, it was hoped, be able to expose the fascist position by the use of "realistic" means. Anti-fascist artists representing widely differing political and philosophical positions joined together under the banner

Advertisement for Matheus Müller champagne (1941).

Advertisement for Rosenthal porcelain (c. 1940).

Advertisement for Mercedes-Benz (c. 1940) with Josef Thorak's *Monument to Work on the Reich Autobahn*.

Advertisement for the spa at Bad Tölz.

of realism to invoke against fascism a truth that was not Schirach's. Fascist rule, totalitarian as it was, did not encompass the totality that art had been commissioned to project to the oppressed masses under the motto of "eternal truth." Totality could only be achieved in the struggle of those who opposed fascism and whose historical position and right to exist fascism tried to annul. Art in and by itself never encompasses totality in the way idealism insisted it should if it were to counter social alienation understood as "division." But art does approach totality and has a share in it when it works toward its political realization by engaging in the battle on the subjective side.

Finally, then, the relationship between realism and fascism must be understood as one whose dialectic lies in the extreme mobilization of all the forces necessary for the defense against and the destruction of fascism and in the imperative task of continually and indefatigably whetting on reality the cutting edge of art and its methods. This must be done both theoretically and practically—in short, "realistically." As long as there is social antagonism between individual nations and in the population of the world, this kind of realism will have its place and will need to make itself felt.

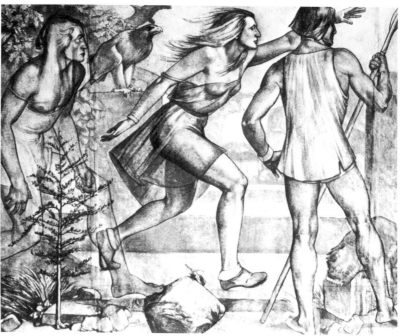

Paul Bürck, *Nibelungen Frieze* (Communal Room of the Düren Metal Works in Berlin).

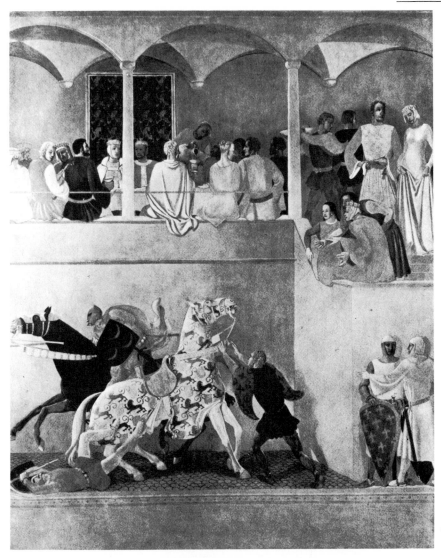

Albert Burkart,
Nibelungen Cycle
(Flag Room of an
air force academy).

Wilhelm Dohme,
*Settlers Presenting
Harvest Gifts of
Gratitude to Heinrich*
(Pattern for graffiti
in the Braunschweig
Cathedral).

Karl Truppe,
Joys of the Senses.

Karl Truppe, *Youth*.

Raffael Schuster-Woldan,
Odi profanum.

Wilhelm Dachauer,
Spring Visits the Land.

Hans Schlereth,
In the Fitting Room.

Gisbert Palmié,
The Rewards of Work.

Ferdinand
Staeger, *Mountain
Guard Duty* (title sup-
plied by the painter in
1974: *Border Guard*).

Carl Schwalbach,
*The Wise and the
Foolish Virgins.*

Fritz Erler,
Land (Mosaic in the
main hall of the Reich
Central Bank, Berlin).

Fritz Erler, *Sea*
(Mosaic in the main
hall of the Reich
Central Bank, Berlin).

Hans Toepper,
The People in Danger.

Art in the
Third Reich

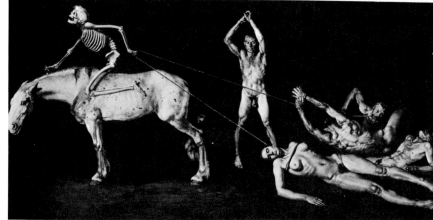

Thomas
Baumgartner,
*The Doctor's Battle
with Death.*

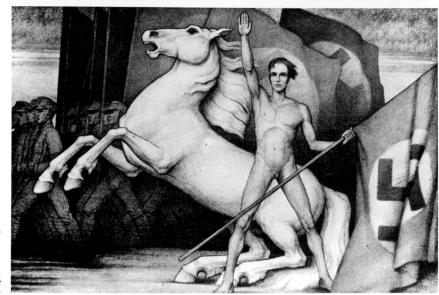

Walter Hoeck,
Young Germany
(Railroad station
waiting room,
Braunschweig).

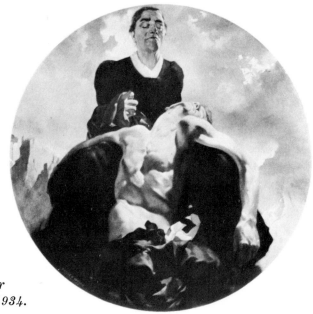

Heinrich Berann, *To Those Who Died for
the Austrian National Socialist Party in 1934.*

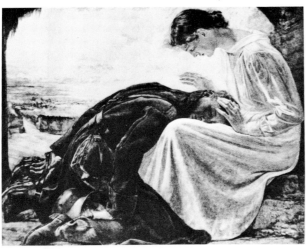

Hans Adolf Bühler, *Coming Home.*

Herbert Kampf,
Defender of the Flag.

Anonymous, *Crucified.*

Oskar Oestreicher,
Steeds of the Sea.

Rudolf Otto, *Armor*.

Wilhelm Petersen,
The Horseman of Valsgarde.

Wilhelm Sauter, *Bundschuh Captain Joss and His Peasants*.

Photography is relevant to our study in two respects, first, as a medium for presenting reproductions of artistic artifacts to a mass audience and, second, as an artistic medium in itself.

Whether we are justified in making such a sharp distinction between these two functions of photography, even for heuristic purposes, will only become clear after closer examination.

In turning to photography as an artistic product, we would expect to find that photography was assigned a low status because of the often noted excessive emphasis placed on the "substantial" concept of art in National Socialism. This does not apply, of course, to the significance and usefulness of photography as a tool of documentation, information, and propaganda. For these purposes, photography and motion pictures had been deliberately promoted and strategically employed. But as a branch of the visual arts, photography was recognized neither in practice—by accepting photographers as members of the Reich Chamber of the Visual Arts, for example—nor in theory. This represents, of course, an attack on the position that photography had won for itself and on the status it had been granted during the Weimar period.

In Baldur von Schirach's Vienna speech, which we have already quoted and which was meant to be a theoretical discussion of the distinction between truth and reality, color photography was disqualified as an artistic medium because, contrary to our expectations of art, it "adheres more rigorously than any other medium to the dogma that reality reflects truth"[183] and therefore shows a fundamental affinity to realism.

Art photography—we will exclude documentary photography and reportage from our discussion—could have a chance to be accepted only if it held to the requirements placed on painting and sculpture. It could not be "progressive," experimental, or "unfinished." Photography of this kind, like painting in a comparable vein, had a long tradition. Now this tradition became dominant in both fields. The results of numerous photography contests and the many volumes of photographs published in this period demonstrate this.

What was promoted and demanded was, as the phrase had it, "picturelike photography."[184] "Picturelike" means that the photographer had to select a perspective that produced an artistic composition in terms of traditional visual and artistic conventions. By the technical manipulation of lens openings (depth effects), exposure times (high-speed shots, blurring), and filters (contrast effects), photographers attempted to achieve the specific picturelike effects of painting.

Paradoxically, the very fact that photography and painting were regarded as fundamentally different resulted in

CHAPTER 6

PHOTOG-
RAPHY
AND THE
MASS
MEDIA

an obvious affinity in the way they were practiced under National Socialism. It is no coincidence that works of "art in the Third Reich" were felt to have, and described as having, the quality of "photographs" and that, conversely, the quality of "painting" was ascribed to photographs.

Because it was the duty of the painter to "ennoble" and "substantialize" his subject, whether that subject was a human being, an animal, a landscape, or an industrial scene, and because this obligation extended to the photographer as well, photography soon bore a close resemblance to painting. And because painting had been instructed to produce only "finished" and "unproblematic" work, it often took its orientation from trivial photography. Ultimately, the mode of presentation in the one field confirmed the mode of the other. A painting of a beautiful human being representative of the National Socialist racial ideal called for a photographic confirmation from reality. Conversely, the photographic image of such a human being required confirmation of its ideal nature in the medium of art. In this way, the ball could be kept bouncing back and forth between the real, which was photography's field of competence, and the ideal, which was the realm of art, as need arose.

The filmmaker Leni Riefenstahl seems to have been the first to have realized this double effect in a mass medium and on a monumental scale. In her film of the Olympic Games in Berlin in 1936, *Fest der Völker—Fest der Schönheit (Festival of Nations—Festival of Beauty)*, she includes several sequences in which classical sculptures, like the discus thrower, are subtly merged with images of naked bodies in the same poses. The filming of human beings thus becomes a vitalization of the ideal and, at the same time, an idealization of nature.

Art and nature, which undergo an illusionist metamorphosis in Riefenstahl's film, offer appear side by side in photography and form a sanctioned partnership in that medium. In the many opulent art books on nature, culture, and man, paintings and photographs of the German world appear alternately and mutually confirm each other. The preface to the volume *Menschenschönheit—Gestalt und Antlitz des Menschen in Leben und Kunst (Human Beauty —The Human Face and Figure in Life and Art)*[185] explains this method of presentation: "Our book attempts to support our ideas not only through pictures of reality but also through works of visual art." An Artemis head from Herculaneum, for example, is shown next to a contemporary female javelin thrower, an Aeginetan warrior next to a modern javelin thrower. A Bavarian girl poses next to a *Girl from Dachau* painted by Wilhelm Leibl. In another volume, a real girl is juxtaposed with the sculpture of a girl by Georg Kolbe.[186]

But this is not the only way conscious parallels were sought. There is also a general affinity between art and

photography that derives from their shared approach to their subjects. The figure of a female archer, whether photographed, sculpted, or painted, was always based on the image of Diana, which was a favorite theme in "art in the Third Reich."[187] The theme of *Aphrodite Rising from the Sea*[188] had similiar archetypal importance for numerous paintings of *Bathers*.[189] A *Frisian Girl*, whether photographed or painted, is shown as an example of "ideal biological form."[190] The same attitude and approach to composition often prevail in paintings and photographs of groups.[191] A photograph of a *Woman Binding Sheaves* bears a close resemblance to Franz Gerwin's *Farmer Mowing with a Scythe*.[192]

On the whole, these observations apply to all the genres, for National Socialist photography as well as painting adhered to the genre principle. Landscapes were photographed with a painter's eye. Photographers frequently tried to imitate the effects achieved by the Romantic Caspar David Friedrich and by other nineteenth-century painters and to give their photographs substance in this way. A comparison of Karl Haider's *Peace Reigns over the Mountain Tops* (1896) with a photograph, *Black Forest*,[193] or of Karl Leipold's seascape *Let There Be Light* with the photograph *North Sea*[194] makes this clear.

Another common device was to present a partial view of a landscape "framed" in a window.[195] We hardly need mention that the portrayal of farmers and artisans at work was governed by the same criteria in both painting and photog-

Photography and Media Reproductions
"Art" on left, photographs on the right

Roman head of Artemis
from Herculaneum.

Javelin Thrower.

Greek statue of a warrior, c. 490
B.C.,originally in the pediment at Aegina.

Javelin Throw.

Wilhelm Leibl, *Girl from Dachau*
(late nineteenth century).

Girl from Upper Bavaria.

Georg Kolbe, *Young Woman*. Female Nude.

raphy. In concluding our sketch of this particular syndrome,
we will mention still another picture of human labor, a
theme that was, as we have seen, a particularly thorny one
in National Socialist art. The figures in *Work Corps*[196] are
shown in silhouette, just as they are in Ferdinand Staeger's
painting of marching Work Corps columns. In this photo-
graph, as in Lothar Sperl's painting *Clearing Land*, work
is conceived of as nothing but muscular action and physical
gesture without any recognizable function or purpose.

This method of having nature and art, the ideal and the
real, mutually confirm each other extended into advertising,
too. "Forma," a firm producing women's foundation gar-
ments, tried to suggest in its advertising art that the "form-
perfect woman" of classical antiquity had found a worthy
successor in the "forma-perfect woman" of today. The use
of "Forma" products guaranteed the perfect "sculptured
shape of the female body."[197]

If photography was to legitimize itself under National
Socialism it had to cast off the "dogma of the truth of
reality" that the technical nature of the camera seemed to
force on it. The camera therefore had to be used, if not to
say manipulated, in such a way that it did not reproduce
reality. It had to produce "art." Like painting or sculpture,
it had to present the ideal as defined by National Socialism.
Just as painting took the form of refurbished genre paint-
ing, photography had to become a kind of refurbished genre
photography. In summary, we can say that the philosophy
and the products of both art and photography in the Third
Reich were largely identical.

This provides us with our point of departure for dis-

Mathias Schumacher, *Female Archer*.　　　　　　Female Archer.

Fritz Klimsch, *Anadyomene*.　　　　　　Female Nude.

Julius Engelhard, *Bathing in a Mountain Lake.*

Female Nude on a Lake Shore.

Wilhelm Petersen, *Young Frisian Woman.*

Young Frisian Woman.

Adolf Wissel, *Young Farm Women*.

South Tyrolian Youth.

Franz Gerwin, *Farmer Mowing
with a Scythe*.

Woman Binding Sheaves.

cussing the other major function of photography in German fascism, namely, as a means of transmitting phenomena of the visual arts to the masses. Art works are, of course, media in themselves; they transmit artistic information to others. They are messengers for themselves and do not convey any messages outside themselves. Only their immediate observers are touched by them, and the process of observing them usually is an individual one involving no communication with other observers.

Even if this individual process is repeated a hundred thousand times, as it was in the House of German Art, it still does not reach the public in any true sense of that word. But this is true only in a theoretical sense, because art exhibitions have reached some part of a growing bourgeois public for as long as we have had techniques of reproduc-

The Black Forest.

Karl Haider, *Peace Reigns over the Mountain Tops.*

The North Sea.

Karl Leipold, *Let There Be Light.*

tion, and we have had these techniques just as long as we have had art exhibitions.[198] This means that art and the commentary and discussion associated with it form a public instrument of information and communication.

Under liberal governments, this communications complex focused on art is, so to speak, organic in nature and is subject to the law of supply and demand as well as to private interests. But this was not the situation under German fascism, which wanted and had to prove in all sectors that it and nothing else ruled the world of experience.

Just as it had first launched a negative campaign to ensure that no other view of art but its own—or the people's, as it insisted on calling it—could be heard, it then had to launch a positive one that no one could avoid seeing and hearing and that proclaimed "art in the Third Reich" to be the only form of art that existed and was of value. It was therefore not so important that anything was actually created or achieved in the field of art—which the great mass of the "folk" were in no position to judge anyhow—but that the public was convinced that a project or a promise had been carried out.

Virgental.

Lothar Sperl,
Clearing Land.

Work Corps.

This is what we call propaganda, and its most important method is the multiplication of the messages it wants to convey. What was crucial for the art policy of National Socialism was to suggest and then convincingly prove to the people that a "specifically German" art, an "art for the people," had been created.

This method of multiplying aesthetic appearances is most obviously exemplified in the propagandistic use of architecture. A vast number, indeed most of the projects we associate with National Socialist architecture, were never built, or even took the form of finished blueprints. Instead, it was the continuous stream of publications about these projects, the cleverly photographed models, and the life-size mock-ups of details that created the still prevailing im-

pression of the quantity and quality of National Socialist architecture.

This was the method the film about architecture called *Das Wort aus Stein (Words of Stone)* used when it presented finished and planned projects side by side without bothering to say which was which. All the architectural achievements National Socialism boasted about existed only in the form of photographs and movies. The number of buildings that had actually been completed could effectively be kept vague in this way. And even when architectural projects were completed, they served a purely propaganda function that was possible only with the aid of photography and mass reproduction. Albert Speer's New Reich Chancellery, for example, practically never served the purpose for which it was supposedly built, namely, as a seat of government. The building's practical value for the regime was limited to and realized in the repeated presentation in the mass media of its interior and exterior. The building was more a demonstration of the regime's architectural fantasies than of its realization of specific plans. This particular case in the history of fascism is a telling example in support of Marshall McLuhan's thesis that the medium is the message.

These observations also apply to painting and sculpture. "Art in the Third Reich" could seem so spectacular and legendary only because of the constantly repeated and technically perfected reproduction of it. The lavish staging of the exhibits in the House of German Art was intended only to legitimize the mass reproduction process that would follow and to raise the necessary expectations in the potential audience. The festivals preceding the exhibit openings lasted for several weeks and were attended by hundreds of thousands of spectators, but their essential purpose was to serve as material for National Socialist self-aggrandizement in the art sector, to serve as an archive whose inventory could be made use of at will. The photographer Heinrich Hoffmann, Hitler's art adviser and *Reichsbildberichterstatter des NSDAP* (Reich Journalistic Photographer of the NSDAP), was the most important figure in the field of art reproduction. He had a formal monopoly on photographs of Hitler and an informal one on the many photographs depicting works of visual art. Hoffmann himself published many photographs of exhibits and festivals in the form of portfolios and stereoscopic sets. Photographs of this kind were also made available to the press, to party organizations, to art periodicals, and to publishers of books, prints, and postcards.

As we have already mentioned, the illustrated magazines and the newsreels gave special attention to coverage of the visual arts. The exhibits were supplied with publicity leaflets that, in their layout, implied more and created a different impression than a spectator at the exhibit would have perceived. The leaflet for the 1940 exhibit took the

Advertisement for women's foundation garments, "Die form (a)-vollendete Frau" (1938).

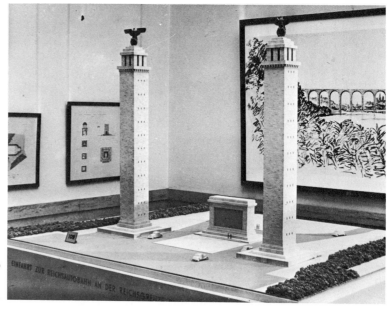

Model for the entrance to
the Reich Autobahn on the
southern border.

form of a polyptych. The central picture in it was Arno
Breker's *Comrades*, in which the figures represent self-
sacrifice and valor in battle. The four pictures vertically
and horizontally adjacent to this central one form an obvi-
ous cross and are given to themes of battle, heroism, and
heraldry. The four corners are taken up by feminine com-
plements, as it were; they are all shown nude, singly and
in groups, as though ready to fulfill their special duties.

Thus, the medium used for reproduction, the way it was
employed, and the material chosen for mass distribution all
shaped the public's reception of "art in the Third Reich."
Excerpts from the annual exhibitions were also published
in special editions for the armed forces. These editions, too,
were Hoffmann's work and were made up for the most part
of color reproductions of particularly lascivious nudes. The
official art publication of the NSDAP, which was edited by
Rosenberg and had the programmatic title *Die Kunst im
Dritten [Deutschen] Reich, (Art in the Third [German]
Reich)* gave great care to the selection and meticulous color
reproduction of paintings from the annual exhibits, and the
selections it made set the standards for the art world. As his
personal contribution to the promulgation of art, the
Reichsführer-SS (Reich Führer of the SS) published series
of postcards based on paintings—mostly nudes and battle
scenes—that best reflected his view of National Socialism.

This nationally imposed communication process presented
a greater amount and a different range of art to the public
consciousness than any individual could possibly absorb
during a visit to an exhibit. Here, too, sketches played
a significant role in shaping the image of "art in the
Third Reich." Werner Peiner's battle sketches for the tapes-
tries that were at some point to hang in the Reich Chan-

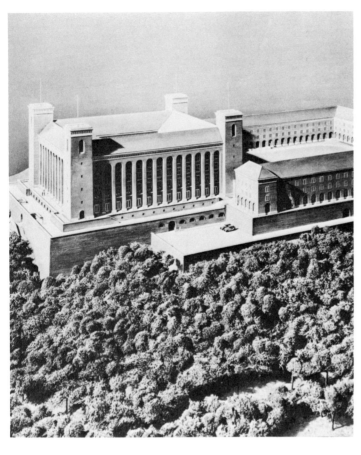

Hans Herrmann Klaje, Model
for the Danzig military academy.

cellery acquired their social existence and their political importance solely through the mass media. The factory in which the tapestries were to have been produced was never built. Nevertheless, the art press kept publishing articles and pictures that proclaimed tapestry to be the "monumental art the nation had longed for for a century," as if these articles were describing actual projects and products.

We can summarize as follows: Only with the help of the mass media could the Third Reich attempt to prove that Germany had become, as Hitler had promised it would, an empire of art and culture. At the beginning of this study, we mentioned the pseudoaesthetic measures the government took to represent the Third Reich as a complete novelty in German history, as a state in which class struggle had been overcome and a "folk community" realized. The government itself had to see to it that this impression was conveyed in the mass media if it was convincingly to deceive the public into thinking it had achieved the goals it had set for itself.

Since art had become an object of politics, as we have seen repeatedly, it was not interesting in itself but only as a political instrument that could become effective in turn only through the media. Only the media were of interest to ·the regime, not art *per se*, despite Hitler's protestations to

GROSSE DEUTSCHE KUNSTAUSSTELLUNG 1940

Illustrated folder for the
Great German Art Exhibi-
tion of 1940.

the contrary. To the extent that the media illustrated the promised national rebirth of art, they fulfilled the political task required of them.

Our concluding theses could be formulated as follows: The fact that the camera was used to *reproduce* art meant that the camera as a *producer* of art could not follow its own laws but was subject to the laws National Socialism had dictated for the visual arts. Conversely, it was a consequence of the laws laid down for the visual arts that the camera, as a reproducer of art, could not develop its own technical and mechanical qualities. Reportage was forbidden to the photographer, just as criticism was forbidden to the writer. The photographer's copy of a painting does not create any critical perspective on that painting but only multiplies its aura. It does not report on art but usurps the role of art.

Art and the camera as both a producer and reproducer of art seem to have entered a kind of alliance of the media in order to fulfill the task imposed upon them. In both art and photography, traditionalist genre painting had to serve as a basis for reproduction. The visual habits of the public, habits that the regime wanted to exploit in its battle against modern art, were not to be challenged. Instead, the illusion that an epoch-making revolution was taking place in art was to be reinforced.

A SYNTHESIS OF FASCIST AESTHETICS

This concluding chapter on National Socialist architecture and on the cult spectaculars surrounding it will not attempt an analysis of that architecture and its history but will instead carry over the method of inquiry we have applied to National Socialist painting to what could be called fascist aesthetics as such.[199] The National Socialist rise to power brought with it a radical change in architecture, just as it did in painting. The international school of modern functional architecture, to which Germany itself had made major contributions, was now written off as "architectural Bolshevism," while the building efforts of the new regime were honored as "architecture in the Third Reich." The parallels between painting and architecture are obvious, and any attempt to form a general theory of fascist aesthetics has to take this interdependence between individual aesthetic sectors as a point of departure. To distinguish between the different fields of art by assigning one a higher and another a lower value would fail to take into account the system—in this case the National Socialist system— that encompassed those fields and extended into all areas of life including aesthetics. In a society where the subjectivity and private existence of those who have nothing to sell but their labor have been "socialized," as it were, art, too, had to relinquish its private nature and adopt a new public status. There was a shift in emphasis, but the private and public aspects of art remained interdependent. Having already studied the mass-media function of National Socialist art we will not make any distinction in our further considerations between works that were completed and those that were projected or only conceived of in fantasy.

There are good reasons why the architecture of National Socialism was recognized both by its producers and by later observers as the art field in which the aesthetic efforts and qualities of German fascism were most clearly embodied. "Never in German history were greater and nobler buildings planned, begun, and completed than in our time,"[200] Hitler had said; and critics agreed with him: "During the years 1934 to 1940 Germany witnessed an architectural renaissance that well deserved the epithet of 'historically unique' that it claimed for itself."[201]

This special status assigned to fascist architecture has made it difficult for later critics to arrive at a concrete, nonideological assessment of the phenomenon. On the one hand, Hitler's personal passion for building, the passion of an architect manqué, and his unlimited power as Führer have been made primarily responsible for the quality and formal repertoire of National Socialist architecture.[202] On the other, arguments based on ideological critique and structuralist analysis have stressed the function of architecture as an instrument of totalitarian government, documenting and explicating that function on the basis of formal characteristics in National Socialist buildings.[203] I do not

ARCHI- TECTURE, ARMS INDUSTRY, AND WAR

Hans C. Reissinger,
Porticus of the House of
German Education in Bayreuth.

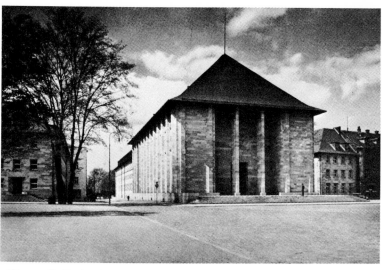

Hans C. Reissinger, Façade of the House of German
Education in Bayreuth.

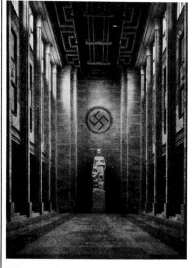

Hans C. Reissinger,
Commemorative Hall in the
House of German Education
in Bayreuth with W. Hosel-
mann's sculpture *German
Mother.*

mean to reduce these diverse lines of argument to a common denominator, but they do resemble each other in failing to consider the link between -National Socialist architecture and the concrete objectives that capital was serving at the time. The size of individual buildings[204] and the extent of all building projects taken together imposed a massive burden on the entire economy. It is therefore incorrect to see their impact restricted solely to the superstructure of society.

Comprehensive statistics on building activity and on the amounts spent for building do not seem to exist.[205] But numerous individual statistics and information from relevant but indirectly related sources make clear what the true and primary function of the National Socialist building program was. We can assume that architecture, like the arms industry, was supported largely by public funds.[206] The *Handbuch der Architektur (Handbook of Architecture)* (1943) explains why this is so: "The authorities in the Weimar state prohibited the construction of office buildings, and generous support for building in the Third Reich helped revitalize the economy and overcome crippling unemployment. This is one example of the profound revision of attitudes that was to have such beneficial consequences for the well-being of the Reich."[207] This retrospective statement, made toward the end of National Socialist rule, can be seen as a restatement of programmatic views Hitler had expressed in 1933. "I believe the most efficient way to create work for the German people is to revive the German economy by initiating large-scale monumental building projects."[208]

The money spent by the state for public buildings—the term "public" was interpreted very broadly in the Third

Reich—had the same economic function as that spent for armaments.[209] It created an artificial demand for goods that, for the time being, could not be consumer goods, and it alleviated unemployment. Here, too, public funds were essential to finance the private accumulation of capital for privileged groups. An unparalleled building boom accompanied by unheard-of corporate profits began.[210] At the same time, monopolies developed in the building trade, destroying many small and medium-sized enterprises and proving that monumental public building projects went hand in hand with a truly "monumental," monopoly-oriented policy governing the use of capital, a policy that did not take the interests of the small or medium-sized enterprise into account.[211]

The key question in assessing the National Socialist building program, quite apart from the fact that it brought far greater gains to capital than it did to labor, is what value it had for the population it was supposed to benefit. Did the population not receive from this program at least some of the basic necessities it needed to sustain and reproduce itself? Did the program concentrate on apartment buildings, nursery schools, athletic facilities, schools, or was there a different focus? The answer, which is implicit in the term "monumental," is obvious. Despite endless promises to give "every German his little house in the country," what was actually accomplished in the way of public housing "fell far short, in both quality and quantity, of what the Weimar Republic had produced for low-income families."[212]

Surprisingly enough, this is also true of athletic fields and facilities.[213] Other building in the public sector is totally insignificant if we disregard the Adolf Hitler Youth Hostels *(Adolf-Hitler-Heime)*, which served a special function.

Putting aside the building projects that were of a purely military nature, we see that the major intent of the building program was to transform and revitalize the appearance of German cities. These projects were not aimed primarily at improving the infrastructure of the cities, however, but only at adding new aesthetic dimensions to them.[214] Since the state itself carried the financial burden of these projects, which could not be seen as social remuneration for work performed by society, the state had to offer another justification for them, and it did so, repeatedly and emphatically. "During the cultural impoverishment that accompanied the bourgeois and liberal era, funds for public buildings were cut more and more while the industrial plants, banks, exchanges, department stores, hotels and so forth of bourgeois capitalist interest groups flourished." This is how Hitler, hoping to exploit anticapitalist resentment, described the Weimar period Germany had just left behind. He went on to outline the purpose of the new building program. "Just as National Socialism sets the larger community of the nation

and of the people above these interest groups, its building program will also give precedence to the needs of this community over those of private interests. This is a crucial point."[215]

The following quotation reveals what kind of social projects are meant here: "The most important architectural task of the future will be to create communal buildings, whether communal settlements or communal halls, that are suitable for Germanic religious celebrations."[216] The fact that Hitler soon retracted this cultic and Germanic religious motivation for building—"We have no cultic halls but only halls for the people, nor do we have cultic arenas but only arenas for gathering and marching"[217]—in no way altered building plans but only indicated an ideological "purging" of excessively folkish ideas. The cultic character of the buildings remained intact.[218]

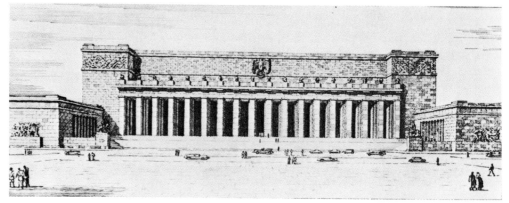

Wilhelm Kreis, Drawing for the Soldiers' Hall, Berlin.

Because no truly communal enterprises were undertaken to satisfy the real needs of the population, National Socialist leadership continued to harp on the "communal" nature of its buildings. Hardly any of them provided a social service in any real sense of the term. This is true of major building complexes, such as the Reich Party Rally Grounds in Nuremberg and the planned Berlin *Achsenkreuz*,* and it is also true of the large annexes that were added to basically utilitarian buildings. An example is the Soldiers' Hall that was part of the Berlin Army High Command Building. Every official or semiofficial building included a large Hall of Consecration, which, like the one in the Bayreuth House of German Education, was way out of proportion to the overall size of the building.[219] Then there were innumerable monuments, memorials, "towers to the dead,"[220] none of which offered the slightest promise of social usefulness.

* Berlin was to have two huge intersecting boulevards running north–south and east–west. The main plaza at the intersection was to have an arch of triumph with an opening 260 feet high. A People's Hall with a massive dome was also to be included. Construction was halted in 1939 (translators' note).

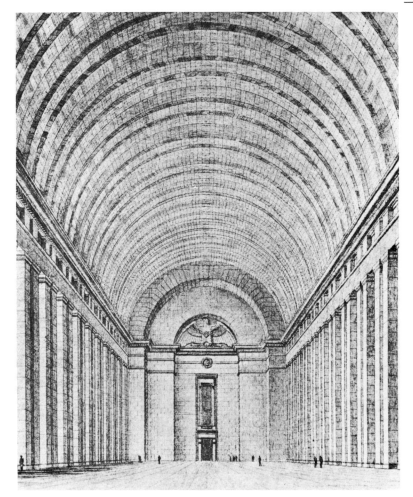

Wilhelm Kreis, Drawing of an interior in the Soldiers'
Hall, Berlin.

Wilhelm Kreis, Drawing for a monument to German war dead near Kutno in Russia.

In addition to serving no utilitarian purpose, National Socialist buildings called for expensive materials and considerable hand labor in their construction[221] and were therefore "ennobled" by the conditions of their production. The use of steel, concrete, and glass—materials used in modern industrialized construction based on engineering principles—was rejected for public buildings as "architectural Bolshevism."[222] These materials continued to be used without question for industrial and military purposes, however. In representative buildings, massive blocks of stone, preferably granite and marble, were used in walls and arches.[223] That these practices were blatantly uneconomical, anachronistic, and pointless had to be disguised by invoking "higher purposes." The buildings of the "decadent period," the National Socialists claimed, were oriented around "interest and amortization."[224] "But anyone who is so concerned with 'economic necessities' should consider that most of these necessities place great demands on a nation's willingness to make sacrifices. Yet the people cannot learn as clearly from this [as they can from buildings] what community means and why their own personal interests should be subordinated to a higher purpose."[225]

Economic and utilitarian considerations had to be blatantly violated in the construction of these buildings to demonstrate the "higher purpose" to which the people's interests had to be subordinated. Over and over again the "false god of economic interest" was condemned, even in the construction of such utilitarian projects as *autobahns* and *autobahn* bridges.[226] In this connection a "saying of the Führer" was often quoted: "No one who confines himself to economic considerations will ever be able to think and act socially." Hitler is not talking here about the asocial economic thinking of private enterprise, the only kind of economic thinking accepted in National Socialism, but about the use of publicly administered national wealth that was invested uneconomically in order to guarantee increased profits for private enterprise. "Every building, whether large or small, can no longer be seen primarily as a part of German national wealth but as a part of our German cultural possessions."[227] What was unprofitable and pointless for the national economy proved to be highly profitable and useful for private economic interests. The public monies invested in building found their way into the private bank accounts of builders and suppliers of building materials.

In an eloquent postulation of this "new" kind of economic thinking, Clemenz Klotz, the architect who drew up plans for a National House of German Labor that was to be located in Cologne and have a capacity of 100,000 people, made the following remarks:

Hasty and slipshod building methods will have no place in this project, and if we take all other relevant factors

into account, such as financing and the building principles essential to good work, we can estimate that about 5,000 workers from all branches of the building trades will be engaged in this project for ten years. The German Workers' Front is not merely an organism functioning through the state, a massive centralized corporation; it is also a growing source of strength the future dimensions of which we can hardly imagine today. Informed by the grand idea of the common good, it will be able to carry out tasks in the future that will put the entire financing process for buildings of this kind on a completely different basis. The figures for this immense building we are planning now begin to suggest what titanic forces the National Socialist state can summon up.[228]

The major premise for realizing a building project of such proportions—and the size of the future projects would soon far exceed even this one[229]—was the specific value put on work in the form of wages. The entire volume of wages and consumption was severely restricted. This resulted in full employment and in the production of absolute surplus value. But at the same time, because mainly forced labor[230] was used to procure the building materials and to construct the buildings, both the buildings and the materials in them represented direct creation of value. The creation of value by the Reich Work Corps and by concentration-camp labor in the stone quarries—labor whose cost did not appear in any cost analysis—did indeed put "the entire financing process for buildings of this kind on a completely different basis."

We have already noted that in the Third Reich work was not regarded as the creation of material values but as a value in itself. Accordingly, the products of such work could only be regarded as products in themselves, as monuments that were not tainted by utilitarian considerations and that only commemorated the self-realizing, self-identifying labor invested in them. This is the underlying meaning of the often quoted story of the three stone cutters. "At a building site, there were three stone cutters, each working on his own stone. When each was asked what he was doing, the first said, 'I'm earning my bread.' The second answered, 'I'm cutting a stone.' But the third said, 'I am helping to build a cathedral.' This third man is the aristocrat of work, and it is only his attitude that helps build the new Reich."[231] The worker who is conscious of the exchange value of his labor is looked down on. The one who helps build the "cathedral," i.e., the "new Reich," without calculating the value of his labor is "ennobled" but receives no material compensation.

"The towering sublimity of our cathedrals provides a measure of the truly monumental cultural spirit of their time."[232] The present will live up to those standards. Its

Ludwig and Franz Ruff,
Congress Hall in Nuremberg
(under construction).

Congress Hall
in Nuremberg
as it appears today.

works, too, will assume absolute, monumental form. When
Hitler laid the cornerstone for the Nuremberg Congress
Hall, he remarked: "Let us mark the beginning of a new
world for the German people by laying this cornerstone of
its first great monument."[233] He spoke similarly when he
laid the cornerstone for the institute of military technology
at the Technical University in Berlin: "This building will
become a monument to German culture, to German knowl-
edge, and to German strength."[234] The monumental aspect
of these buildings was meant to blot out any trace of utili-
tarian considerations and was reflected in the names given
to them. Names like the House of German Art in Munich,
the House of German Labor in Cologne, the House of Ger-
man Education in Bayreuth, the House of German Law in
Munich, were not meant to suggest the administrations of
the centrally manipulated organizations located in these

buildings but to stand as ontological symbols. "For this reason, we would do better to speak of a symbolic rather than of a political architecture."[235]

In similar fashion, the cities that were to be replanned were given "monumental" titles. "If Berlin is to be the capital of the Reich, Hamburg and Bremen the capitals of German merchant shipping, Leipzig and Cologne the capitals of German trade, then Munich will again become the capital of German art."[236] Monuments express timelessness and eternity. This was the justification usually offered for buildings that were freed from the "false god of economic interest" and that used only massive, permanent natural materials.

> Small everyday needs have changed over the milennia, and they will continue to change. But the great cultural documents of humanity, built of granite and marble, have remained unchanged over the milennia. They alone are the truly stable element in the rush of all other phenomena.... This is why these buildings should not be conceived of for the year 1940 or for the year 2000. Like the cathedrals of our past, they will tower over the milennia of the future.[237]

Picking up on this idea, Speer developed a "theory of ruin value." The buildings of the Third Reich were to be designed, in terms of their materials and statics, so that they "would resemble Roman models after centuries or (as we used to say) thousands of years had passed."[238] This required a considerable increase in the amount of material used because the walls would have to be massive if they were to continue to stand once the supporting effect of roofs and ceilings were removed. Ruin value seems to have become a generally accepted value. As late as 1944, when the Greater German Reich itself was on the verge of total ruin, a semiofficial source published the following remarks: "The one remaining bridge pier, relieved of its utilitarian function, represents an architectonic configuration that is complete in itself. It is a kind of monument, and this statement presumes an adherence to the laws of greatness. One of these laws is the law of mass. Without mass, that is to say, without extravagance in the use of materials, no monumental effect can be achieved. . . . No one who is calculating in his use of materials will ever produce monumental works."[239] If pure nonutilitarian monumentality could not exist in the present, then it was at least to be guaranteed for the future.

Monumentality finally revealed itself as a mere function of specific interests controlling the use of capital. The demand for functional buildings alone would never have been great enough to prompt such a building boom. Functional building could never have drawn so heavily on materials and reached such proportions without coming under criti-

cism.[240] According to National Socialist aesthetics, only buildings that had no function at all could be works of art. "Only a small segment of architecture can promptly be classified as art: the tomb and the monument. Everything else, everything that serves a function, has no place in the realm of art."[241] In the face of such buildings and of Goebbels's prohibition on criticism, the critic was forced to keep silent. "We must be guided not only by artistic but also by political considerations as we look to the great models of the past to help us give worthy cultural expression to our new Reich. Nothing is more effective in silencing the nagging critic than the eternal language of great art."[242] The unlimited squandering of national wealth, which resulted in the accumulation of private wealth, was justified by the claim that this wealth had been absorbed in art. Hitler lent support to this claim. "The only truly eternal investment of human labor is in art."[243] The productive labor force, working in total heteronomy, was to receive the economic equivalent of its labor in the manifest autonomy symbolized by art.

Having come to a theoretical understanding of the primary function that National Socialist building had, we can now turn to its style and function in the exercise of governmental control. The invocation of art was not in itself sufficient to silence all criticism. National Socialist buildings had to be provided with forms that added pathos, nobility, and sacred qualities to the utilitarian functions the buildings had. These forms were to lend the buildings in question an existence beyond debate. A number of studies have already worked out the details of the National Socialist formal syndrome, which can be described in broad terms as neoclassicist. These formal details draw on both national[244] and international [245] traditions. There is no need to review these facts here. What determined the relatively uniform style of state buildings was not long deliberations and committee meetings but the first major National Socialist buildings themselves. These were, first, Troost's buildings in Munich, then, in the same vein, Speer's works in Nuremberg as well as his pavillion for the World's Fair in Paris.[247] One characteristic of all National Socialist architecture is the rejection of ornamentation for its own sake. This dislike for superfluous ornamentation was the one thing fascist architects shared with their arch-enemies, the functionalists. Since ornamentation is usually an expression of specific periods, styles, and fashions, the omission of it was meant to suggest temporal neutrality and timelessness.[248] The buildings were laid out in massive rectilinear forms. Their façades were characterized by recessed window bands and projecting wall compartments. "Ornamentation" was provided by sculptural work. The increasing emphasis on sculpture found its quantitative and qualitative counterparts in the economy of architecture.[249]

A special feature of these buildings was the role that masses of people were to assume in them. People would not come to them as admiring tourists but would experience them as members of military formations. Organized and uniformed masses provided National Socialist architecture with the complementary "ornamentation" it needed.[250] Along with the intellectually paralyzing and authoritarian aura of these buildings, there went an explicit command for the individual—together with thousands of his "compatriots" —to submit himself "ornamentally" to them. The situation created in this way was frequently described: "The political soldiers focus their gaze on it [the building]. Standing together in the *same* posture, in the *same* uniform, intent on the *same* goal, they are bound to perceive the straight lines of columns as an expression of the order to which they have submitted themselves. They find, expressed in stone, the same will to order that has taken possession of them as living human beings. They feel a total harmony between themselves and this architecture."[251] In this connection, H. Fischer wrote of the "work soldiers"—and here we should recall Ferdinand Staeger's paintings discussed in Chapter 5 above—that they had come to Nuremberg "to stand before the Führer. The simple precision of the white columns on the Nuremberg parade ground extended over into the orderly columns of men assembled there."[252]

The secondary, ideological function of National Socialist architecture, a function that followed logically from its primary purpose, was to convey a physical experience of the authority of the National Socialist system and of its economic basis. "Our opponents will begin to realize and, more important, our adherents will know that our buildings were created to strengthen this authority. . . . This is the underlying purpose of these buildings. . . . For they will help unify and strengthen our people more than ever. . . . In the presence of these mighty witnesses to our communal existence, earthly differences among people shrink away to nothing."[253]

But in the field of architecture, too, we would be overlooking the sophistication that National Socialism developed in its methods of domination if we were to reduce them to the mere physical presence of the masses that were drawn into the architectonic scheme. Even if the number of people involved was 180,000 (the planned capacity of the People's Hall in Berlin) or rose as high as 400,000 (as in the Nuremberg Stadium), the total secondary psychological function of the buildings was still not realized. The individual member of the Work Corps, the individual soldier, NSDAP functionary, or "compatriot" could not take in the entire scene, especially if the ceremonies were being held at night.[254] The combination of stone and "human architecture"[255] could not reveal its full aesthetic effect to the participant but only to those who could survey the entire scene.

But the only eyes to enjoy this perspective were those of the National Socialist leadership and of strategically placed cameras. Here we should recall the section above in which we treated the function of the mass media in the visual arts. Only in the media created by the camera, in photographs and movies (there were plans to introduce television), was it possible to convey the full view of these spectacles made up of stone and human beings, and only in these media was it possible, too, to create a true mass appeal. The masses that gathered and marched in the ordering presence of this architecture—masses that seemed huge but that actually represented only a minute percentage of the total population —could suggest the identity of people and state if their image was multiplied and distributed to the millions of "compatriots" not present. The masses depicted stood for the total mass of the population and were meant to represent it.

These immense rooms and arenas, then, were not needed to convey news and information to large numbers of people. In the technological age, this was accomplished by press, radio, and film, over which the National Socialists had absolute control. The manner in which the media carried information from the outer, "objective" world into the inner, subjective one of homes and apartments was often depicted in painting. Pictures of this nature constituted a kind of iconography of the media. Examples are Otto Kirchner's *Old Newspaper Reader*, who is shown holding a copy of the *Völkischer Beobachter* in his hand; Udo Wendel's *The Art Magazine*, which depicts the painter reading *Die Kunst im Dritten Reich* with his parents;[256] and P. M. Padua's *The Führer Speaks*, a title that refers to the speech the family is shown listening to on the radio as well as to the headline in the newspaper on the table. In Fascist Italy, this iconography of the media attained considerable importance. One picture of this type illustrates the almost irresistible intrusion of fascistic projections of masses and architecture into the private world of mother and child, forcing them to interact with the outside world.[257]

The technically communicated aesthetic omnipotence of the National Socialist system celebrated many visual and acoustic triumphs. A well-known example is when nearly a million party members gathered under loudspeakers in many cities and towns and repeated in unison the oath that Rudolf Hess read over the radio.[258] Photographs and movies, particularly the newsreels, also reproduced mass events. It is only in this connection that the "megalomania" of the buildings, which we deprive of its real significance if we ascribe it solely to Hitler's own personal megalomania, developed its "rationality." This rationality was, however, a purely technical one, a rationality of tyranny.[259]

The cultic linking of masses of people with architecture finds its truest and most solemn expression in the staging of

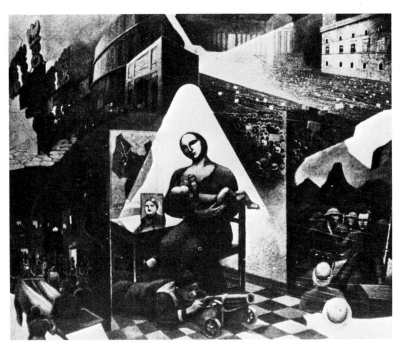

Painting from the exhibit "Premio Cremona" (1936).

ceremonies honoring the dead. A good example of this is the
memorial ceremony for the war dead held at Luitpoldhain
and vividly described by Hubert Schrade.[260] Other examples
are the annual celebrations held at the Munich "forum" for
the *putschists* who died a "sacrificial death" on November 9,
1923. Wilhelm Sauter's painting *Shrine of Heroes*, which
brings together the war dead and those who died for the
party's cause, is in this same spirit. We should recall here
the affinity that Loos noted between artistic architecture and
the memorial or tomb. Every communal building the Na-
tional Socialists constructed included a memorial chapel for
"victims" who died in the war or for the movement.[261] There
were plans to cut the names of every one of the 1,800,000
soldiers who died in the First World War into the granite
of the Berlin Victory Gate. We have already mentioned
Wilhelm Kreis's oversized Soldiers' Hall with its crypt for
the graves of German war heroes. Finally, a large number
of the monumental buildings have an element of sepulchral
and memorial architecture.[262] The intent of adopting this
extreme formula for conveying a sense of dignity was not
only to make the desire for absolute respect visible and the
lack of respect punishable, but also to convince the people
that there was no distinction between death caused artifi-
cially in war and the natural death everyone inevitably
faces. The solemn evocation of those already dead had the
purpose of justifying the future deaths of the living who
were gathered in these sacred shrines to take part in fre-
quent memorial ceremonies.

Erich Mercker, *Granite
Quarry, Flossenbürg* (1941).

Erich Mercker, *Märzfeld
in Nuremberg* (1941).

Albert Speer, The Märzfeld
in Nuremberg (under construction).

Ernst Sagebiel, Model of
Tempelhof Airport (con-
struction completed in 1937).

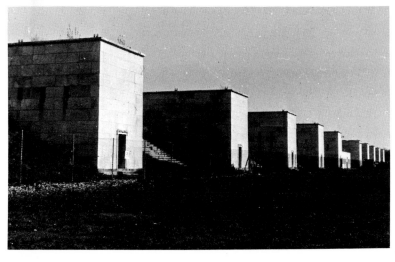

Albert Speer,
Grandstands at the
Zeppelinfeld in Nuremberg
(as they appear today).

The memorial elements of National Socialist buildings, influenced as they were by the idea of death in war, tended to resemble architectural features of fortifications. The Tannenberg memorial in East Prussia provided a model for National Socialist buildings no matter what their individual purposes were. In the Tannenberg memorial, the polygonal plan of the structure is emphasized by "defensive towers" placed at each angle in the walls. This design is reminiscent of medieval structures like the city walls of Visby on the island of Gotland or like Castel del Monte in Apulia. In National Socialist architecture, this fundamental concept is adapted to structures with extremely long fronts—whether straight, curved, or in circular form—which are subdivided and accentuated at equal intervals by bastionlike projections.[263] Examples of this kind of construction can be seen in the Zeppelinfeld and the Märzfeld in Nuremberg, in the Swimming Facilities for Twenty Thousand in Rügen,[264] in the Tempelhof Airport in Berlin, in urban apartment houses, and in military barracks.

But the most far-fetched synthesis of bastion and tomb was reached in a plan to construct a ring of "towers to the dead"—extending from the Atlantic coast to the "far reaches of Russia," from Norway to Africa—that would provide aesthetic documentation for the extent of National Socialist influence.[265] Such symbols of the "disciplinary power of the Germanic impulse for order" had already been built in Bitola, Yugoslavia, and in Quero on the Piave in Italy. "We will win the war," Hitler had declared after the surrender of France, "but we will secure our victory through our buildings."[266]

To the extent that the National Socialist building program helped create national debt, it helped prepare the way for war economically. In this process it developed forms that bore a direct aesthetic relationship to war. The sepulchral and fortificationlike elements of National Socialist buildings were translated into reality when the war began to deliver up the dead in unprecedented numbers, numbers that reached the monumental proportions of the buildings. The National Socialist building program, the arms build-up, and the eventual realization of German military potential in a war of aggression are all functions of a consistently carried out policy to exploit the people and deprive them of the fruits of their labor. All three of these phases not only symbolize but actually are crimes committed against the people, crimes that could no longer be legitimized but could only be aestheticized.[267] National Socialist aesthetics culminated in the aesthetic synthesis of architecture, arms build-up, and war. These three elements became, on the one hand, monuments of permanent terror for the people and, on the other, spread that terror everywhere among the people who were forced to join, march, and die.

Elk Eber (SS-Attack Leader) painting a soldier's portrait in his atelier.

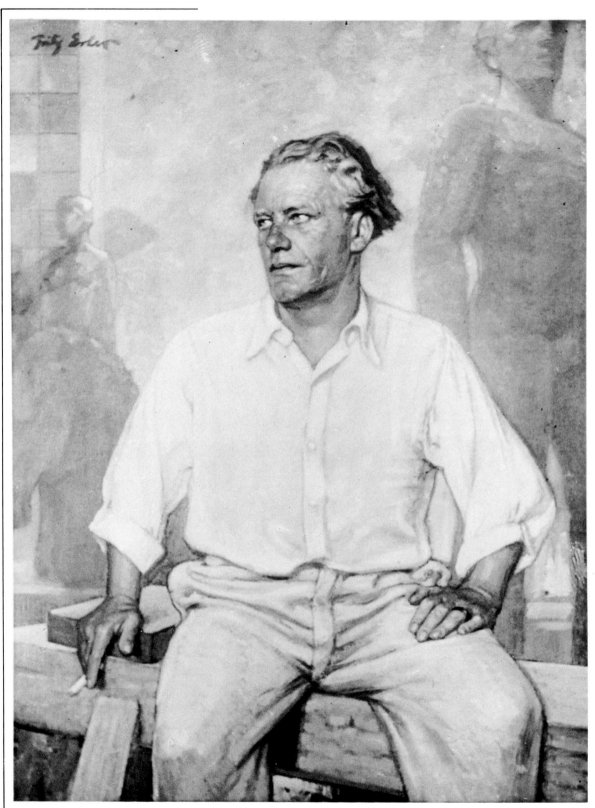

Fritz Erler, *Professor Josef Thorak.*

Walter Einbeck, *Reich Minister Rudolf Hess.*

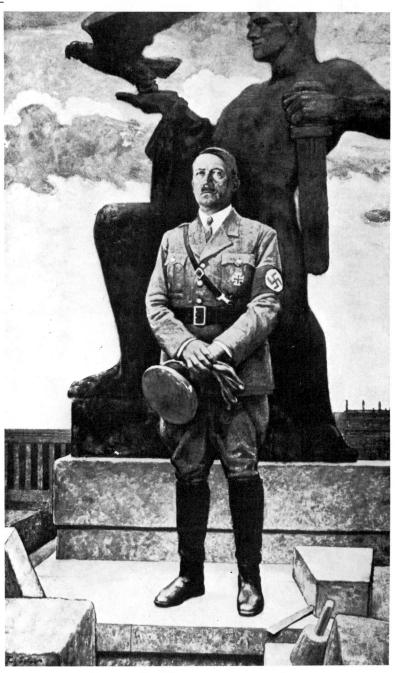

Fritz Erler, *Portrait of the Führer.*

Lothar Bechstein, *Discus Thrower*.

Ernst Kretzschmann, *Mountain Climbers at the Peak.*

Georg Siebert, *Lovers*.

Albert Bürkle, *Fighting Peasant*.

Georg Poppe, *Thor*.

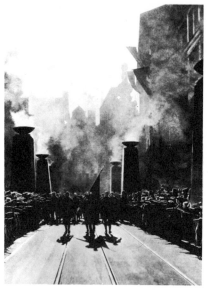

Paul Herrmann, *The Flag.*

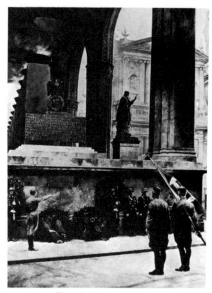

Paul Herrmann,
But Victory Is Yours.

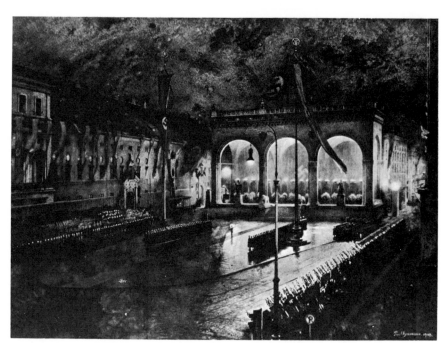

Paul Herrmann, *November 9 Celebration
at the Hall of Generals.*

Dem Terror von links kann man nur mit noch schärferem Terror begegnen

Print showing the SA clearing a hall of a leftist meeting, published in the
propaganda pamphlet *Deutschland von heute* (*Germany Today*) (Berlin, 1935).

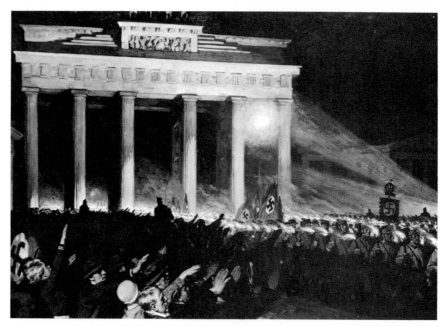

Arthur Kampf, *January 30, 1933.*

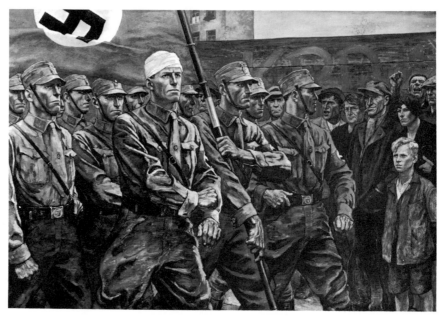

Elk Eber, *This Was the SA.*

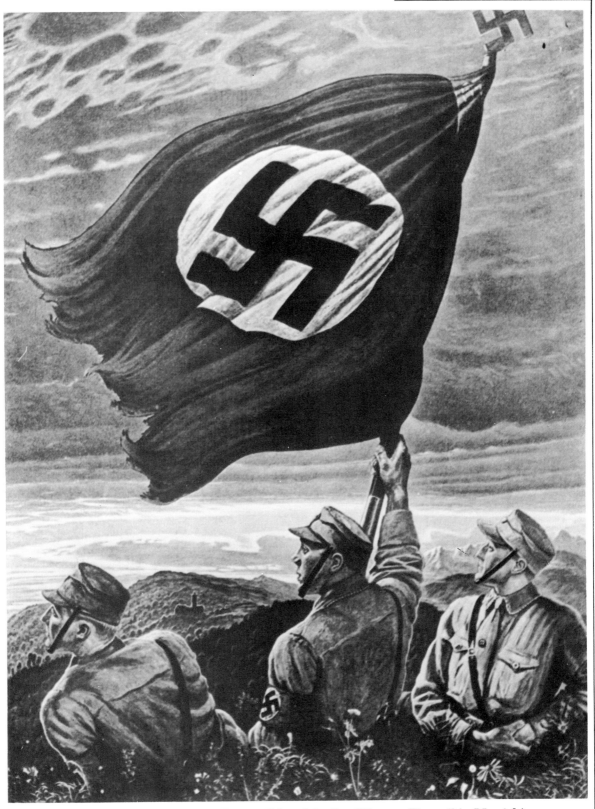

Walter Gasch, *German Dawn* (Mural in the "Brown House" in Munich).

Wilhelm Sauter, *Shrine of Heroes*.

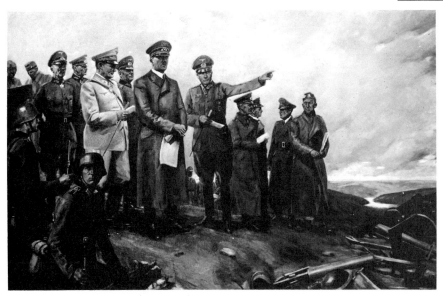

Conrad Hommel, *The Führer at the Battlefield.*

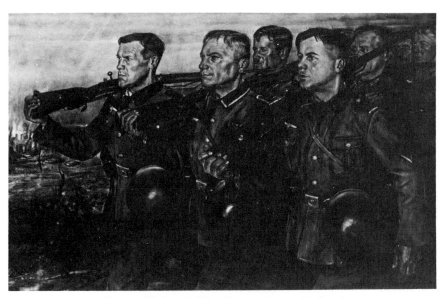

Georg Siebert, *My Comrades in Poland.*

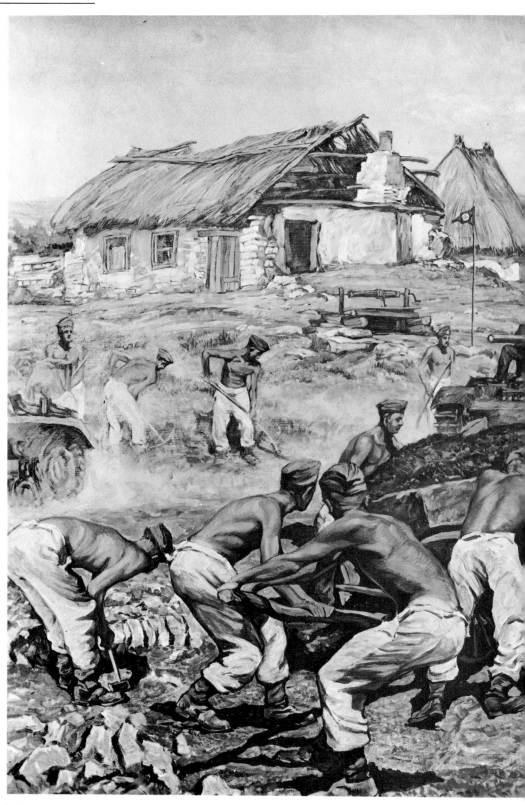

Thomas Bachmaier, *Advancing Columns*.

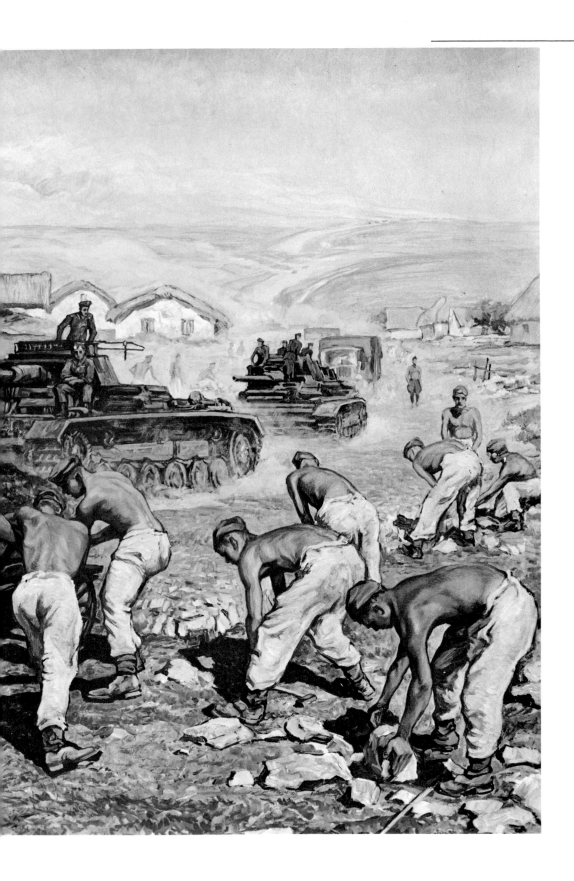

Ernst Krause, *SS Tank Crew.*

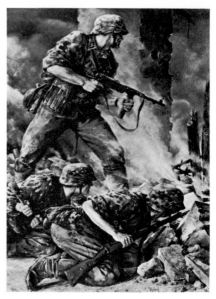

Will Tschech,
Weapons-SS in Battle.

Paul Mathias Padua, *May 10, 1940* (the attack on France).

Emil Dielmann, *Watch in the East*.

Georg Emig, *Advance Troops*.

Oskar Martin-Amorbach, *They Carry Death with Them.*

Rudolf Hausknecht, *Soldiers.*

Richard Rudolph, *Comrades.*

Georg Lebrecht, *Bombs over England.*

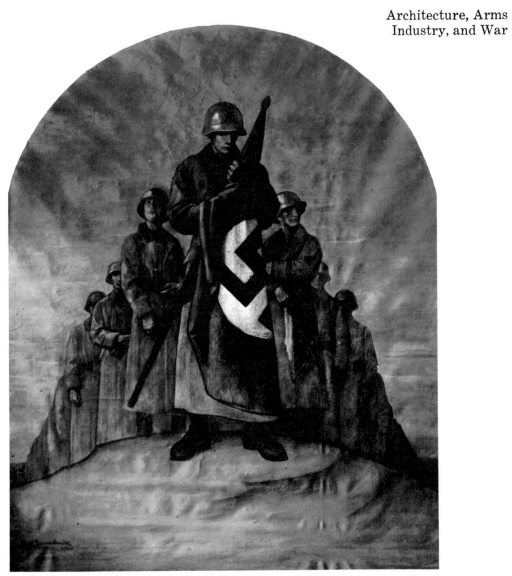

Ernst Pfannschmidt, *Honoring the Memory of Dead Heroes.*

FOOTNOTES

Abbreviations:

KiDR—Die Kunst im Dritten Reich, 1937–1944 (later known as *Die Kunst im Deutschen Reich*).

GDK—Catalog of the Grosse Deutsche Kunstausstellung, Munich 1937–1944.

1. Bess Hormats, "Art of the Götterdämmerung," *Art News*, 74 (1975), 1. Bess Hormats, "The German War Art Collection in the U. S. A.," *Art News*, 74 (1975), 11.
2. Title of the official art magazine "edited by the Führer's commissioner [Alfred Rosenberg] for the supervision of the entire intellectual and philosophical training and education of the NSDAP." This magazine first appeared in 1937. From September 1939 on it was called *Die Kunst im Deutschen Reich*. On the policy of this magazine, see A. Rosenberg, *"Wege deutscher Kunstpolitik," KiDR*, 2, 1 (1938) 4.
3. A. Behne (1946), P. O. Rave (1949), F. Roh (1962), Catalog *Entartete Kunst* (Munich, 1962), H. Brenner (1963), G. Busch (1969), and others.
4. F. Roh (1958), p. 151.
5. Hitler at the party convention of 1935; cf. B. Hinz (1974), p. 139.
6. A. Teut (1967), p. 13.
7. G. Hellack (1960), pp. 78f.
8. Hitler in his opening speech in 1937; cf. B. Hinz (1974), p. 15.
9. Cf. W. Hartmann (1976), pp. 50ff.
10. Hans Kiener in *GDK* (1937), p. 23.
11. Hitler in his opening speech in 1937; cf. B. Hinz (1974), p. 163.
12. P. O. Rave (1949), p. 54.
13. *Ibid.*, p. 55.
14. Hitler in his opening speech in 1938; cf. B. Hinz (1974), p. 174.
15. H. Brenner (1963), p. 86; A. Rabinbach (1976).
16. Archives of the Federal Republic of Germany, Koblenz R43II/1054. The author is indebted to Angela Schönberger, West Berlin, for this information.
17. Cited in J. Wulf (1963), p. 191.
18. H. Brenner (1963), pp. 112f.
19. *KiDR* 2, 4 (1938), p. iv.
20. B. Kroll (1937).
21. C. Einstein (1931).

22. Letter of June 9, 1933, from Josef Achmann to Ludwig Justi in the archives of the Nationalgalerie Berlin, German Democratic Republic (GDR), Folder "1933."
23. H. Brenner (1963), pp. 22ff.
24. *Ibid.*, Document 11, pp. 172f.
25. *Ibid.*, p. 39.
26. *Ibid.*, p. 54.
27. K. F. Schrieber (1935), pp. 1ff.
28. J. Wulf (1963), p. 102.
29. H. Brenner (1963), p. 56.
30. *Ibid.*, p. 63.
31. H. Brenner (1962).
32. W. Hofer (1957), p. 49.
33. H. Brenner (1963), pp. 82f.
34. K. F. Schrieber (1937), V, pp. 26f.
35. P. O. Rave (1949), pp. 52f.
36. *Ibid.*, pp. 79ff.; F. Roh (1962), pp. 122ff.
37. P. O. Rave (1949), pp. 85ff.
38. *Ibid.*, p. 56.
39. The "Guide to the Exhibition of Degenerate Art" appears in a complete photomechanical reproduction in F. Roh (1962).
40. *Ibid.*, "Guide to the Exhibition of Degenerate Art," pp. 26ff.
41. P. O. Rave (1949), p. 57.
42. H. Brenner (1963), Document 53, pp. 205f.
43. P. O. Rave (1949), p. 68.
44. P. Schultze-Naumburg (1932), p. 5.
45. M. Nordau (1893). Nordau, alias Südfeld, was a physician and a founder of political Zionism.
46. P. de Lagarde (alias Bötticher), *Deutsche Schriften* (Göttingen, 1878–81).
47. A. J. Langbehn (1909).
48. H. S. Chamberlain, *Die Grundlagen des neunzehnten Jahrhunderts* (Munich, 1898; 27th ed., 1941).
49. A. Bullock (1972), p. 61.
50. A. J. Langbehn and M. Nissen (1928).
51. Cited in F. Roh (1962), p. 30.
52. Cited in P. Vogt (1972), p. 332.
53. .T. Alt (1911); C. Vinnen (1911).
54. O. Kokoschka (1971), p. 108.
55. El Lissitzky and Hans Arp, *Kunst-Ismen* (Zurich, 1925).
56. A. Durus (Alfréd Keményi), "Abstrakt, abstrakter, am abstraktesten," in H.-J. Schmitt (1973), p. 150.
57. H. Brenner (1963), p. 21.
58. B. Feistel-Rohmeder (1938).
59. G. Köhler (1937).
60. G. Grosz and W. Herzfelde (1925), p. 41.
61. K. Kollwitz (1967), p. 41.
62. B. Brecht, "Über gegenstandslose Malerei," in *Über*

Politik und Kunst (1971), p. 106.

63. Cf. H. Brenner (1963), p. 71.

64. W. Ilberg, "Die beiden Seiten des Expressionismus," in H.-J. Schmitt (1973), p. 171.

65. A. Durus, in Schmitt (1973), pp. 146ff. and 155ff.

66. H. Vogeler, in Schmitt (1973), pp. 165f.

67. M. Domarus (1973), p. 718, Hitler's speech on September 7, 1937.

68. W. Willrich (1938), p. 76. Willrich, in his turn, asked and received exorbitant prices for his paintings in the Third Reich.

69. Hitler in his opening speech in 1937, B. Hinz (1974), pp. 155ff.

70. K. Engelbrecht, "Deutsche Kunst im totalen Staat," cited in J. Wulf (1963), p. 254.

71. *Kunst dem Volk—Monatsschrift für die bildende Kunst*, special issue on the Great German Art Exhibition in Munich in 1942, edition for the armed forces (Vienna, n.d. [1942]), p. 3.

72. K. Luther, "Zur Ausstellung 'Deutsche Städtebilder' der NS-Kultur-Gemeinde, Berlin," *Das Bild* 6, 9 (1936), editorial section.

73. K. Luther, "Zur 'Deutschen Werbegraphik-Ausstellung' im 'Haus der Kunst' zu Berlin," *Das Bild* 6, 4 (1936), p. 131.

74. On November 9, 1923, Hitler attempted a *putsch* in Munich. Some of his party comrades were killed in this attempt, and from 1933 on pompous memorial ceremonies were held in their honor.

75. E. Schindler, "Gedanken zur Deutschen bildenden Kunst der Zukunft," *Das Bild*, 6, 9 (1936), pp. 290f.

76. Cf. *Das Bild* 5, 12 (1935), editorial section.

77. C. Gurlitt (1924), p. 507.

78. F. Reber (1876), p. 6.

79. H. Floerke, *Studien zur niederländischen Kunst- und Kulturgeschichte—Die Formen des Kunsthandels, das Atelier und die Sammler in den Niederlanden vom 15.–18. Jahrhundert* (Munich and Leipzig, 1905), remains the most comprehensive study on this subject.

80. G. W. F. Hegel, *Ästhetik*, I, p. 568.

81. *Ibid.*, pp. 568f.

82. *Ibid.*, II, p. 256.

83. *Ibid.*, I, p. 581.

84. A. Hauser (1958), I, p. 499.

85. A. Gehlen (1960), pp. 41f.

86. J. Kuczynski (1964), pp. 40f. and 105ff.

87. A. Sohn-Rethel (1973).

88. Cited in *Maler und Zeichner schauen den Krieg*, ed. by the propaganda company of Busch's army, 2d. sequence in the series that began with the portfolio *Bilddokumente von Kampf und Sieg* (Verlag Heinrich Hoffmann: Munich, n.d.).

Footnotes

89. F. A. Kauffmann (n.d.).
90. In his speech opening the Rhenish exhibit in Vienna in 1941, cited in B. Kroll (n.d.), pp. 140f.
91. E. Lutze, "Sinnbilder deutschen Landes—Zu Hermann Gradls Gemälden für die neue Reichskanzlei," *KiDR* 3, 7 (1939), pp. 218ff.
92. Accomplished by the "Law on the New Structure of the Reich" of January 30, 1934.
93. W. Horn (1942), p. 49.
94. *GDK* 1937, Nr. 310, Illus. 48.
95. F. A. Kauffmann (n.d.), p. 45.
96. G. W. F. Hegel, *Ästhetik*, I, pp. 170f.
97. *Ibid.*, II, p. 258.
98. On Zügel, see E. T. Rohnert, *Heinrich von Zügel—Ein Malerleben* (Berlin, 1942).
99. B. Kroll (n.d.), pp. 28f.
100. G. W. F. Hegel, *Ästhetik*, I, p. 171.
101. Catalog *Grosse Berliner Kunstausstellung* 1905, Nr. 375, Illus. 88.
102. Cf. R. Klein (n.d.); K. Braun (1936), pp. 33ff.
103. *KiDR* 1 (1937), p. 32.
104. Cf. H. Hammer (1938).
105. On the House of German Education in Bayreuth, see *Die Kunst* 77 (1937), pp. 89ff.
106. Painted in 1892, Kunsthalle Bremen.
107. Painted in 1890, Kunsthalle Bremen.
108. R. Hamann and J. Hermand (1973), pp. 326ff.
109. Title of a peasant triptych by Adelina Zandrino, *KiDR* 4, 11 (1940), p. 325.
110. *Das Bild*, 5, 6 (1935).
111. W. Rittich (1943), p. 64.
112. *KiDR* 6, 1 (1942), p. 26.
113. *GDK* 1940, Nr. 774.
114. *GDK* 1941, Nr. 717.
115. *KiDR* 3, 7 (1939), p. 236.
116. Cf. *Sachwörterbuch der Geschichte Deutschlands und der deutschen Arbeiterbewegung* (Berlin, GDR, 1969–70), II, p. 89.
117. Title of a book edited by A. Speer (Berlin, 1941).
118. GDK 1941, Nr. 1008.
119. *KiDR* 5, 8–9 (1941), p. 238, Color Illus. on p. 229.
120. W. Horn (1942), p. 45.
121. W. Horn (1943), pp. 16f.
122. See K. Lankheit (1959) on the triptych as a "vehicle of pathos."
123. Sketch (Kunsthaus, Zurich) for the painting, executed in 1780, for the Zurich city hall. In the finished painting the figures are clothed.
124. On these two paintings, see F. Antal (1973), pp. 70ff.
125. Done in 1617.
126. H. F. K. Günther (1943).
127. Cf. the *Organisationsbuch der NSDAP* (1936), p. 465f.

128. H. Fischer (1943), p. 84. The title of this painting is a National Socialist adaptation of the anti-Fascist song *Wir sind die Moorsoldaten (We Are the Moor Soldiers)*.

129. The defense budget (given in billions of RM) rose as follows in the years 1933 to 1943, the numbers in parentheses representing the percentage of the gross national product in each case: 1933—.7 (1.2); 1934—4.2 (5); 1935—5.5 (7.1); 1936—10.3 (11.2); 1937—11 (12); 1938—17.2 (15.7); 1939—32.3 (23); 1940—58.1 (40); 1941—75.6 (52); 1942—96.9 (64); 1943—117.9 (70). In this same period, the percentage of total state expenditures that went for defense rose from 8.3 to 81. Cited according to C. Bettelheim (1974), p. 327.

130. *GDK* 1942, Nr. 940, Illus. 11.

131. *Kunst dem Volk* (as in fn. 71), p. 12.

132. R. Volz (1938), pp. 341ff.

133. Hitler in his NSDAP campaign appeal *Mein Programm* for the presidential elections of 1932, cited in W. Reich (1933), pp. 95f.

134. Cited in J. C. Fest (1963), p. 366.

135. *Ibid.*, pp. 366f.

136. O. Kirchheimer (1972), pp. 126ff. A wife's illness was recognized as cause for divorce.

137. Cf. W. A. Boelcke (1966), p. 718.

138. H. Picker (1951), p. 301.

139. The National Socialists' intention of encouraging sexual aggression with paintings seems to have been successful even after the fall of the Third Reich. One of the female figures in Adolf Ziegler's *Four Elements* was slit open, presumably by American soldiers, in precisely the area that critics identified as Ziegler's specialty when they ironically honored him with the title "Master of German Pubic Hair."

140. R. Schulz (1940), pp. 292ff.

141. P. Schulze-Naumburg (1932), p. 42.

142. Painted in the years 1872 to 1878, Österreichische Galerie, Vienna.

143. *KiDR* 3, 3 (1939), pp. 82ff.

144. Cf. H. Fischer (1943).

145. W. Horn in *Nationalsozialistische Monatshefte* (1939), cited in E. Klessmann and W. Kunz (1973), p. 15.

146. See the photograph of a sitting area in a living room in the Munich "Führerhaus" that shows Ziegler's *Four Elements* hanging over the fireplace. *KiDR* 2, 10 (1938), p. 295.

147. R. Scholz in his review of the exhibition, *KiDR* 7, 7–8 (1943), p. 150.

148. W. Rittich in his review of the Munich exhibition of 1942, *KiDR* 6, 11 (1942), p. 268.

149. *GDK* 1941, Nr. 1059, in the possession of Countess

Footnotes

Arnim-Muskau. See, also, *Die Kunst* 83 (1941), p. 268.

150. W. Hofer (1957), p. 217.
151. *Das Bild* 6, 3 (1936), p. 90.
152. *KiDR* 5, 5 (1941), p. 136.
153. J. Sommer (1940), pp. 114ff. The format of the individual tapestries was to be 5.4 by 10 meters.
154. *Ibid.*, pp. 114 and 121. On the revival of tapestry weaving, see B. Kroll (1938), pp. 372ff.
155. Proclamation issued on January 30, 1943.
156. W. Flechsig (1939), pp. 358ff. W. Flechsig (1940), pp. 86ff.
157. O. Lill (1941), pp. 15ff.
158. K. Rupflin (1942), pp. 155ff.
159. J. A. Beringer (1934), pp. 296ff.
160. J. Lampe (1939), pp. 236ff.
161. *GDK* 1942, Nr. 43, now in the possession of the Bayrische Staatsgemäldesammlungen, Munich.
162. *KiDR* 6, 8–9 (1942), p. 235.
163. *Ibid.*, 7, 7–8 (1943), p. 148.
164. *Ibid.*, 5, 8–9 (1941), p. 260.
165. *Ibid.*, 6, 8–9 (1942), p. 216.
166. *Das Bild*, 5, 1 (1935), p. 18.
167. *KiDR* 7–8 (1943), p. 154.
168. *Kunst dem Volk* (as in fn. 71), p. 27.
169. *KiDR* 6, 11 (1942), p. 274.
170. *Ibid.*, 6, 8–9 (1942), p. 208.
171. *GDK* 1943, Nr. 1003, Illus. 27.
172. *GDK* 1942, Nr. 1098.
173. *GDK* 1940, Nr. 1264, Illus. 37.
174. *GDK* 1939, Nr. 1200, Illus. 41.
175. *GDK* 1939, Nr. 1175, Illus. 43.
176. Nine Makarts were to be included in the Linz gallery.
177. See the many portraits by Raffael Schuster-Woldan, e.g., in *Das Bild* 5, 11 (1935), p. 356. Also those by Hans Schlereth, *GDK* 1942, Nr. 926, Illus. 37; *GDK* 1943, Nr. 847, Illus. 28, and by Carl Otto Müller, *KiDR* 5, 7 (1941), p. 211.
178. The few advertisements there were for consumer goods reflected this same spirit. The goods advertised were usually pure luxury items designed for those with expensive tastes. See the illustrated ads in *KiDR*, where the goods most often advertised were champagne (MM, Söhnlein), porcelain, figurines, jewelry (Rosenthal, Hutschenreuther, Fahrner, WMF), furniture (Deutsche Werkstätten), cameras (Leica), luxury cigarettes (Haus Neuerburg), cars (Mercedes-Benz), cosmetics, spas, and resorts.
179. B. Brecht (1971), pp. 40ff.
180. *Ibid.*, pp. 75ff.
181. This is so even if we elevate reality as it is presented in the "new art" to a "new reality." Cf., for example, W. Horn (1938), p. 44, "Die Kunst in unserer neuen

Wirklichkeit."

182. A. Gehlen (1960), p. 15.

183. In B. Kroll (n.d.), p. 141.

184. Cf. *Die Lichtbildkunst dem Volke* (Berlin, 1936).

185. H. W. Fischer (1935), p. 9.

186. H. Wilke (1939), pp. 97 and 131.

187. W. Burghardt (1940), p. 179, a photograph; Mathias Schumacher, *Archeress*, in H. Wilke (1939), p. 124.

188. Photograph in A. R. Marsani (1939), p. 116; Fritz Klimsch, *Anadyomene, GDK* 1941, Illus. 55.

189. Photograph in W. Burghardt (1940), p. 129; Julius Engelhard, *Bathing in a Mountain Lake.*

190. Wilhelm Petersen, *Young Frisian Woman*, in B. Kroll (n.d.), opposite p. 144; photograph in A. R. Marsani (1939), p. 19.

191. Adolf Wissel, *Young Farm Women*, in B. Kroll (n.d.), p. 172; photograph *South Tyrolian Youth*, in H. W. Fischer (1935), p. 79.

192. Photograph in H. L. Oeser (1933), p. 115.

193. *Ibid.*, p. 19.

194. *Ibid.*, p. 31.

195. A. R. Marsani (1939), p. 20.

196. H. W. Fischer (1935), p. 83.

197. Advertisement of the firm "Forma" in *Die neue Linie* (March, 1938), p. 48.

198. On this subject, see J. Habermas (1962).

199. On architecture, see A. Teut (1967), K. Arndt (1968), B. Miller-Lane (1968), A. M. Vogt (1970), R. R. Taylor (1974), Catalog *Kunst im 3. Reich—Dokumente der Unterwerfung* (1974), and J. Petsch (1976).

200. Hitler in his speech on September 7, 1937, in M. Domarus (1973), p. 719.

201. H. Brenner (1963), p. 118.

202. See, for example, B. K. Arndt (1968).

203. See H. Lehmann-Haupt (1954) and J. Petsch (1976).

204. A. M. Vogt (1970) notes that utopian building plans of the French Revolutionary period, like National Socialist buildings, strove to convey a sense of cosmic vastness. See, too, fn. 229 below.

205. The *Deutsche Bauzeitung* of July 27, 1938, p. 807, tabulates the value of public, commercial, and residential building activity for the years 1928 to 1937.

206. The amount of government subsidy for building rose from about 33 percent in 1927 to 67.5 percent in 1936 and 72.6 percent in 1937. In 1938, it was about 80 percent, and by the beginning of the war it had reached the 100 percent mark. See A. Teut (1967), p. 77.

207. H. Seeger (1943), p. 9.

208. Speech of September 23, 1933, initiating *autobahn* construction in Frankfurt, cited in F. Meystre (1935), p. 58.

209. Hitler saw the construction of both battleships and

Footnotes

buildings in this light. See A. Speer (1969), p. 82.

210. Between 1932 and 1939, the gross income of the Frankfurt company Philipp Holzmann A. G., one of the largest German building firms, rose by almost 900 percent. The only other firms to achieve comparable rises were those in the arms industry. See C. Bettelheim (1974), p. 234.

211. "The predominance of large buildings constructed by large firms is obvious." A. Teut (1967), p. 77.

212. *Ibid.*, pp. 251ff.

213. Cf. *Statistik des Deutschen Reiches*, vol. 518 (*Die sportlichen Übungsstätten im Deutschen Reich*) (Berlin, 1938). Instead, the regime constantly referred to the Berlin Olympic Stadium and the Nuremberg Stadium in an effort to convince the public that it was furthering the cause of sports and public health.

214. See G. Fränk and W. Hempfing (1939).

215. Speech of September 7, 1937, in Nuremberg, cited in A. Teut (1967), p. 188.

216. E. Schindler (1936), p. 290.

217. Speech of September 6, 1938, in Nuremberg, cited in M. Domarus (1973), pp. 893f.

218. See A. Speer (1969), p. 167. On the ceremonial and communal room, see, too, J. Wulf (1963), pp. 178f.

219. See *Die Kunst* 77, 3 (1937), pp. 89ff.

220. On ideological aspects, see H. Schrade (1934); on practical ones, see H. Stephan (1944).

221. In accordance with a law of June 1, 1933, limiting the use of machinery, the Prussian government reintroduced, for example, stone cutting by hand in place of stone processing by machine. See C. Böhm (1973), p. 75.

222. On the aversion or, indeed, aggression of many architects toward industrialized construction, see A. von Senger (1934), p. 497.

223. F. Tamms, *KiDR* 8, 11 (1944). The craft of stone cutting, which had nearly died out, enjoyed a renaissance. Speer commissioned Walter Hege to make the film *Stone Cutters at Work* (1941) for the specific purpose of promoting this profession.

224. According to Paul Giesler, the architect of the so-called "castles of the order," the NSDAP training centers. Cited in J. Wulf (1963), p. 226.

225. Hitler on September 7, 1937, in Nuremberg, A. Teut (1967), p. 188.

226. On Fritz Todt's principles governing building, see *KiDR* 6, 3 (1942) "Die Baukunst," p. 51.

227. P. Schmitthenner (1934), p. 21.

228. *Das Bild* 4, 11 (1943), editorial section.

229. See A. Speer (1969), particularly the chapter "Entfesseltes Empire," pp. 147ff. Whenever Speer speaks about his major buildings, he compares them

with the mammoth buildings of world history. "The
Cheops pyramid . . . measuring 230 meters long and
146 high, has a volume of 2,570,000 cubic meters. The
Nuremberg stadium . . . would have had a volume of
8,500,000 cubic meters, about three times that of the
Cheops pyramid" (p. 81). This irrelevant competition
betrays a lack of concern for function and is meant to
lend a mythical stature to these projects. The build-
ings to be included in the planned Adolf-Hitler Square
in Berlin were to comprise 25,250,000 cubic meters of
enclosed space. The domed hall alone would have had
a volume of 21,000,000 cubic meters. For notes on the
financing, see pp. 147ff.

230. Also in the form of forced gifts, which further
reduced the level of individual consumption. *Ibid.*, p.
155.
231. Cited in P. Schmitthenner (1934), p. 38.
232. Hitler on September 11, 1934, in Nuremberg, M.
Domarus (1973), p. 526.
233. *Ibid.*, p. 527.
234. Hitler on November 27, 1937, in Berlin, *Ibid.*, p. 766.
235. *Illustrierter Beobachter—Das Deutschland Adolf
Hitlers, die ersten vier Jahre des Dritten Reiches*
(Munich, 1937), p. 46.
236. Hitler's speech on the occasion of laying the corner-
stone for the House of German Art, September 15,
1933, M. Domarus (1973), p. 316.
237. Hitler on September 7, 1937, in Nuremberg, A. Teut
(1967), p. 189.
238. A. Speer (1969), p. 69.
239. F. Tamms, *KiDR* 8, 3 (1943), p. 60.
240. In laying the cornerstone for the school of Military
Technology on November 27, 1937, Hitler said, "We
are therefore deliberately removing the work to be
done in the next twenty years [in redesigning Berlin]
from the criticism of the present and submitting it
instead to the judgment of those generations that are
to follow." M. Domarus (1973), p. 765.
241. A. Loos (1910), p. 315.
242. Hitler on September 11, 1935, in Nuremberg, B. Hinz
(1974), p. 151.
243. Hitler on September 9, 1935, in Nuremberg, M.
Domarus (1973), p. 639.
244. See Möller van den Bruck's book (1931), which re-
ceived considerable attention at the time.
245. Cf. K. Arndt (1970), p. 42.
246. To some extent, government buildings provided models
for private ones, such as the AEG headquarters
planned for the center of Berlin by Peter Behrens,
KiDR 3, 10 (1939), "Die Baukunst," pp. 447ff.; also
I. G. Farben's "Agfa House," *KiDR* 4, 1 (1940), "Die
Baukunst," pp. 1ff.

Footnotes

247. This building, incorporating steel construction and cut stone façades, was especially typical of the monumental character of National Socialist architecture. An important consideration in this type of construction was how imposing it was under illumination at night.

248. See W. von Wersin (1940).

249. On the ordinance "Art in Building" and on the financing of this art, see A. Teut (1967), pp. 187ff.

250. On this use of metaphor, see S. Kracauer (1963).

251. H. Schrade (1937), p. 19.

252. H. Fischer (1943), p. 77.

253. Hitler on September 7, 1937, in Nuremberg, A. Teut (1967), p. 189. Under the heading "The Law of Monumentality," F. Tamms, *KiDR* 8, 3 (1944), p. 60, summarizes the basic characteristics of National Socialist architecture:

> It must be rigorous, of spare, clear, indeed classical form. It must be simple. It must have a quality of "touching the heavens." It must transcend everyday utilitarian considerations. It must be generous in its conception, sturdy in its construction, built for the ages according to the best principles of the trade. In practical terms, it must have no purpose but instead be the vehicle of an idea. It must have an element of the unapproachable in it that fills people with admiration and awe. It must be impersonal because it is not the work of an individual but the symbol of a community bound together by a common ideal.

254. See A. Speer (1969), p. 71.

255. H. Schrade uses this phrase (June 1934), p. 512.

256. The issue in the painting is *KiDR* 2, 3 (1938), p. 84, which shows Fritz Klimsch's *Woman Looking into the Distance*.

257. See U. Silva (1973), Illus. 5–7.

258. See M. Domarus (1973), p. 367.

259. K. Arndt (1970), pp. 65f., lists the most important films on architecture. His purpose is, however, the purely documentary one of "providing insights, which cannot be gained by any other method, into the formal repertoire of National Socialist buildings."

260. H. Schrade (June 1934); also, H. Brenner (1963), pp. 118ff.

261. This is a requirement laid out in the "Guidelines for Constructing Communal Centers for Local NSDAP Groups," *Zentralblatt der Bauverwaltung* 61 (1941), pp. 146ff.

262. J. Kunst (1971), pp. 51f.

263. This concept had already been used in Poeltzig's I. G. building in Frankfurt.

264. Cf. F. Hellwag (1937).

265. See H. Brenner (1963), pp. 127ff., and A. Teut (1967), pp. 222ff. Wilhelm Kreis, who had always been a specialist for memorial monuments, was appointed "General Architectural Consultant for the Design of German Military Cemeteries" and commissioned with carrying out this project.
266. Cited in A. Teut (1967), p. 13.
267. On this theme, see M. Jürgens (1970).

BIBLIOGRAPHY

Abbreviations:

KiDR—Die Kunst im Dritten Reich, 1937–1944 (later known as *Die Kunst im Deutschen Reich*).

GDK—Catalog of the Grosse Deutsche Kunstausstellung, Munich 1937–1944.

Abendroth, W., ed. *Faschismus und Kapitalismus—Theorien über die sozialen Ursprünge des Faschismus*. Frankfurt a. M., 1967.

Albrecht, G. *Nationalsozialistische Filmpolitik—Eine soziologische Untersuchung über die Spielfilme des Dritten Reiches*. Stuttgart, 1969.

Aley, P. "Das Bilderbuch im Dritten Reich," in Doderer and Müller, eds. *Das Bilderbuch*. Weinheim and Basel, 1973.

Alff, W. "Die Angst vor der Dekadenz—Zur Kunstpolitik des deutschen Faschismus," in Alff, *Der Begriff Faschismus und andere Aufsätze zur Zeitgeschichte*. Frankfurt a. M., 1971, pp. 124ff.

Alt, T. *Die Herabsetzung der deutschen Kunst durch die Parteigänger des Impressionismus*. Mannheim, 1911.

Ammann, H. *Lichtbild und Film in Unterricht und Volksbildung*. Munich, n.d. [c. 1936].

Antal, F. *Füssli-Studien*. Dresden, 1973.

Appel, H. "Düsseldorfer Landschaftsmaler im 19. Jahrhundert," in H. Trier, ed. *Zweihundert Jahre Kunstakademie Düsseldorf*. Düsseldorf, 1973, pp. 85ff.

Arndt, K., and Dohl, H. *Das Wort aus Stein—Kommentardruck zur zeitgeschichtlichen Edition G 47 des Instituts für den wissenschaftlichen Film (IWF)*, in the series *Filmdokumente zur Zeitgeschichte*. Göttingen, 1965. Also in *Publikationen zu wissenschaftlichen Filmen*, ed. G. Wolf, section *Geschichte, Pädagogik, Publizistik*, 1, 2 (May 1968), pp. 171ff.

Arndt, K. "Zur Eröffnung der Grossen Deutschen Kunstausstellung durch Hitler, München 1938," *Kommentardruck zur Edition G 32 des IWF*. Göttingen, 1968, pp. 158ff.

———. "Filmdokumente des Nationalsozialismus als Quellen für architekturgeschichtliche Forschungen," in G. Moltmann and K. F. Reimers, eds. *Zeitgeschichte im Film- und Tondokument—17 historische, pädagogische und sozialwissenschaftliche Beiträge*. Göttingen, 1970, pp. 39ff.

———. "Baustelle Reichsparteitagsgelände 1938/39," *Kommentardruck G 142, Filmdokumente zur Zeitgeschichte*. Göttingen, 1973.

Bibliography

Behne, A. *Entartete Kunst*. Berlin, 1946.

Benn, G. *Kunst und Macht*. Stuttgart and Berlin, 1934.

Beringer, J. A. "Adolf Hildenbrand," in *Die Kunst* 69, 10 (1934), pp. 296ff.

Bettelheim, C. *Die deutsche Wirtschaft unter dem Nationalsozialismus*. Munich, 1974.

Bie, R. *Deutsche Malerei der Gegenwart*. Weimar, 1930.

Bleuel, H. P. *Das saubere Reich—Theorie und Praxis des sittlichen Lebens im Dritten Reich*. Bern, Munich and Vienna, 1972.

Bloch, C. *Die SA und die Krise des NS-Regimes 1934*. Frankfurt a. M., 1970.

Bode, W. *Die Meister der holländischen und vlämischen Malerschulen*. Leipzig, 1923.

Boelcke, W. A., ed. *Kriegspropaganda 1939–1941—Geheime Ministerkonferenzen im Reichspropagandaministerium*. Stuttgart, 1966.

Böhm, C. "Zur Entwicklung der Arbeitslosigkeit und zur Lage der Notstandsarbeiter im faschistischen Deutschland 1933–34," in *Wissenschaftliche Zeitschrift der Humboldt-Universität zu Berlin—Gesellschaftswissenschaftliche Reihe*, 22, 1/2 (1973), pp. 67ff.

Bötticher, R. *Kunst und Erziehung im neuen Reich*. Breslau, 1933.

Bonatz, P., and Wehner, B. *Reichsautobahn-Strassenmeistereien*. Berlin, Prague, and Vienna, 1942.

Braun, K. "Fritz Boehle, ein deutscher Maler." *Die Kunst*, 75, 2 (1936), pp. 33ff.

Brecht, B. *Über Politik und Kunst* ed. W. Hecht, Frankfurt a. M., 1971.

———. *Über Realismus* ed. W. Hecht, Frankfurt, a. M., 1971.

Brenner, H. "Die Kunst im politischen Machtkampf der Jahre 1933/34." *Vierteljahrshefte für Zeitgeschichte*, 10, 1 (1962), pp. 17ff.

———. *Die Kunstpolitik des Nationalsozialismus*. Reinbek, 1963.

———. *Ende einer bürgerlichen Kunstinstitution*. Stuttgart, 1972.

Brinkmann, R. *Wirtschaftspolitik aus nationalsozialistischem Kraftquell—Eine Sammlung ausgewählter Vorträge, Reden und Ansprachen*. Jena, 1939.

Burghardt, W. *Sieg der Körperfreude*. Dresden, 1940.

Busch, G. *Entartete Kunst—Geschichte und Moral*. Frankfurt a. M., 1969.

Catalog *Kunst in Duitsland 1919–1944*. N. p. [Amsterdam], n.d. [after 1966].

———. *Russischer Realismus—Malerei in der 2. Hälfte des 19. Jahrhunderts*. Baden-Baden, 1972.

———. *Makart*. Baden-Baden, 1972.

———. *Grosse Berliner Kunstausstellung 1905*.

———. *Ausstellung deutscher Kunst aus der Zeit von 1775–*

1875 in der königlichen Nationalgalerie Berlin 1906.
Munich, 1906.

―――. *Grosse Berliner Kunstausstellung 1906.*

―――. *Grosse Deutsche in Bildnissen ihrer Zeit.* On the
occasion of the 11th Olympic Games. Berlin, 1936.

―――. *Bauen in Berlin 1900–1964.* Berlin, Akademie der
Künste, 1964.

―――. *Realismus und Sachlichkeit—Aspekte deutscher
Kunst 1919–1933.* Berlin (GDR), 1974.

―――. *Kind und Kunst—Zur Geschichte des Zeichnen- und
Kunstunterrichts.* Berlin, 1976.

―――. *Deutsche Kunst Düsseldorf 1928.*

―――. *Industrie und Technik in der deutschen Malerei von
der Romantik bis zur Gegenwart.* Duisburg, 1969.

―――. *Kunst und Technik.* Essen, 1928.

―――. *Kunst im 3. Reich—Dokumente der Unterwerfung.*
Frankfurt a. M., 1974. On this exhibition: *Reaktionen—
Kunst im 3. Reich—Dokumente der Unterwerfung.*
Frankfurt a. M., 1975.

―――. *Kunst in Deutschland 1898–1973.* Hamburg, 1973.

―――. *Arno Breker.* Cologne, n.d.

―――. *Gemälde Galerie Linz—Inhaltsverzeichnis Band
I–XX.* n.p., n.d.

―――. *Deutsche Kunstausstellung München 1930 im
Glaspalast.*

―――. *"Entartete Kunst"—Bildersturm vor 25 Jahren.*
Munich, 1962.

―――. *Verkannte Kunst.* Recklinghausen, 1957.

Courtade, F., and Cadars, P. *Geschichte des Films im
Dritten Reich.* Munich, 1975.

Czichon, E. *Wer verhalf Hitler zur Macht?* Cologne, 1967.

Domarus, M. *Hitler—Reden und Proklamationen 1932–1945.*
Wiesbaden, 1973.

Dresler, A. *Das Braune Haus und das Verwaltungsgebäude
der Reichsleitung der NSDAP in München.* Munich, 1937.

―――. *Deutsche Kunst und entartete Kunst—Kunstwerk
und Zerrbild als Spiegel der Weltanschauung.* Munich,
n.d. [1938].

Dreyer, E. A. *Deutsche Kultur im Neuen Reich—Wesen,
Aufgaben und Ziele der Reichskulturkammer.* Potsdam,
1934.

―――. *Werner Peiner—Vom geistigen Gesetz deutscher
Kunst.* Hamburg, 1936.

Einstein, C. *Die Kunst des 20. Jahrhunderts.* Propyläen-
Kunstgeschichte, 16. Berlin, 1931.

Engelbert, K. *Deutsche Kunst im totalen Staat.* Lahr
(Baden), 1933.

Farner, K. *Kunst als Engagement—Zehn ausgewählte
Essays.* Darmstadt and Neuwied, 1973.

Faschismus-Theorien, Nrs. 1–6, in *Das Argument,* 1964–70.

"Faschistische öffentlichkeit," in *Ästhetik und Kommunika-
tion,* 26 (1976).

Bibliography

Feistel-Rohmeder, B. *Im Terror des Kunstbolschewismus—Urkundensammlung des "Deutschen Kunstberichtes" aus den Jahren 1927–33.* Karlsruhe, 1938.

Fest, J. C. *Das Gesicht des Dritten Reiches—Profile einer totalen Herrschaft.* Munich, 1963.

Fischer, H. "Das Thema 'Reichsarbeitsdienst'—Maler, Bildhauer und Zeichner besuchen den Arbeitsmann an der Front." *KiDR* 7, 4/5, (1943), pp. 76ff.

Fischer, H. W. *Menschenschönheit—Gestalt und Antlitz des Menschen in Leben und Kunst.* Berlin, 1935.

Fischer, J. *Maler und Zeichner schauen den Krieg (Maler als Soldaten).* Published by the Propagandakompanie der Armee Busch in Verbindung mit der graphischen Arbeitsgemeinschaft Jupp Daehler, Berlin, n.d.

Flechsig, W. "Der Braunschweigische Staatsdom mit der Gruft Heinrichs des Löwen—Ein Vorbild gegenwartsnaher Denkmalspflege im neuen Deutschland." *KiDR* 3, 11 (1939), pp. 358ff.

————. "Sinnbilder der Geschichte—Zu Wilhelm Dohmes Wandbildern im Braunschweiger Dom." *KiDR* 4, 3 (1940), pp. 86ff.

Floerke, H. *Studien zur niederländischen Kunst- und Kulturgeschichte—Die Formen des Kunsthandels, das Atelier und die Sammler in den Niederlanden vom 15.–18. Jahrhundert.* Munich and Leipzig, 1905.

Frank, G., and Hempfing, W. *Die Neugestaltung deutscher Städte—Kommentar zum Gesetz vom 4. Oktober 1937.* Berlin and Munich, 1939.

Frescot, J., Geist J. F., and Kerbs, D. *Fidus—Zur ästhetischen Praxis bürgerlicher Fluchtbewegungen.* Munich, 1972.

Friedländer, M. J. *Essays über die Landschaftsmalerei und andere Bildgattungen.* Den Haag and Oxford, 1947.

Friemert, C. "Das Amt 'Schönheit der Arbeit'—Ein Beispiel zur Verwendung des Ästhetischen in der Produktionssphäre." *Das Argument*, 72 (1972), pp. 258ff.

Fritzsche, R., ed. *Jahrbuch der deutschen Wirtschaft 1937.* Leipzig, 1937.

Frommhold, E., ed. *Kunst im Widerstand.* Dresden, 1968.

Gamm, H.-J. *Der braune Kult—Das Dritte Reich und seine Ersatzreligion—Ein Beitrag zur politischen Bildung.* Hamburg, 1962.

Gehlen, A. *Zeit-Bilder—Zur Soziologie und Ästhetik der modernen Malerei.* Frankfurt a. M., 1960.

Glaser, H. *Spiesserideologie—Von der Zerstörung des deutschen Geistes im 19. und 20. Jahrhundert.* Freiburg (Breisgau), 1964.

Goebbels, J. *Signale der neuen Zeit—25 ausgewählte Reden von Dr. Joseph Goebbels.* Munich, 1938.

Grosz, G., and Herzfelde, W. *Die Kunst ist in Gefahr.* Berlin, 1925.

Günther, H. F. K. *Rasse und Stil—Gedanken über ihre*

Beziehungen im Leben und in der Geistesgeschichte der europäischen Völker, insbesondere des deutschen Volkes. Munich, 1926.

―――. *Kleine Rassenkunde des deutschen Volkes.* Munich and Berlin, 1943.

Gurlitt, C. *Die deutsche Kunst des Neunzehnten Jahrhunderts—Ihre Ziele und Taten.* Berlin, 1899. (4th ed. publ. in Berlin, 1924, as *Die deutsche Kunst seit 1800—Ihre Ziele und Taten.*)

Guthmann, H. *Zweierlei Kunst in Deutschland?* Berlin, 1935.

Habermas, J. *Strukturwandel der Öffentlichkeit.* Neuwied and Berlin, 1962.

Haftmann, W. *Malerei im 20. Jahrhundert.* Munich, 1957.

Hansen, W. *Judenkunst in Deutschland—Quellen und Studien zur Judenfrage aus dem Gebiet der bildenden Kunst. Ein Handbuch zur Geschichte der Verjudung und Entartung deutscher Kunst 1900–1933.* Berlin, 1942.

Hamann, R., and Hermand J. *Stilkunst um 1900. Epochen deutscher Kultur von 1870 bis zur Gegenwart,* vol. 4. Munich, 1973.

Hammer, H. *Albin Egger-Lienz—Ein Buch für das deutsche Volk.* Innsbruck, 1938.

Hartmann, W. *Der historische Festzug.* Munich, 1976.

Haug, W. F. *Der hilflose Antifaschismus.* Frankfurt a. M., 1970.

―――. *Kritik der Warenästhetik.* Frankfurt a. M., 1971.

Hauser, A. *Sozialgeschichte der Kunst und Literatur.* Munich, 1958.

Hegel, G. W. F. *Ästhetik,* ed. F. Bassenge. Frankfurt a. M., n.d.

Hellack, G. "Architektur und bildende Kunst als Mittel nationalsozialistischer Propaganda." *Publizistik—Zeitschrift für die Wissenschaft von Presse, Rundfunk, Film, Rhetorik, Werbung und Meinungsbildung,* 5 (1960), pp. 77ff.

Hellwag, F. "Das Seebad der Zwanzigtausend—Wettbewerb für 'Kraft durch Freude.'" *Die Kunst,* 75, 1 (1937), pp. 185ff.

Hentzen, A. *Die Berliner Nationalgalerie im Bildersturm.* Cologne and Berlin, 1971.

Herding K., and Mittig, H.-E. *Kunst und Alltag im NS-System. Albert Speers Berliner Strassenlaternen.* Giessen, 1975.

Hiepe, R. *Gewissen und Gestaltung—Deutsche Kunst im Widerstand.* Frankfurt a. M., 1960.

Hildebrandt, H. *Die Kunst des 19. und 20. Jahrhunderts (Handbuch der Kunstwissenschaft).* Potsdam, 1924.

Hinkel, H., ed. *Handbuch der Reichskulturkammer.* Berlin, 1937.

Hinkel, H. *Zur Funktion des Bildes im deutschen Faschismus—Bildbeispiele, Analysen, didaktische Vorschläge.* Giessen,

1975.

Hinz, B. "Zur Dialektik des bürgerlichen Autonomiebegriffs," in *Autonomie der Kunst—Zur Genese und Kritik einer bürgerlichen Kategorie*. Frankfurt a. M., 1972.

———. "Säkularisation als verwerteter 'Bildersturm'—Zum Prozess der Aneignung der Kunst durch die Bürgerliche Gesellschaft," in M. Warnke, ed. *Bildersturm—Die Zerstörung des Kunstwerks*. Munich, 1973.

———. "Tesi sull' estetica del nazionalsocialismo." *Arte e fascismo*. Milan, 1974.

———. *Die Malerei im deutschen Faschismus—Kunst und Konterrevolution*. Munich, 1974. Includes 5 complete "speeches on culture" by Hitler.

Hitler, A. *Mein Kampf*. Munich, 1926.

Hofer, W. *Der Nationalsozialismus—Dokumente 1933–1945*. Frankfurt a. M., 1957.

Hoffmann, H. *Tag der Deutschen Kunst*. Diessen, 1937. Includes 100 original stereoscopic photographs.

Hofmann, W. *Grundlagen der modernen Kunst—Eine Einführung in ihre symbolischen Formen*. Stuttgart, 1966.

Horn, W. "Die Kunst unserer neuen Wirklichkeit—Zur Ausstellung 'Deutscher Bauer—Deutsches Land' in Berlin." *KiDR* 2, 1 (1938), pp. 44ff.

———. "Kunst und Technik." *KiDR* 6, 2 (1942), pp. 42ff.

———. "Ein Denkmal der deutschen Arbeit." *KiDR* 7, 1 (1943), pp. 16f.

Illustrierter Beobachter—Das Deutschland Adolf Hitlers, die ersten vier Jahre des Dritten Reiches. Munich, 1937.

Im Kampf um die Kunst. Munich, 1911.

Jürgens, M. "Bemerkungen zur 'Ästhetisierung der Politik,'" in *Ästhetik und Gewalt*. Gütersloh, 1970, pp. 8ff.

Kauffmann, F. A. *Die neue deutsche Malerei*. Berlin, 1941. Nr. 11 in a series published by the Deutsche Informationsstelle, entitled *Das Deutschland der Gegenwart*.

Kemp, W. "Das Bild der Menge (1789–1830)," in *Städel-Jahrbuch*, new series 4 (1973), pp. 249ff.

Kiener, H. "Das Haus der Deutschen Kunst in München," in the catalog *Grosse Deutsche Kunstausstellung 1937*. Munich, 1937, pp. 17ff.

Kindt, W. "Kunsterziehung durch die NS-Gemeinschaft 'Kraft durch Freude.'" *KiDR* 3, 8 (1939), "Die Baukunst." pp. 1f.

Kirchheimer, O. *Funktionen des Staats und der Verfassung—Zehn Analysen*, Frankfurt a. M., 1972.

Klein, R. "Fritz Boehle," in *Kunst der Gegenwart*, 1, vol. 4, Berlin, n.d.

Klessmann, E., and Kunz, W. "Musen im Gleichschritt—Kunst im Dritten Reich (1)." *Zeitmagazin*, Nr. 21 of May 18, 1973.

Köhler, G. *Kunstanschauung und Kunstkritik in der nationalsozialistischen Presse—Die Kritik im Feuilleton des "Völkischen Beobachters" 1920–1932*. Diss. Munich, 1936.

Published in book form, Munich, 1937.

Kokoschka, O. *Mein Leben.* Munich, 1971.

Kollwitz, K. *Aus meinem Leben.* Munich, 1967.

Kracauer, S. *Das Ornament der Masse—Essays.* Frankfurt a. M., 1963.

Kratsch, G. *Kunstwart und Dürerbund.* Göttingen, 1969.

Kroll, B. *Deutsche Maler der Gegenwart—Die Entwicklung der Deutschen Malerei seit 1900.* Berlin, 1937.

———. "Der neue deutsche Gobelin." *KiDR* 2, 12 (1938), pp. 372ff.

Kruck, A. *Geschichte des Alldeutschen Verbandes 1890–1939.* Wiesbaden, 1954.

Kuczynski, J. *Darstellung der Lage der Arbeiter in Deutschland von 1933 bis 1945: Die Geschichte der Lage der Arbeiter unter dem Kapitalismus,* Pt. 1, vol. 6. Berlin (GDR), 1964.

Kühnl, R. *Der deutsche Faschismus in Quellen und Dokumenten.* Cologne, 1975.

Kunst, J. "Architektur und Macht—Überlegungen zur NS-Architektur." *Philipps Universität Marburg—Mitteilungen, Kommentare, Berichte,* 3, 9 (1971), pp. 51f.

Lärmer, K. *Autobahnbau in Deutschland 1933 bis 1945—Zu den Hintergründen.* Berlin (GDR), 1975.

Lampe, J. "Zu neuen Arbeiten von Carl Schwalbach." *Die Kunst,* 79, 11 (1939), pp. 326ff.

Langbehn, J. *Rembrandt als Erzieher—Von einem Deutschen.* 47th ed. Leipzig, 1909.

Langbehn J., and Nissen, M. *Dürer als Führer.* Munich, 1928.

Lankheit, K. *Das Triptychon als Pathosformel.* In the series *Abhandlungen der Heidelberger Akademie der Wissenschaften. Philosophisch-historische Klasse 1959,* Nr. 4. Heidelberg, 1959.

Lehmann-Haupt, H. *Art under a Dictatorship.* New York, 1954.

Lexikon der Kunst. Leipzig, 1971ff. Entries "Entartete Kunst," vol. 1, col. 625ff., "Kapitalismus und Kunst," vol. 2, col. 535ff., and "Kunstgattung," vol. 2., col. 784ff.

Lill, G. "Ein Nibelungenzyklus von Albert Burkart." *Die Kunst* 85, 1 (1941), pp. 15ff.

Lindner, W., and Tamms, F. *Das Mauerwerk.* Berlin, 1937.

Liska, P. *Nationalsozialistische Kunstpolitik.* Berlin, n.d., [1974].

Loos, A. *Architektur* (1910), in *Gesammelte Schriften,* ed. F. Glück, vol. 1. Vienna and Munich, 1962.

Lukács, G. *Die Zerstörung der Vernunft.* Neuwied and Berlin, 1962.

———. *Von Nietzsche zu Hitler oder der Irrationalismus und die deutsche Politik.* Frankfurt a. M., 1966.

Luther, K. "Zur 'Deutschen Werbegraphik-Ausstellung' im 'Haus der Kunst' zu Berlin." *Das Bild,* 6, 4 (1936), p. 131.

Lutze, E. "Sinnbilder deutschen Landes—Zu Herrmann

Gradls Gemälden für die neue Reichskanzlei." *KiDR* 3, 7 (1939), pp. 218ff.

March, W. *Bauwerk Reichssportfeld*. Berlin, 1936.

Marsani, A. R. *Frauen und Schönheit in aller Welt*. Berlin, 1939.

Marx, K. *Das Kapital*. vol. 1. Individual issue of vol. 23 of Marx' and Engels' works.

Mason, T. W. *Arbeiterklasse und Volksgemeinschaft— Dokumente und Materialien zur deutschen Arbeiterpolitik 1936–1939*, in the series *Schriften des Zentralinstituts für sozialwissenschaftliche Forschung der Freien Universität Berlin*, Nr. 22.

Meier-Gräfe, J. *Entwicklungsgeschichte der modernen Kunst*. Munich, 1904.

Metzger, G. "Art in Germany under Nationalsocialism." *Studio International* (March/April, 1970), pp. 110ff.

Meystre, F. *Sozialismus wie ihn der Führer sieht—Worte des Führers zu sozialen Fragen*. Munich, 1935.

Mierendorff, M. "Kann Kunst den Staat gefährden?" in *Welt der Arbeit*, 49, Cologne, Dec. 4, 1959.

Miller-Lane, B. *Architecture and Politics in Germany 1918– 1945*. Cambridge, Mass., 1968.

Möller van den Bruck, A. *Der preussische Stil*. 3d. ed. Breslau, 1931.

Muschler, R. C. *Ferdinand Staeger—Eine Monographie*. Leipzig, 1925.

Muther, R. *Geschichte der Malerei im XIX. Jahrhundert*. Munich, 1893/94.

Negt, O., and Kluge, A. *Öffentlichkeit und Erfahrung—Zur Organisationsanalyse von bürgerlicher und proletarischer Öffentlichkeit*. Frankfurt a. M., 1972.

Neumann, F. L. *Behemoth—The Structure and Practice of National Socialism*. London, 1943.

————. *Demokratischer und autoritärer Staat—Studien zur politischen Theorie*. Frankfurt a. M., 1967.

Nordau, M. *Entartung*. Berlin, 1893.

NS-Gemeinschaft "Kraft durch Freude," Amt Feierabend: *Der Arbeiter und die bildende Kunst—System und Aufgabe der Kunstausstellung in den Betrieben (Werkausstellungen, Fabrikausstellungen)*. N.p., n.d. [after 1938].

Oeser, H. L. *Deutsches Land und deutsches Volk*. Berlin, 1933.

Organisationsbuch der NSDAP, ed. Der Reichsorganisationsleiter der NSDAP. Munich, 1936.

Pennel, W. (i.e. Alfred Hentzen.) "Kampf um die Kunst." *Der Ring*, 5, 35 (Aug. 26, 1932).

Petsch, J. *Baukunst und Stadtplanung im Dritten Reich— Herleitung, Bestandsaufnahme, Entwicklung, Nachfolge*. Munich, 1976.

Pfefferkorn, R. *Die Berliner Secession—Eine Epoche deutscher Kunstgeschichte*. Berlin, 1972.

Pfister, R. "Hitlers Baukunst." *Baumeister*, 43, 2 (1946), pp. 25ff.

Picker, H. *Hitlers Tischgespräche im Führerhauptquartier 1941–1942*. Bonn, 1951.

Rabinbach, A. "Beauty of Labour—The Aesthetics of Production in the Third Reich." *Journal of Contemporary History*, London, Dec. 1976.

Raczynski, A. Count. *Geschichte der neueren deutschen Kunst*. Berlin, 1836–41.

Rave, P. O. *Kunstdiktatur im Dritten Reich*. Hamburg, 1949.

Reber, F. *Geschichte der neueren deutschen Kunst vom Ende des vorigen Jahrhunderts bis zur Wiener Ausstellung 1873—Mit Berücksichtigung der gleichzeitigen Kunstentwicklung in Frankreich, Belgien, Holland, England, Italien und den Ostseeländern*. Stuttgart, 1876.

Reich, W. *Massenpsychologie des Faschismus*. Copenhagen, Prague, and Zurich, 1933. Reprinted, Frankfurt a. M., 1972.

Ries, B. *Die Finanzpolitik im Deutschen Reich 1933–1935*. Diss. Freiburg, 1964.

Rittich, W. *Architektur und Bauplastik der Gegenwart*. Berlin, 1936.

———. "Der Maler Karl Leipold." *KiDR* 2, 6 (1938), pp. 184ff.

———. "Bilder der Arbeit." *Kunst und Volk*, 5, 1 (1937), pp. 4ff.

———. *Deutsche Kunst der Gegenwart 2—Malerei und Graphik*. Breslau, 1943.

Rodens, F. *Vom Wesen deutscher Kunst*. Berlin, 1942. Nr. 5 in the series *Volkswerdung und Glaube*.

Roh, F. *Geschichte der deutschen Kunst von 1900 bis zur Gegenwart*. Munich, 1958.

———. *"Entartete Kunst"—Kunstbarbarei im Dritten Reich*. Hanover, 1962.

Rohnert, E. T. *Heinrich von Zügel—Ein Malerleben*. Berlin, 1942.

Rosenberg, A. *Der Mythos des 20. Jahrhunderts—Eine Wertung der seelisch-geistigen Gestaltenkämpfe unserer Zeit*. Munich, 1930.

———. *Revolution in der bildenden Kunst?* Munich, 1934.

Roxan, D., and Wanstall, K. *Der Kunstraub—Ein Kapitel aus den Tagen des Dritten Reichs*. Munich, 1966.

Rumpf, K. *Eine deutsche Bauernkunst*. Marburg, 1943.

Rupflin, K. "Neue Wandmalereien von Paul Bürck." *Die Kunst*, 85, 1 (1941), pp. 155ff.

Sachwörterbuch der Geschichte Deutschlands und der deutschen Arbeiterbewegung. Berlin (GDR), 1969–70. Entries: "Faschismus," vol. 1, pp. 571ff., and "Revolution," vol. 2, pp. 382ff.

Sager, P. *Neue Formen des Realismus—Kunst zwischen Illusion und Wirklichkeit*. Cologne, 1974, pp. 33ff.

Bibliography

Sauerland, M. *Im Kampf um die moderne Kunst—Briefe 1902–1933*. Munich, 1957.

Scharfe, S. *Deutschland über Alles—Ehrenmale des Weltkrieges*. Königstein (Taunus) and Leipzig, 1940.

Scheerer, H. "Gestaltung im Dritten Reich." *Form—Zeitschrift für Gestaltung*, (1975) 69, pp. 21ff.; 70, pp. 27ff. and 71 pp. 25ff.

Scheltema, F. A. van. "Kunstgeschichtliches Zwischenspiel." *Prisma* 23/24 (1948), pp. 30ff.

Schindler, E. "Gedanken zur Deutschen bildenden Kunst der Zukunft." *Das Bild*, 6, 8 (1936), pp. 259ff.

Schirach, B. von. *Zwei Reden zur deutschen Kunst*. Munich, 1941.

Schmeer, K. *Regie des öffentlichen Lebens im Dritten Reich*. Munich, 1956.

Schmidt, D. *In letzter Stunde—Künstlerschriften (2) 1933–1943*. Dresden, 1964.

Schmitt, H.-J., ed. *Die Expressionismusdebatte—Materialien zu einer marxistischen Realismuskonzeption*. Frankfurt a. M., 1973.

Schmitthenner, P. *Baukunst im neuen Reich*. Munich, 1934.

Schmalenbach, F. "Die Malerei der 'Neuen Sachlichkeit.'" *Das Münster—Zeitschrift für christiliche Kunst und Kunstwissenschaft*, 26, 3 (1973), pp. 180ff.

Scholz, R. "Das Problem der Aktmalerei." *KiDR* 4, 10, (1940), pp. 292ff.

Schorer, G. *Deutsche Kunstbetrachtung*. Munich, Dortmund, and Breslau, 1939. In the series *Bayreuther Bücher für Erziehung und Unterricht*, published by the Reichsverwaltung des NSLB.

Schrade, H. *Das deutsche Nationaldenkmal*. Munich, 1934.

———. "Der Sinn der künstlerischen Aufgabe und politischen Architektkur." *Nationasozialistische Monatshefte*, 5 (June 1934), pp. 508ff.

———. *Schicksal und Notwendigkeit der Kunst*. Leipzig, 1936.

———. *Bauten des Dritten Reiches*. Leipzig, 1937.

Schrieber, K. F. *Das Recht der Reichskulturkammer*. Berlin, 1935ff.

Schultze, I. *Der Missbrauch der Kunstgeschichte durch die imperialistische deutsche Ostpolitik*. Leipzig, 1970.

Schultze-Naumburg, P. *Kunst und Rasse*. Munich, 1928.

———. *Kampf um die Kunst*. Munich, 1932.

———. *Kunst aus Blut und Boden*. Leipzig, 1934.

———. "Zeitgebundene und blutgebundene Kunst." *Das Bild*, 4, 8 (1934), pp. 237ff.

Schweitzer, A. *Big Business in the Third Reich*. Bloomington (USA): Indiana U. Press, 1964.

Seeger, H. *Öffentliche Verwaltungsgebäude*. 3d ed. Leipzig, 1943. *Handbuch der Architektur*, pt. 4, vol. 7, Nr. 1b.

Seifert, A. *Volk und Kunst*. Freiburg, 1940.

Selle, G. *Ideologie und Utopie des Design—Zur gesell-*

schaftlichen Theorie der industriellen Formgebung. Cologne, 1973.

Sello, G. "Die Ausgestossenen—Kunst im Dritten Reich" (2). *Zeitmagazin,* 22 (May 25, 1973).

Senger, A. von. "Der Baubolschewismus und seine Verkoppelungen mit Wirtschaft und Politik." *Nationalsozialistische Monatshelfte,* 5 (June 1934), pp. 497ff.

Seydewitz, R. and M. *Die Dame mit dem Hermelin.* Berlin (GDR), 1963.

Silva, U. *Ideologia e arte del fascismo.* Milan, 1973.

Sluytermann von Langeweyde, W. *Kultur ist Dienst am Leben.* Berlin, 1938.

Sohn-Rethel, A. *Ökonomie und Klassenstruktur des deutschen Faschismus—Aufzeichnungen und Analysen.* Frankfurt a. M., 1973.

Sombart, W. *Der Bourgeois—Zur Geistesgeschichte des modernen Wirtschaftsmenschen.* Munich and Leipzig, 1913.

Sommer, J. "Marksteine deutscher Geschichte—Zu Werner Peiners Entwürfen der Bildteppiche für die Marmorgalerie der neuen Reichskanzlei." *KiDR* 4, 4 (1940), pp. 114ff.

Speer, A. *Erinnerungen.* Berlin, 1969.

Sperling, E. *Neue deutsche Bildschnitzkunst.* Burg b. M., 1943.

Staeger, F. "Die Kunstakademien des Dritten Reiches." *Das Bild,* 9, 8/9 (1939), pp. 225f.

Statistik des Deutschen Reiches. vol. 518, *Die sportlichen Übungsstätten im Deutschen Reich.* Berlin, 1938.

Steinberg, R., ed. *Nazi-Kitsch.* Darmstadt, 1975.

Stephan, H. *Baukunst im Dritten Reich.* Berlin, 1939. Nr. 43 in the series *Schriftenreihe der Hochschule für Politik.*

———. *Wilhelm Kreis.* Oldenburg, 1944.

Stern, F. *The Politics of Cultural Despair—A Study in the Rise of the Germanic Ideology.* Berkeley, 1961.

Strauss, G. "Dokumente zur 'Entarteten Kunst,'" in *Festgabe an Carl Hofer.* Berlin, 1948.

Strothmann, D. *Nationalsozialistische Literaturpolitik. Ein Beitrag zur Publizistik im Dritten Reich.* Bonn, 1960.

Struwe, M. "Nationalsozialistischer Bildersturm—Funktion eines Begriffs," in M. Warnke, ed. *Bildersturm—Die Zerstörung des Kunstwerks.* Munich, 1973, pp. 121ff.

Sweezy, P. M. *Theorie der kapitalistischen Entwicklung.* 3d ed., Frankfurt a. M., 1972.

Tamms, F. "Das Grosse in der Baukunst." *KiDR* 8, 3 (1944), "Die Baukunst," pp. 47ff.

———. "Die Bedeutung des Natursteins für die Baukunst." *KiDR* 8, 11 (1944), "Die Baukunst," pp. 199ff.

Taylor, R. R. *The World in Stone—The Role of Architecture in the National Socialist Ideology.* Berkeley and Los Angeles, 1975.

Teupser, W. "Künstler im Lichte einer neuen Zeit—Albin

Egger-Lienz." *Die Kunst*, 69, 4 (1934), pp. 101ff.

Teut, A. *Architektur im Dritten Reich 1933–1945*. Berlin, Frankfurt, and Vienna, 1967.

Treue, W. *Kunstraub—Über die Schicksale von Kunstwerken in Krieg, Revolution und Frieden*. Düsseldorf, 1957.

Troost, G., ed. *Das Bauen im Neuen Reich*. Bayreuth, 1938. 2 vols.

Valland, R. *Le Front de l'Art*. Paris, 1961.

Vinnen, C. *Protest deutscher Künstler*. Jena, 1911.

Vogt, A. M. "Revolutions-Architektur und Nazi-Klassizismus," in *Argo—Festschrift für Kurt Badt*. Cologne, 1970, p. 354.

Vogt, P. *Geschichte der deutschen Malerei im 20. Jahrhundert*. Cologne, 1972.

Vollbehr, E. *Arbeitsschlacht—Fünf Jahre Malfahrten auf den Bauplätzen der "Strassen Adolf Hitlers."* Berlin, 1938.

Volz, R. "Neue Wandmalerei—Zu den Fresken von Franz Eichhorst im Rathaus zu Berlin-Schöneberg." *KiDR* 2, 11 (1938), pp. 341ff.

Waentig, H. *Wirtschaft und Kunst—Eine Untersuchung über Geschichte und Theorie der modernen Kunstgewerbebewegung*. Jena, 1909.

Walden, N. *Herwarth Walden—Ein Lebensbild*. Berlin and Mainz, 1963.

Weber, H. *Deutsche Holzschnitzerei der Gegenwart*. Bayreuth, 1940.

Weidner, H. *Berlin im Festschmuck—Vom 15. Jahrhundert bis zur Gegenwart*. Berlin, 1940.

Weigert, H. *Die heutigen Aufgaben der Kunstwissenschaft*. Berlin, 1935.

———. *Geschichte der deutschen Kunst von der Vorzeit bis zur Gegenwart*. Berlin, 1942.

Wendland, W. *Kunst und Nation*. Berlin, 1934.

Wernert, E. *L'Art dans le III^e Reich—Une tentative d'ésthetique dirigée*. Paris, 1936.

Wersin, W. von. *Das elementare Ornament und seine Gesetzlichkeit*. Ravensburg, 1940.

Wilke, H. *Dein "Ja" zum Leibe*. Berlin, 1939.

Willrich, W. *Männer unserer U-Boot-Waffe*. Berlin, 1940.

———. *Säuberung des Kunsttempels—Eine kunstpolitische Kampfschrift zur Gesundung deutscher Kunst im Geiste nordischer Art*. 2d ed. Munich and Berlin, 1938.

Witte, K. "Die Filmkomödie im Dritten Reich," in D. Denkler and K. Prümm, eds. *Die deutsche Literatur im Dritten Reich*. Stuttgart, 1976.

Wolters, R. *Albert Speer*. Oldenburg, 1942.

Wulf, J., ed. *Die bildenden Künste im Dritten Reich*. Gütersloh, 1963.

———. *Literatur und Dichtung im Dritten Reich*. Gütersloh, 1963.

———. *Musik im Dritten Reich*. Gütersloh, 1963.

————. *Presse und Funk im Dritten Reich.* Gütersloh, 1964.

————. *Theater und Film im Dritten Reich.* Gütersloh, 1964.

Zerull, L. "Die Bildende Kunst des Dritten Reichs." *Kunst und Unterricht*, 6 (1971).

INDEX

ILLUSTRATION SOURCES

Illustrations are indicated by page number and location—t.r. (top right), c.l. (center left), b. (bottom), b.l. (bottom left), etc. Because the color section is not numbered, color illustrations are identified by (col.) and the corresponding page and location in that section: (col.) 2 b.—bottom of second page in the color section.

Archiv für Kunst und Geschichte, Berlin: 120 c., 132 t.r., 135 t., 136 t., 145 t.l., 211 t., 214 b.

Bilderdienst Süddeutscher Verlag, Munich: 7, 99 t., 100 t., 134 t.r. and b., 139 t., 142 b., 144 b., 147 t.l., 155, 217 t., 221 t., 223

Burghardt, W., *Sieg der Körperfreude*, Dresden, 1940: 178 t.r., 179 t.r.

Das Bild, Munich: 86 t., 88 t., 90 b., 93 b., 94 t. and b., 96 t., 98 c., 118, 120 t., 122 t. and c.l., 131 l., 134 t.r., 141 t.r., 145 c.l., 169 b., 170 c. and b., 207, 216, 218–219

Die Kunst. Monatshefte für freie und angewandte Kunst, Munich: 6, 101 c., 164 b.r., 165 t., 166 b., 168 c.

Fischer, H.W., *Menschenschönheit—Gestalt und Antlitz des Menschen in Leben und Kunst*, Berlin, 1935: 175, 176, 180 t.r., 182 b.l.

Hinz, Frankfurt: 3, 4, 18, 107 b., 109, 113 b., 127 c., 133 t.l., 140 t.l., 141 t.l. and b., 142 t., 143 t.r. and t.l., 153 t., 162 t.r., 196, 203, 220 t.l. and t.r.

Grossen Deutschen Kunstausstellungen, Catalogs, Munich: 90 t.r., 92 t., 107 t., 133 b., 143 b., 162 t.l. and b.l., 164 b.l., 171 b.r., 172 t.l., 202, 206

Kunst im Dritten Reich, Munich: 86 b., 87 t., 91 b., 119 t., 123 b., 125 t.r., l., and b.r., 127 t. and b., 128, 129, 130, 133 t.r., 135 b.l., 145 b., 146 b., 151, 159, 160, 163, 164 t., 165 b., 166 c., 168 b., 192, 193 b., 208, 211 t., 222 t., 224

Kunsthalle, Hamburg: 152

Kunsthaus, Zurich: 133 t.

Marsani, A.R., *Frauen und Schönheit in aller Welt*, Berlin, 1939: 178 b.r., 179 b.r., 182 t.

Neue Deutsche Baukunst, Berlin, 1941: 185, 193 t.

Oberfinanzdirektion, Munich (Property of the Federal Republic of Germany): (col.) 2 b., (col.) 5, (col.) 6, (col.) 7, (col.) 8, (col.) 11

Oeser, H.L., *Deutsches Land und deutsches Volk*, Berlin, 1933: 180 b.r., 181 t.r. and b.r.

Osterreichische Galerie, Vienna: 154

Rittich, W., *Deutsche Kunst der Gegenwart*, Breslau, 1943: 123 c.l.

Silva, Umberto, *Ideologie e arte de Fascismo*, Milan, 1973:
201

Städtische Galerie, Munich: 153 b.

Ullstein GmbH Bilderdienst, Berlin: 103, 126 b.

Wilke, H., *Dein "Ja" zum Leibe*, Berlin, 1939: 177, 178 t.l.

Zeitgeschichtliches Bilderarchiv Heinrich Hoffmann, Munich: 84 t., 85 t., 132 c. and b.l., 137, 140 t.r.

Zeitungsmagazin, Hamburg: (col.) 1, (col.) 2 t., (col.) 4, (col.) 9, (col.) 10, (col.) 12, (col.) 13, (col.) 14, (col.) 15, (col.) 16

Zentralinstitut für Kunstgeschichte, Munich: 84 b., 87 b., 88 b., 89 t., 91 t., 92 b., 93 t., 95, 97, 98 t.l. and t.r., 99 b., 101 t., 119 b., 121, 122 c.r., 123 c.r., 124, 132 t.l. and b.r., 136 b., 139 c. and b., 144 t., 145 c.r., 146 t., 147 t.r. and b., 167 t.l. and b., 168 t., 170 t., 171 b.l., 172 t.r. and b., 209, 210, 211 b.l. and b.r., 212, 214 t., 217 b., 221 b., 222 b.

About the Author

Berthold Hinz was born in Königsberg in 1941. As a member of the Frankfurter Kunstverein, Professor Hinz was a leading contributor to a catalogue on art in the Third Reich, prepared in conjunction with a major exhibition in Frankfurt in 1974. He is the author of two other books, on Dürer and Caspar David Friedrich, and is currently at work on an exhibition and book dealing with the English painter and engraver William Hogarth. He makes his home in West Berlin, where he is a professor of art history at the Pedagogic Institute.